SPLASH 8 ✳ Watercolor Discoveries

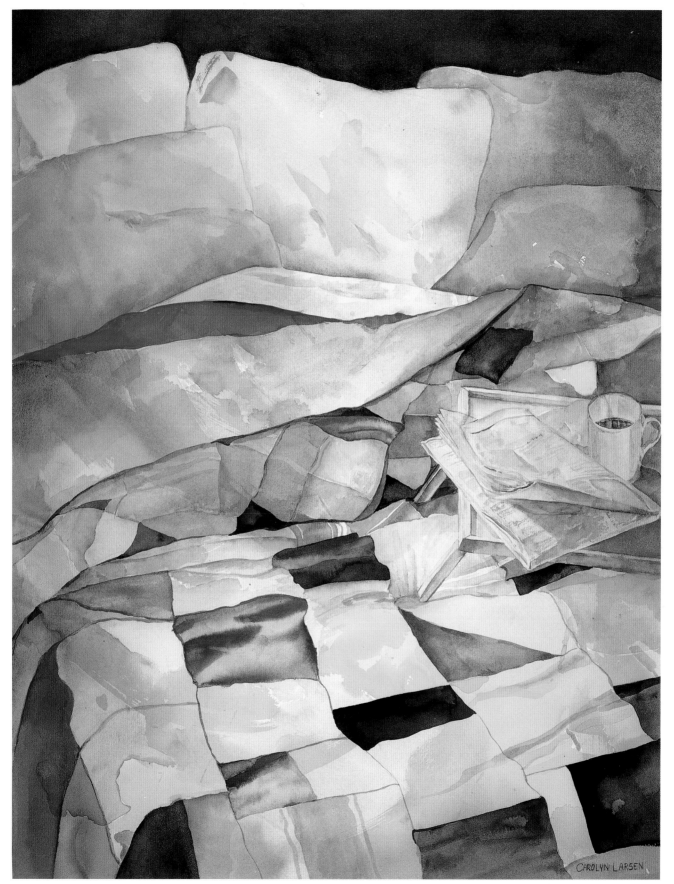

SUNSTRUCK MORNING

Carolyn Larsen • Transparent Watercolor • 26 ½" x 20 ½" (67cm x 52cm)

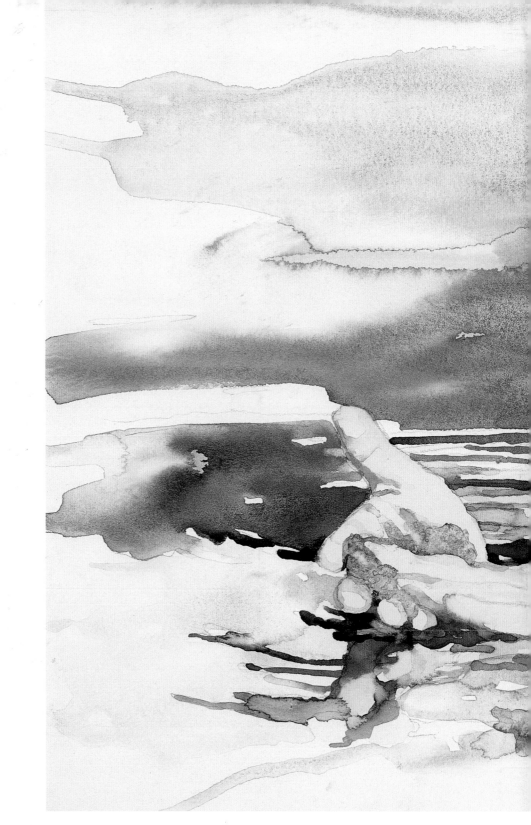

SPLASH 8
Watercolor Discoveries

edited by Rachel Rubin Wolf

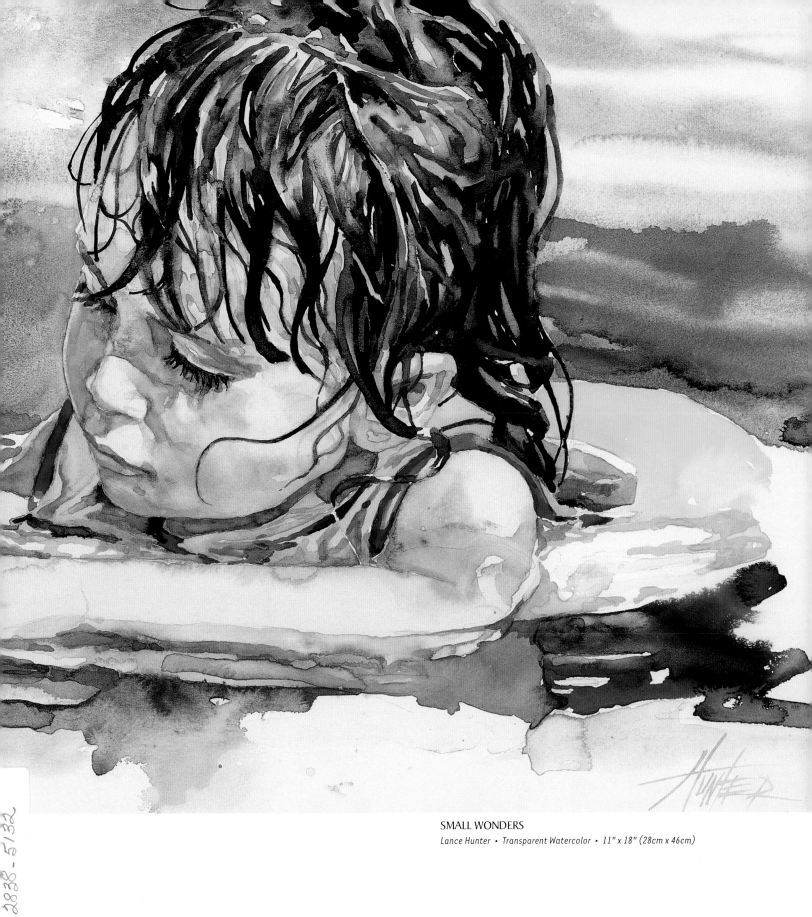

SMALL WONDERS
Lance Hunter • Transparent Watercolor • 11" x 18" (28cm x 46cm)

NORTH LIGHT BOOKS
CINCINNATI, OHIO
www.artistsnetwork.com

About the Editor

Rachel Rubin Wolf is a freelance editor and artist. She edits and authors fine art books for North Light Books, including the *Splash* series (Best of Watercolor), *The Best of Wildlife Art* (editions 1 & 2), *The Best of Portrait Painting*, *The Best of Flower Painting 2*, *The Acrylic Painter's Book of Styles and Techniques*, *Painting Ships, Shores and the Sea* and *Painting the Many Moods of Light*. She has also acquired numerous new fine art book projects and authors for North Light Books.

Acknowledgments

Thank you to the editors and staff at North Light who helped organize the profusion of details that Splash generates, including Marylyn Alexander, Wendy Dunning, Courtney Heldman and Layne Vanover.

Many thanks again to the artists themselves—both to you who have shared your art and your thoughts so generously in this volume, and to you who partake of the beauty within.

Splash 8: Watercolor Discoveries. Copyright © 2004 by North Light Books. Manufactured in China. All rights reserved. No part of this book may be reproduced in any form or by any electronic or mechanical means including information storage and retrieval systems without permission in writing from the publisher, except by a reviewer who may quote brief passages in a review. Published by North Light Books, an imprint of F+W Publications, Inc., 4700 East Galbraith Road, Cincinnati, Ohio, 45236. (800) 289-0963. First Edition.

Other fine North Light Books are available from your local bookstore, art supply store or direct from the publisher.

08 07 06 05 04 5 4 3 2 1

Library of Congress Cataloging-in-Publication Data
Splash 8: watercolor discoveries / edited by Rachel Rubin Wolf.
 p. cm
 Includes index.
 ISBN 1-58180-442-3 (hc. : alk. paper)
 1. Watercolor painting—Technique. I. Title: Splash eight

ND2237 .B67 2001
571.42'24328—dc21 00-068694

ISBN 0-89134-349-0 (1), ISBN 0-89134-503-5 (2), ISBN 0-89134-561-2 (3),
ISBN 0-89134-677-5 (4), ISBN 0-89134-904-9 (5), ISBN 0-89134-960-X (6)
ISBN 1-58180-147-5 (7), ISBN 1-58180-442-3 (8)

Edited by Layne Vanover
Designed by Wendy Dunning
Production art by Donna Cozatchy
Production coordinated by Mark Griffin

The permissions on pages 138-142 constitute an extension of this copyright page.

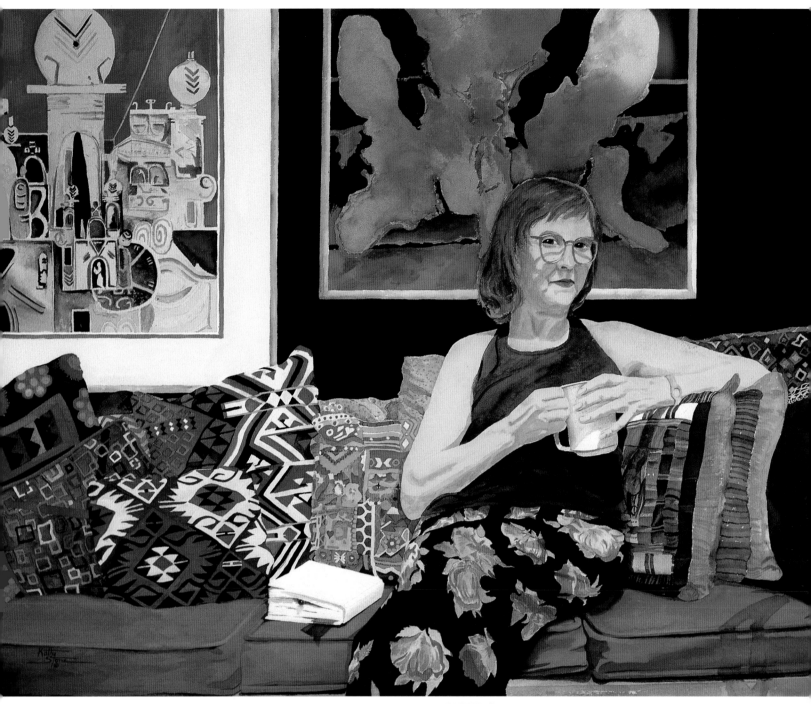

PATTERNS
Kathy Miller Stone • Transparent Watercolor • 22" x 30" (56cm x 76cm)

TABLE of CONTENTS

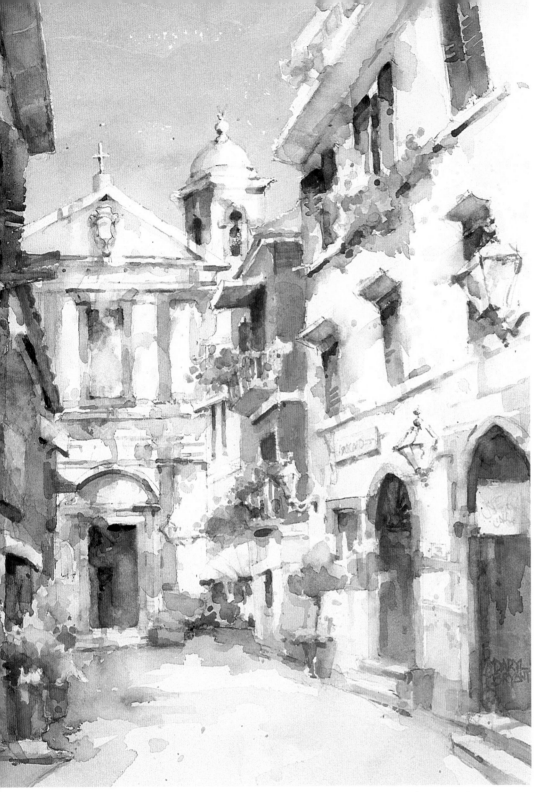

STRADA A MONTEPORZIO · *Daryl Bryant* · *Transparent Watercolor* · *16" x 12" (41cm x 31cm)*

Introduction

Watercolor Discoveries. Somehow the two words just naturally go together.

Over the years we have been privileged to view many fascinating discoveries, made by numerous and diverse artists: discoveries about the watercolor medium and about the act of painting in watercolor. We could no longer keep them to ourselves, so we decided to offer some of them to you in this eighth edition of Splash.

Some of the discoveries here are "Breakthrough Discoveries" that changed the artistic path of the artist. I would encourage you not only to view the glorious pictures, but also to read the text. There is much of interest to be learned here, both for the artist and for the art lover.

Perhaps you will make some discoveries as well. Perhaps, like Gene Rizzo (pages 112-113), you will discover a new aspect of yourself.

7

DISCOVER
Color

The artists in this chapter made discoveries about color: glowing color, layered color, bold color, accidental color, irreplaceable color, color that hides in dark Venetian canal passages and, above all, color that is fun.

Soon Y. Warren [opposite page] discovered that combining linear movement with dramatic color can produce a joyful effect. "I wanted the majestic ruffled peony to comfortably snuggle in the art-glass bowl surrounded by dramatic color. I focused on my feeling of joy in the painting, expressing it with variations and movement in the lines, and with bright color. I intensified the colors and shadows to make the painting sing out my feelings of spring."

Color tends to sing with contrast:
light against dark
and opacity next to transparency.

—ALEX McKIBBIN

PEONY WITH GLASS
Soon Y. Warren • Watercolor • 22" x 15" (56cm x 38cm)

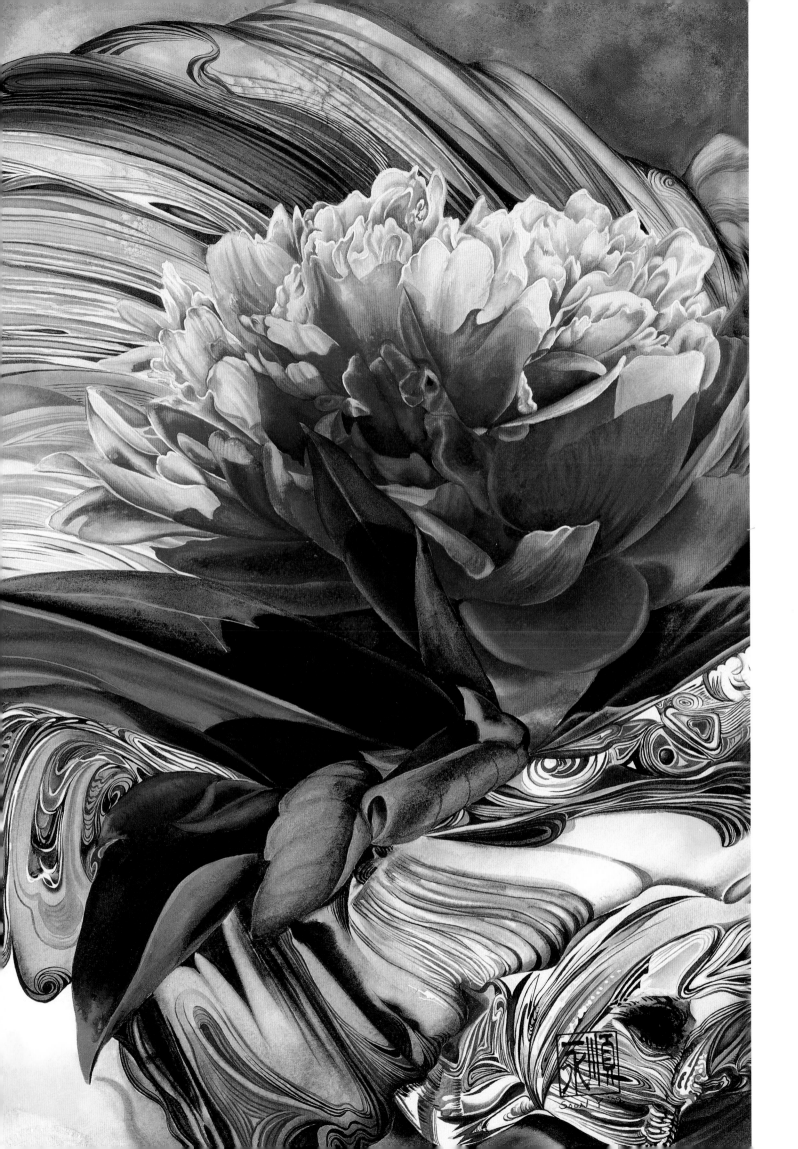

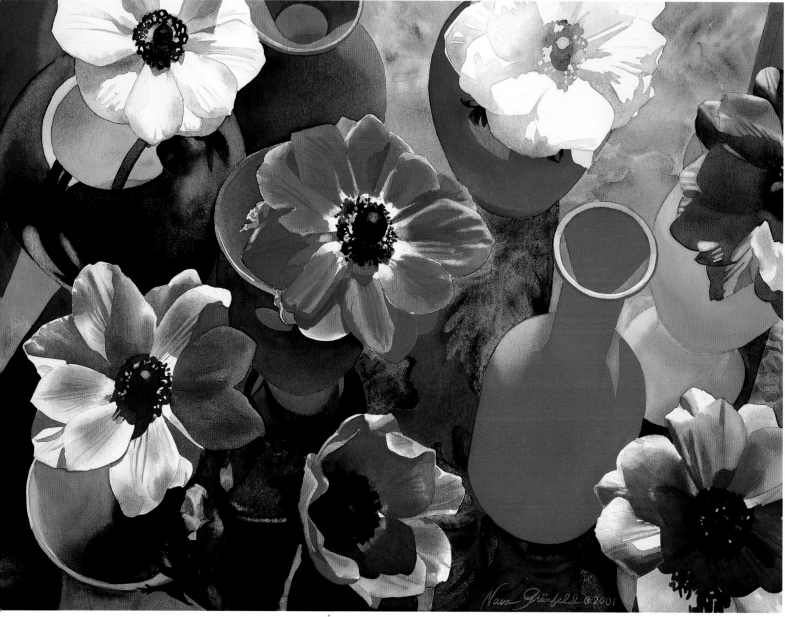

RED VASE

Nava Grunfeld · Watercolor · 29" x 41" (74cm x 104cm)

Many layers of transparent color
make colors glow with intensity.

Nava Grunfeld

Working on a grand scale in watercolor has allowed me to take a medium that is sometimes considered fussy and weak and show it capable of making a bold statement. In recent years I have concentrated on adding high-intensity color, strong light and an unusual perspective to my paintings of everyday objects, figures and flowers. Each painting is layered with many veils of transparent color, which I discovered gives it an intense color-saturated luminosity. The paintings glow almost as though they are lit from behind like a stained glass window. ✳ Anemones are my favorite flower. I have done many paintings of them and am always intrigued; no two are alike. I use a round brush and paint wet-into-wet in sections of the painting, such as the vase. Under the red of the vase is a layer of yellow, which is what gives it its warm glow.

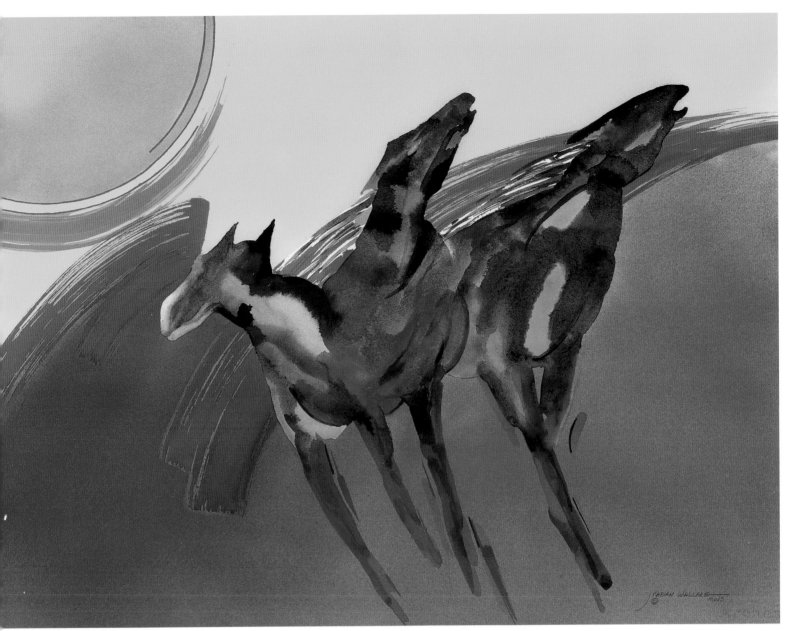

SUN RUNNERS
Jan Fabian Wallake • Watercolor • 21" x 28" (53cm x 71cm)

Pouring on glazes
keeps pure watercolor brilliant and transparent.

Jan Fabian Wallake

I love pure, transparent color. I discovered a way to create brilliant color glazes by pouring pigment mixtures from a cup rather than brushing them on the paper. ✳ I mix each pigment in a separate mixing cup with enough water to form a milky consistency. Once the sketch is in place, I wet the surface of the area to be glazed. A pump-style sprayer filled with clean water is best for wetting the paper since it assures that the paper's surface fibers will not be disturbed (brushing can flatten those fibers and decrease the transparency of a glaze). After draining off the excess water, I pour on my first color, run it around the area, then wait for it to dry. I repeat this process several times with the same color or an analogous color until the glaze glows. In *Sun Runners*, I poured the top area in yellows and golds, then glazed the lower section in a variety of blues. With a swish of red, a glaze of orange within the sun and a loose painting of the horses, *Sun Runners* was completed.

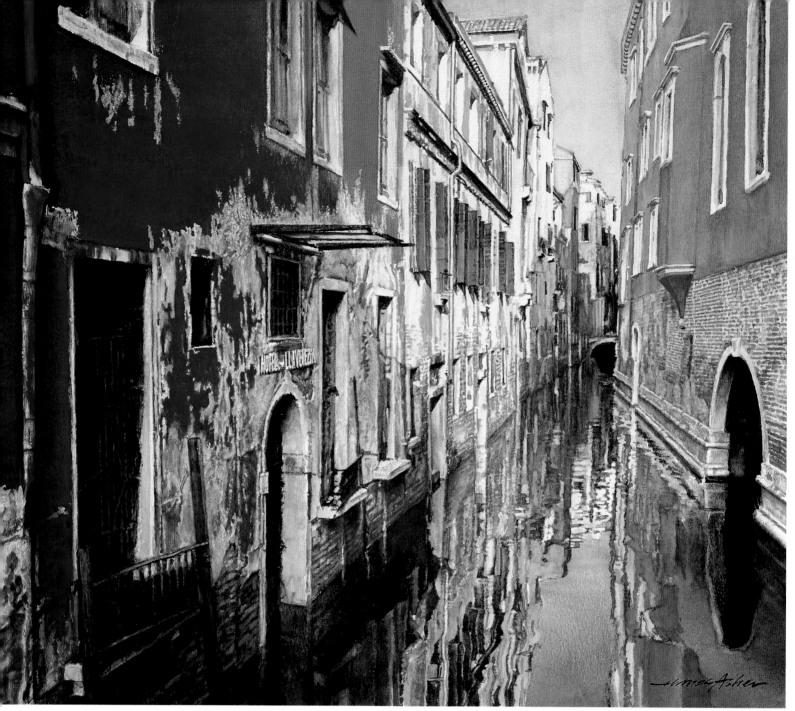

HOTEL VILLA VENEZIA, VENICE
James Asher • Watercolor • 13 ½" x 15 ½" (34cm x 39cm)

Find color away from the crowds in popular locations like Venice.

James Asher

Venice is a complex, crowded, fascinating group of islands crisscrossed by tiny canals and narrow passageways. Most tourists never see the interior of Venice, but rather stroll that section of the city next to the Grand Canal. My discovery, and the subject of many of my paintings, was to explore the many passages and tiny canals in the center of the city. I came to Venice thinking that too many paintings had already been done here. I thought I would not be able to find "new" subject matter to stimulate me. I was wrong. Only a short walk away from the crowds of the Piazza San Marco, I was in the dark, quiet recesses of Venice. That's where I discovered the Hotel Villa Venezia with its crumbling red facade. ✳ One rare artistic challenge is to create a painting with the dominant color being red. There are just a few examples from the impressionists, notably Gauguin and Degas. So, when I saw this weathered facade with its crumbling red plaster, I was elated at the prospect of creating a composition in red.

BY A HARBOR NAMED PEARL
Cindy Brabec-King • Watercolor • 22" x 30" (56cm x 76cm)

Naples Yellow is an irreplaceable color
for flesh tones.

Cindy Brabec-King

In *By a Harbor Named Pearl* the challenge was the sunburned skin, the man's textured back and the shine on oiled multiple figures. Painting around his white hair meant much patience and a 00-brush; ten hours alone went into painting his back and chest area. Small strokes of Burnt Sienna, Alizarin Crimson and Naples Yellow created the sunburn underneath. Older people can have more brushstrokes applied, whereas building up color and added strokes make younger skin look older. Contrasting colors, textures and statements of the personalities created difficulty in simplicity. ✳ When painting flesh, a crucial color is Naples Yellow. The pigment qualities are irreplaceable. This creamy, fleshy color, when mixed, has a beneficial lifting ability and prevents immovable stains. By painting one figure at a time and then getting away from the piece, you can occasionally avoid unfixable mistakes.

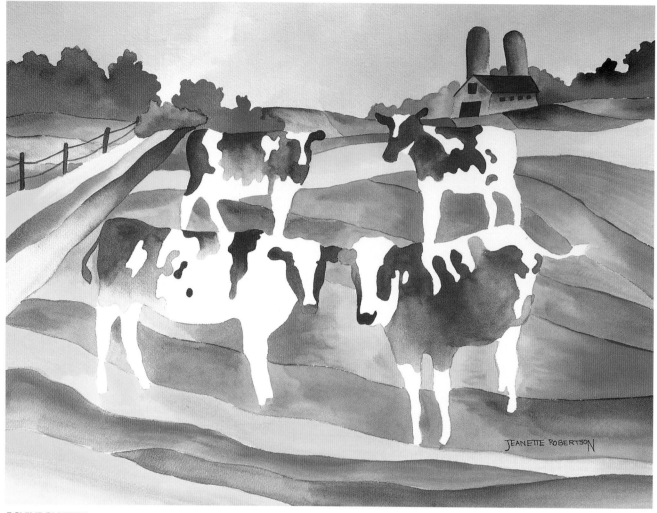

BOVINE RHYTHM
Jeanette Robertson • Transparent Watercolor • 13" x 16 ½" (33cm x 42cm)

It was challenging and fun
to paint a personal twist
on the Fauve movement of the early 1900s.

Jeanette Robertson

Exaggerated shapes and forms with unrealistic colors were key to the Fauve style, which was different for me. Since landscape was a popular subject for the Fauves, I would paint what was near me: rolling hills, farms and cows. My own twist was to paint in watercolor; most Fauve paintings appeared to be done in oil. I added a more graphic slant to the imagery with harder edges and clean, crisp, bright color. Some people mistakenly consider the look Peter Max, but my images are not "pop," as in the popular 1960s style. ✳ I painted with a sense of freedom and fun, but had to keep in mind a balance of colors, forms and shapes. I did not want flat graphic color, so I varied my values.

ENVIRONS OF PAMAJERA #230
Alex McKibbin • Watercolor • 29" x 40" (74cm x 102cm)

Never completely painting one area of color smack up against another
seems to create a jump in space
that causes the color to sing or vibrate.

Alex McKibbin

Color tends to sing with contrast: dark against light, opacity next to transparency. I've also discovered the importance of edges—or more specifically, the importance of creating a narrow space of light and halation (halo) between colored areas that tends to make these areas stand out. ✳ Manipulation of the medium to maintain these halations can include masking tape, rubber cement, frisket or just plain dexterity. When I've failed to preserve the white of the paper, I'll often put the work in my shower for a half day and then scrub through a layer or two. Using stencils I'll attempt the same while the work is dry. The result does not have to look murky or abused. These scrubbed areas create a rather mysterious quality in marked contrast, making a much more direct, declarative statement. They can almost create a subplot to the major action.

15

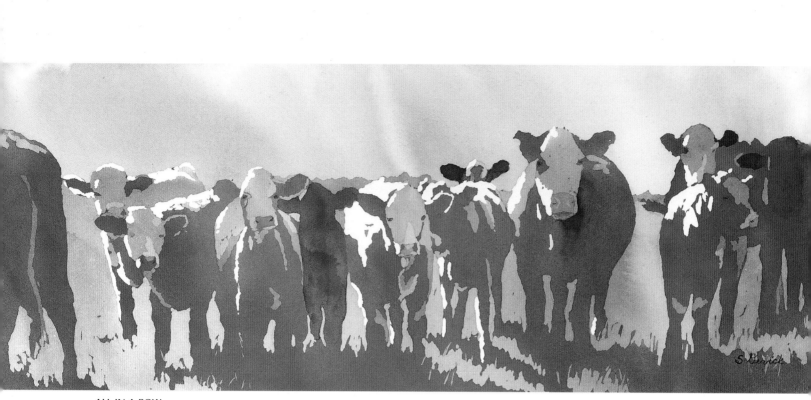

ALL IN A ROW
Saundra Devick • Transparent Watercolor • 11" x 30" (28cm x 76cm)

With *guidance from Jean Grastorf and others*
I discovered that I could plan the values of a painting
and allow the colors to just happen.

Saundra Devick

After much planning of design, composition and values, I proceeded by pouring paint on my prepared paper and the painting almost painted itself. As I continued to do successive pours, new and unplanned colors appeared from light to dark. I was drawn to this particular composition because it had a full range of values. The morning sun on the backs of the cows created an interesting design of whites, even though some of the cows had very dark hair. ✳ Pouring hues of cool Lemon Yellow, warm Quinacridone Gold, Red Rose Deep and Phthalo Blue at the same time gave the paint an opportunity to blend, or not blend, depending on how much the paper was tipped. To protect the areas that I wanted to remain undisturbed, I covered them with masking before continuing with another application of paint.

A Raw Sienna underpainting
adds a warm glow to the whole painting.

Esther Melton

To emphasize the warm light in this painting, I covered the entire painting area with an underpainting of Raw Sienna, with the exception of a few whites in the silver gravy boat. The Raw Sienna added a nice glow, and now I use this technique frequently, especially for paintings in which warm colors dominate. ✳ Many layers of color were painted to create the softness and flowing movement I wanted to convey in the old linen cloth. Once this was completed, I carefully painted the dark shapes in the linen, allowed time for the paper to dry and repeated the process to create the strong contrasts.

PEARS AND SILVER GRAVY BOAT
Esther Melton • Transparent Watercolor • 28" x 20" (71cm x 51cm)

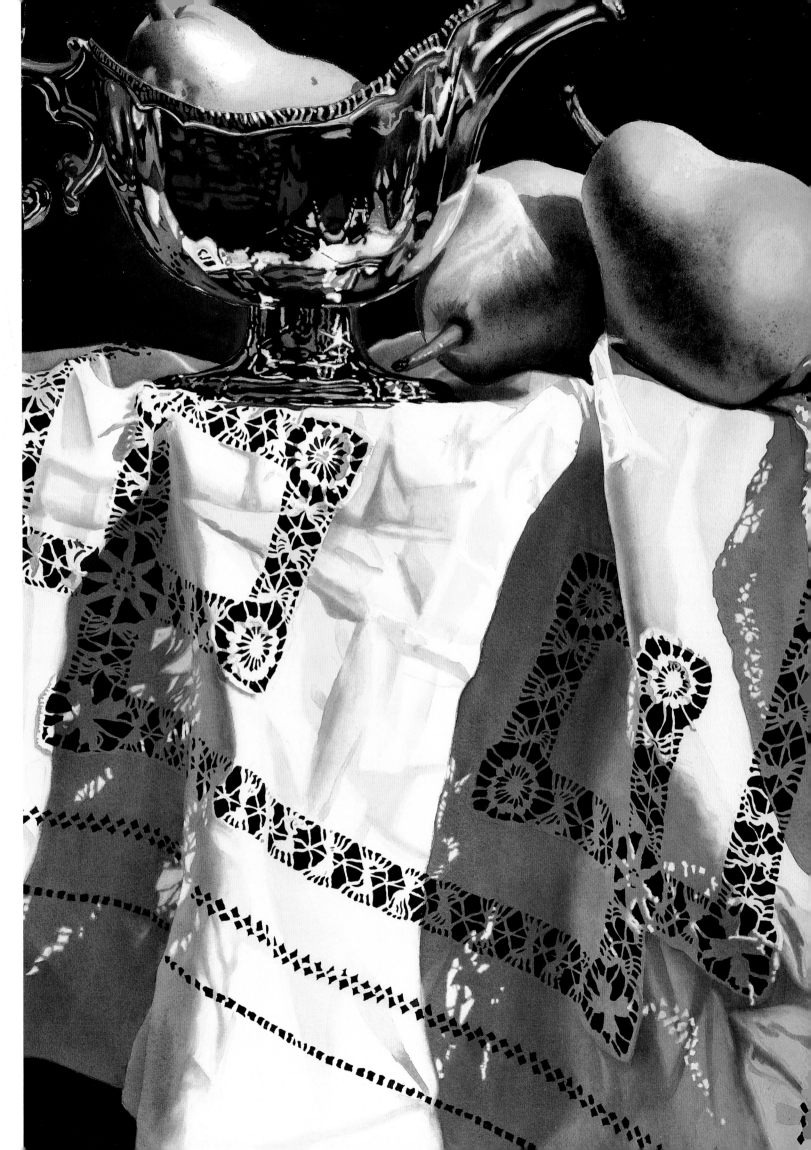

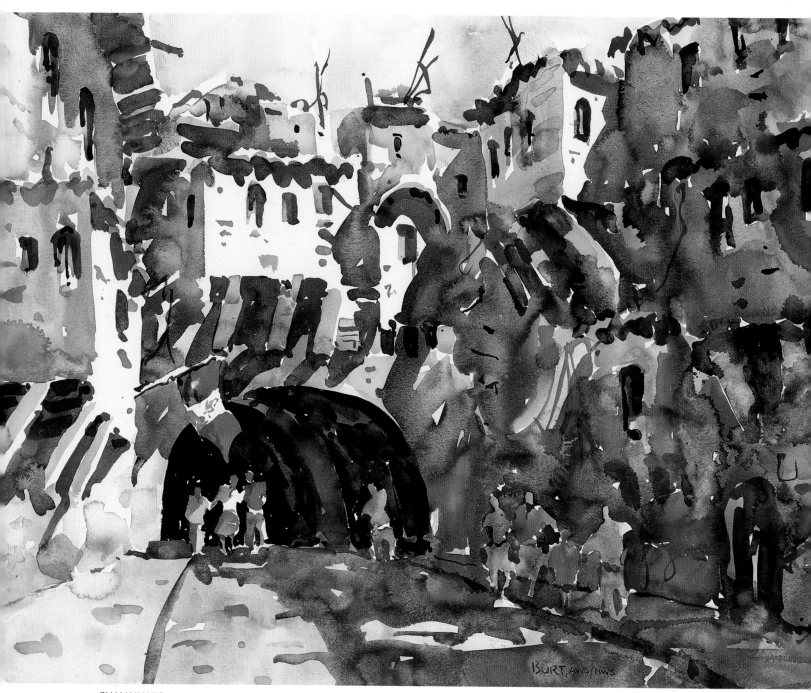

GUANAJUATO
Dan Burt • Transparent Watercolor • 22" x 30" (56cm x 76cm)

Be bold with color
to entertain your viewers.

Dan Burt

To my delight, I discovered years ago in Guanajuato, Mexico that value and intense color contrasts provide entertainment. The pure colors next to their complements that were used for the figure symbols in the foreground provide visual excitement. Add to this the fact that the three joined figures in sunlight are pushed out by the darkest dark of the tunnel and the scene ends with an exclamation point. The other figures in shadow play a supporting role, as do the small pieces of intense color repeated throughout. The wet-into-wet mixing of pure colors for the large dark areas provides a variety of grays, which in turn enhance the intense colors. ✳
I worked light to dark in stages on dry cold-pressed paper using sable brushes and pure colors. I painted around saved whites and saved colors. The middle-value sky and foreground were painted wet-into-wet, as were most of the darks. I finished by putting in the darkest dark.

SCHOOL'S OUT
Lawrence Danecke • Watercolor • 22" x 30" (56cm x 76cm)

Liquid concentrated colors
create a "Wow!" intensity.

Lawrence Danecke

Living in South Florida tunes my sense of colors toward bright and tropical. Flowers, birds and animals here flaunt bold colors, and saltwater fish have colors that even border on neon. Trying to capture those colors in "traditional" watercolors is a challenge and often not even possible. So when I can't get enough intensity with tube paints and need a jolt of color, I use liquid concentrated watercolors. The colors are amazing, but I find their performance is very limited. They stain almost immediately, are difficult to blend and creating textures is almost impossible. So I use them sparingly, and only when I need that "Wow!" they provide. ✳
On Arches cold-press I mask all the fish with drafting tape, then saturate the background with strong rich darks. Just before it dries, I load a brush with water and empty it by swinging it briskly back and forth just above the paper. The fish are painted once lightly in staining colors. I then apply masking fluid for the scales and patterns, and paint again with darks. Finally I use Dr. Ph. Martin's concentrates for the really intense colors.

DISCOVER
Design
and composition

Design and composition are the areas in which the artists in this chapter made discoveries. These discoveries include new ways to combine perspective with other art elements, adding an element of chance to a composition, narrowing one's focus, working in a new format, experimenting with new subjects and renewing old disciplines.

Laurel Hart [opposite page] discovered that strong composition is the vehicle that delivers your content. "A good painting is first and foremost a well-designed rectangle. It was Arne Westerman who taught me this principle, which, simply stated, is that composition is more important than the subject. Once I discovered this idea and began to let the story take a back seat to design, my work became stronger and, interestingly enough, my content became more powerful."

A good painting is first and foremost
a well-designed rectangle.

—LAUREL J. HART

HEADING HOME
Laurel J. Hart • Watercolor • 20" x 14" (51cm x 36cm)

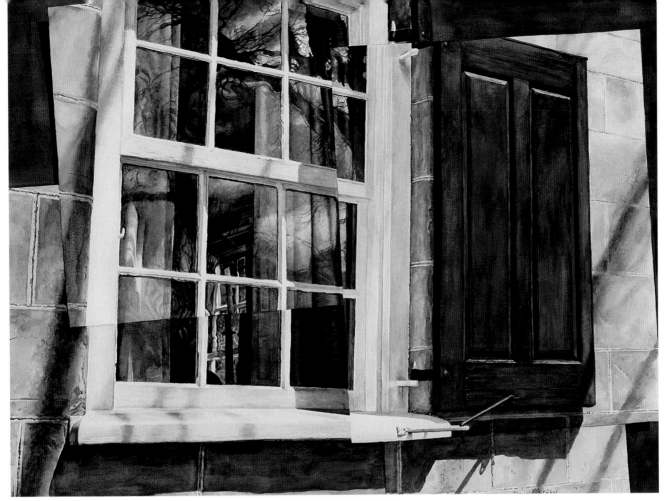

BRANCHING OUT
David L. Stickel • Watercolor • 24" x 29" (61cm x 74cm)

Adding an element of chance to realism
caused me to "branch out" from my typical approach. Λ

David L. Stickel

This piece was a breakaway from my typical approach to realism in that I chose not to be so concerned with the lines of the actual image, but to utilize the edges of the photos from which I worked. I wanted the very heart of the window showing through to another window for interest. The reflection of the branches and the tree limbs adds a three-dimensional depth. ✳ After choosing the photos I planned to use for this painting, I arranged them on my table, sliding my hand over them and moving them around, not concerning myself with where the contour lines fell. I then painted this window using the contours of the photos.

Combining the elements of one-point perspective
with the wonderful reflections in these windows
is what makes this composition especially interesting.

David L. Stickel

I was intrigued with the many images found inside the windows. Each windowpane represents a miniature painting in and of itself. The Ultramarine and Thalo Blue of the atmosphere bring a sense of light and transparency that contrasts with the dark reflections and the heavy earth tones of the bricks. The reflections of the cars and even my older son's face in the windows provide a depth that is convincingly realistic. ✳ After taping the paper to the table, I established my vanishing point off the paper, on the table itself. This was used as a reference point for all lines, from the brick pavers to the lines in the windows to the guttering on the roof line.

TREASURES OF THE HEART
David L. Stickel • Watercolor • 30" x 22" (76cm x 56cm)

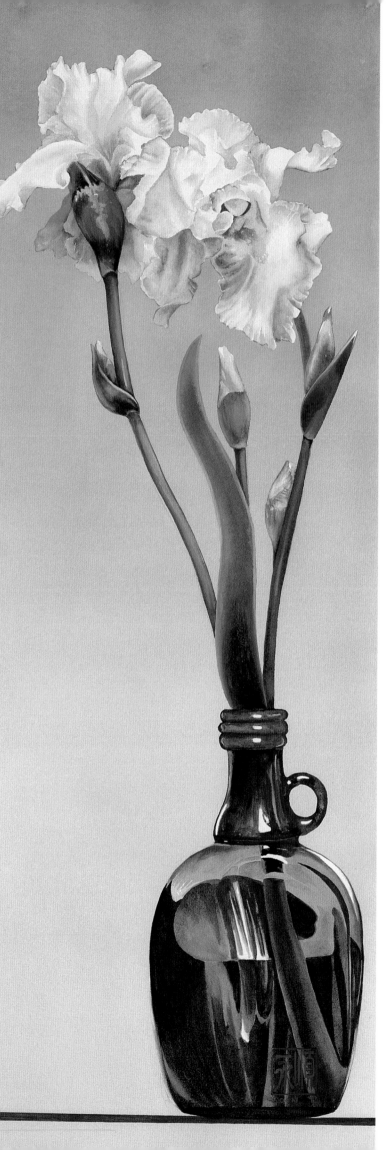

A two-toned solid background wash creates a sense of depth while retaining simple elegance.

Soon Y. Warren

Long-stemmed, fragile irises in a dark green recycled vase was the subject of the minimal, elegant composition that I wanted to paint with an uncomplicated solid background. As elongated stems and ruffled flowers danced freely on the top of the page, filtered light emanated through the dark, jug-shaped vase to highlight its subtle, mysterious transparency. I wanted the painting to be simple and elegant, so the challenge was to anchor the objects without distracting the viewer from the elegance of the primary subject. ✳ In order to make a smooth, two-toned background, I masked the petals and highlight of the vase. Then, I used Prussian Blue on top and Yellow Ochre on bottom to make the background wash, repeating the process until I achieved the desired value. After removing the masking fluid, I painted the flower, stem and vase, adding a solid line near the bottom to anchor the foreground subjects. In order to maintain the simple composition, I hid my signature in the green vase.

GREEN VASE

Soon Y. Warren • Watercolor • 30" x 11" (76cm x 28cm)

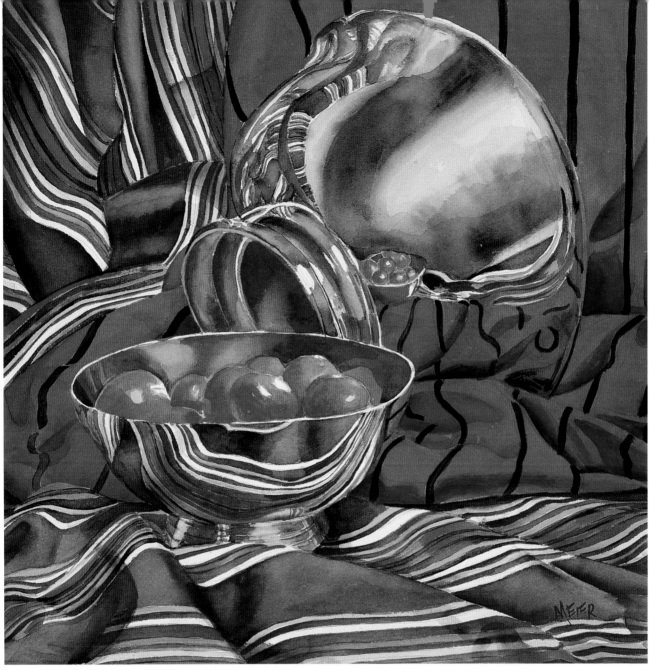

ECHOES AND RESONANCE
Eleanor Tyndall Meier • Watercolor • 17" x 17" (43cm x 43cm)

Narrowing the focus of a still life to two objects helped intensify the visual interest.

Eleanor Tyndall Meier

A constant theme in my still-life paintings is the use of transparent and reflective objects. The objects that I select have come down through the generations and are important because of their past. My goal is to design a work that is an exciting, moving, visual feast that celebrates my heritage. I want to push the watercolor medium so that the color is saturated with richness, depth and clarity. I discovered in *Echoes and Resonance* that I was able to intensify the visual experience by narrowing the focus to two objects. Their reflective qualities became the central theme, as they produced echoes, or paintings within the painting. To further unify the design, the silk fabrics were arranged to lead the eye through the composition. ✳ The use of quinacridone pigments, with their unrivaled transparent qualities, allowed for a pulsating beat in the silver and enriched the resonance in the red silk fabric, lending a luminosity and brilliance to the painting that was not possible when using traditional pigments.

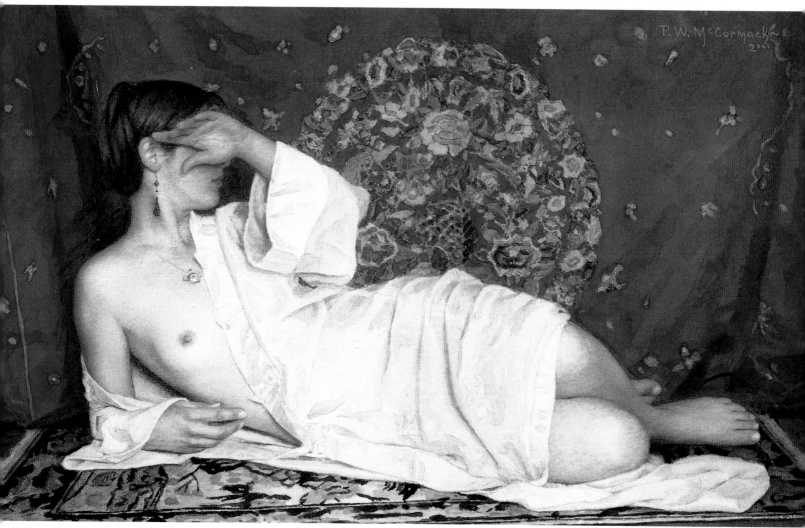

HUMILITY
Paul W. McCormack • Watercolor • 6" x 10" (15cm x 25cm)

Working in a small format
*can simplify compositional problems
and allow for faster results.*

Paul W. McCormack

With every painting there are always new discoveries. They can be technical, inspirational, philosophical or simply practical. Working on a smaller scale is very sensible when you consider that it takes me two months on the average to complete larger full-scale works. The simplification of my subject matter due to the smaller scale allows me to achieve gratifying results within a week's time. A successful smaller work can also act as a working study for a much larger painting. *Humility* has in fact inspired a much larger painting that contains all of the same elements. Although the composition is entirely different, the use of the same light source, model and surrounding elements adds a great amount of certainty to the success of the larger painting. ✳

As are all of my watercolor paintings, *Humility* was painted on Arches 140-lb. (300gsm) cold-pressed paper. The hard-textured surface and durable nature of this paper are vital for the employment of my techniques.

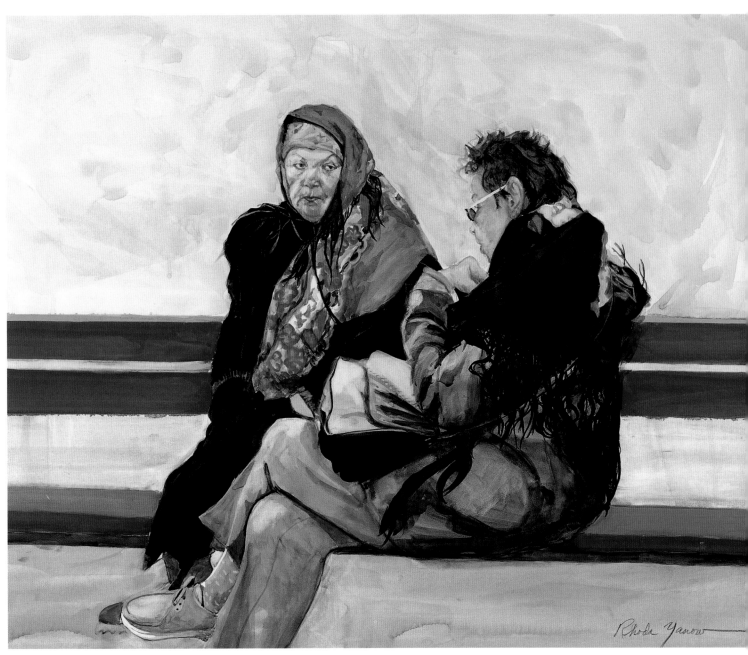

CONVERSATION
Rhoda Yanow • Semitransparent Watercolor • 22" x 28" (56cm x 71cm)

Reviving the discipline
of doing a compositional sketch
helps paintings to flow.

Rhoda Yanow

Burt Silverman got me interested in watercolor by making it fun. My favorite subject is people. Discovering two women in animated conversation with such wonderful etched faces and colorful scarves inspired me. First I did a drawing in my sketchbook to work out the composition. This discipline causes the final painting to flow; it is a renewed discovery from college days that really works. I stress it over and over to my students who are often too eager to get started painting. ✳ Using Strathmore 5-ply hot-pressed watercolor paper, I lightly applied a gouache wash. I then lightly and loosely sketched with a neutral watercolor pencil. I blocked in color boldly with watercolor, working from light to dark and building up glazes. I wiped out what didn't work, reworking these elements until they felt right.

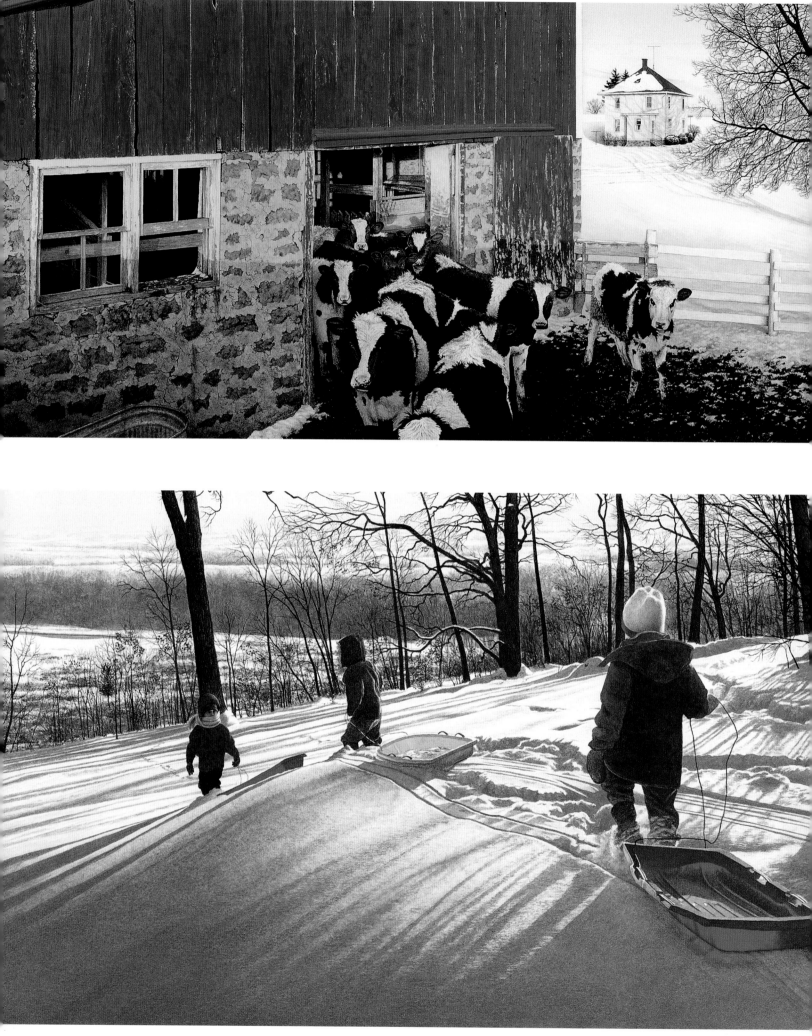

When things just aren't working, sometimes a radical change will help.

Steven R. Kozar

There are several important discoveries I made with this painting. I had sketched out the whole composition from a series of slides, but I set it aside because the far right side of the composition was too disconnected from the rest of the painting. One day, I simply erased a section of fence and then all the rest of the fence and two small outbuildings. I then redrew everything about three or four inches to the left. By compressing this panoramic scene just a little bit, I immediately saw a better, more unified painting. Another discovery was when an art teacher told me that her class had discussed how I "broke the rule" about dividing the painting right down the middle, but that they liked the painting in spite of that. I was too embarrassed to tell her that I hadn't even noticed! Although I'm familiar with the "rules" of composition, I much prefer to let my intuition guide me. ✳ This is a pretty straightforward transparent watercolor taken to a level of extreme detail. I invested about two months of work painting it, with a tremendous number of transparent layers involved.

CURIOUS COWS: END OF DAY
Steven R. Kozar • Watercolor • 11 1/2" x 32" (29cm x 81cm)

When you find an intriguing effect, concentrate on that; don't try to paint "everything."

Steven R. Kozar

Sorting through my slides of a stately historic house and some sledding children (two of which are mine), I became most intrigued with the effect of the sun shining through the red plastic sled. I decided to crop out many of the things I had intended to include. The composition took on a wonderful, almost abstract quality once I decided not to paint everything—something I continue to remind myself. The strange red glow from the sled is one of my favorite visual discoveries. ✳ I discovered that a dry-brush/stippling technique allows me to render very accurate, yet soft shadows.

SLEDDING AT THE BRIGHAM FARM
Steven R. Kozar • Watercolor • 8 1/4" x 18" (21cm x 46cm)

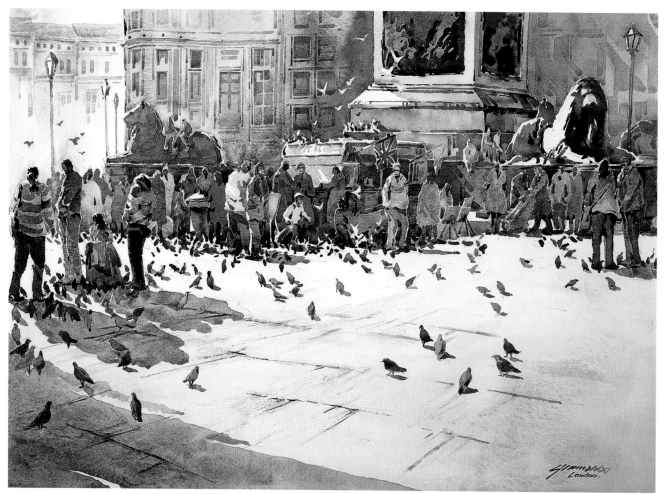

TRAFALGAR SQUARE I
Woon Lam Ng • Transparent Watercolor • 22" x 30" (56cm x 76cm)

Movement enhances the storytelling power
of a work of art.

Woon Lam Ng

In the picture, the boy in the orange shirt is chasing the pigeons. The movement lets the viewer's imagination run wild. What's going to happen? Will the boy continue to chase the pigeons or will he stop and laugh? The rest of the pigeons look toward the inner part of the painting to create direction. They are like the viewers in the painting seeing the second part of the story. ✳ In order to have an accurate sense of motion, I started with detailed and careful pencil drawings of the figures. I used blue as my dominant color to emphasize the cold weather. The red of the United Kingdom flag and plastic bag were placed on a diagonal to create tension between the foreground subjects and the mid-ground subjects.

Sometimes bigger is better.

Heidi Lang Parrinello

Strength is part of a series of iris paintings in which I attribute a human emotion to the flowers. I had always been reluctant to paint on anything larger than 22" x 30" (56cm x 76cm) paper, but realized that this subject needed to be large—really large— to project the "strength" I saw there. The towering "ant's-eye" view of the irises juxtaposed with the somewhat fragile-looking ladies in the background also helped get that across.
✳ The most interesting thing about the painting process was that, because of its size, most of the work was done upside-down or sideways. I had to work standing up and walk around all sides of the painting just to reach inside it. This was very exciting, as I was limited to concentrating on just line, color and form. When I'd step back to view it right-side-up, I'd always be pleasantly surprised.

STRENGTH
Heidi Lang Parrinello • Watercolor • 60" x 40" (152cm x 102cm)

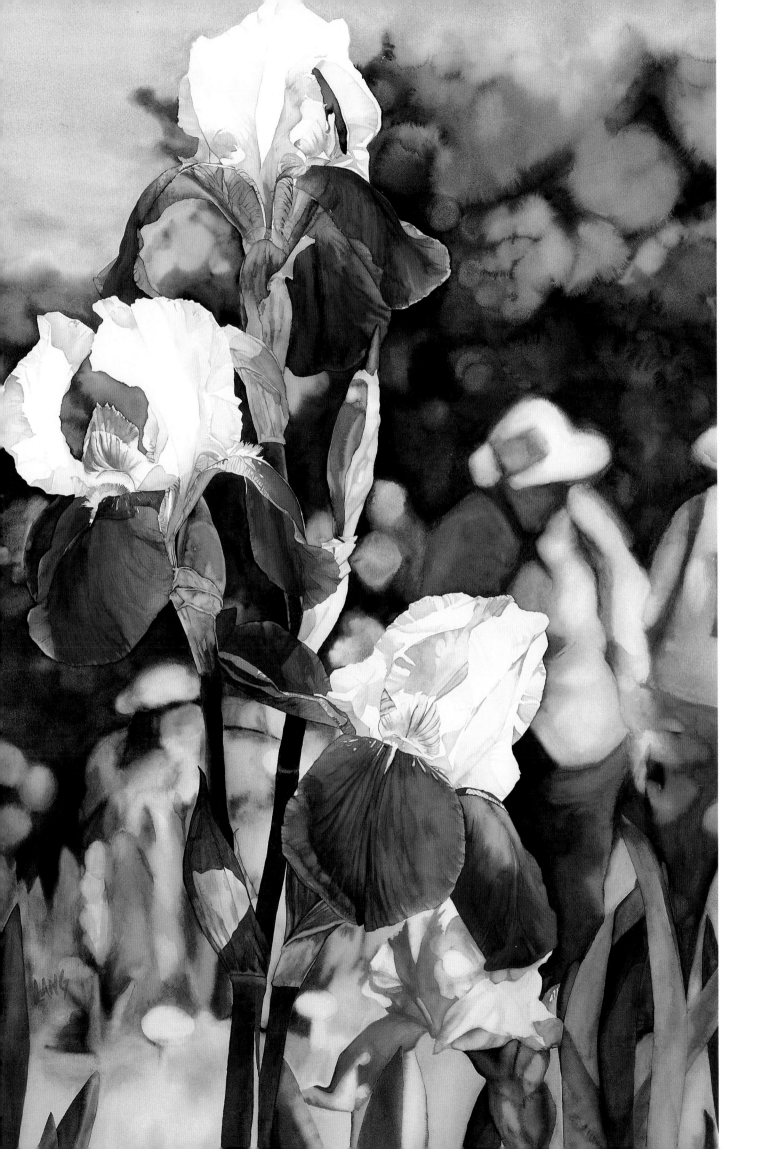

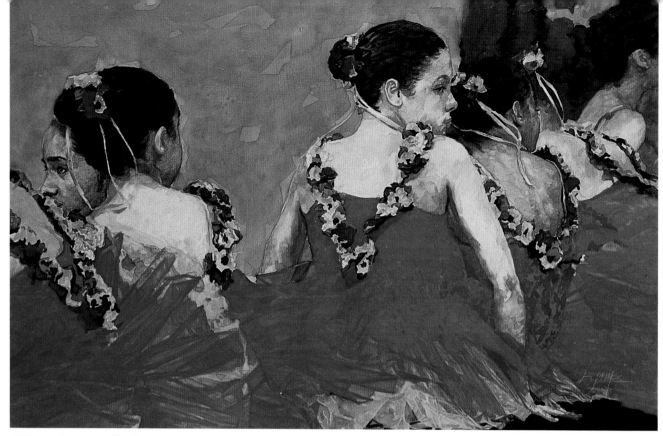

CORNUCOPIA BALLERINAS
Bill James • Transparent Gouache • 19 ½" x 27 ½" (50cm x 70cm)

The challenge of painting multiple figures
leads to discovering new design avenues.

Bill James

Most of my figurative works involve only one or two figures. This was the first watercolor that depicted a group, and it was definitely a new challenge for me. What made me go ahead with it was the fact that all of the ballerinas were wearing the same red and yellow tutu. I realized this would give the painting unity. Back in my studio, the figures were arranged so the girl a little right of center is the center of interest. I included a girl to the left of the group who is bending forward so only the head is visible to add interest. I painted in a dark tree shape to the right of the figures to create an *L*-shape, making the whole design complete. ✳ I used transparent gouache on a gesso-covered watercolor board. The light green background color was selected as a complement to the red tutu. I then glazed one wash over another until the watercolor was completed.

In a composition without linear elements,
implied directional lines can create eye movement.

James Toogood

Most artists know how directional lines move the eye through a composition. In a cityscape, directional lines are obvious; your eye naturally moves down the street. When a subject has no actual directional lines, you can create implied directional lines to carry the eye anywhere you want. ✳ The goal here is to move your eye from the foreground throughout the painting to the focal point, the white house. The foreground rocks and foliage carry your eye deeper into the painting. This shape is reinforced by a subtle band of violet in the water that carries your eye to the right edge of the painting. Your eye moves back across the painting via the lighter violet shape in the middle ground to the shoreline where the house is. The clouds, like arrows, point almost directly at the house.

CAVELLO BAY
James Toogood • Watercolor • 14 ½" x 11 ½" (37cm x 29cm)

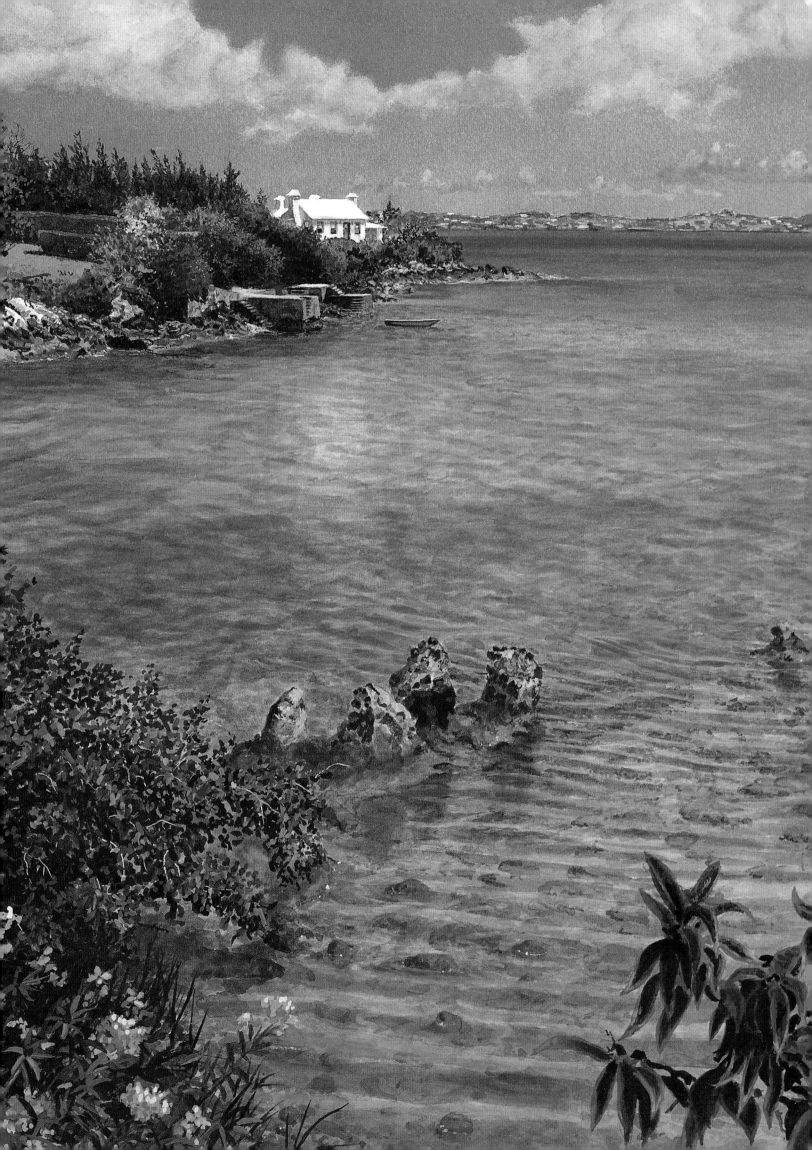

DISCOVER *Materials*
and techniques

Artists in this chapter made many and varied discoveries all related to their materials or technique. There is much exciting and useful information to explore on the following pages.

Some, such as Jean Sadler, found new surfaces to work on [opposite page]: "I have discovered an exciting new creative freedom since painting with transparent watercolor on Yupo plastic paper. The slick surface makes complete control of the paint impossible and I like the unique effects which are produced spontaneously by this somewhat unpredictable painting procedure. At first I felt frustrated because I could not depend on my usual technique, but now I am thrilled by the distorted shapes and unique color blends which occur."

"Another special advantage to Yupo plastic paper is that it offers easy correction. Any area of wet or dry paint may be quickly removed when pure water is applied. A completely dry painting can be sprayed with a coat of fixative."

Any excuse is good enough to leave
some of the beautiful white
watercolor paper showing.

—G. BRUCE JOHNSON

DAISIES
Jean Sadler • Transparent Watercolor on Yupo Plastic Paper • 14" x 11" (36cm x 28cm)

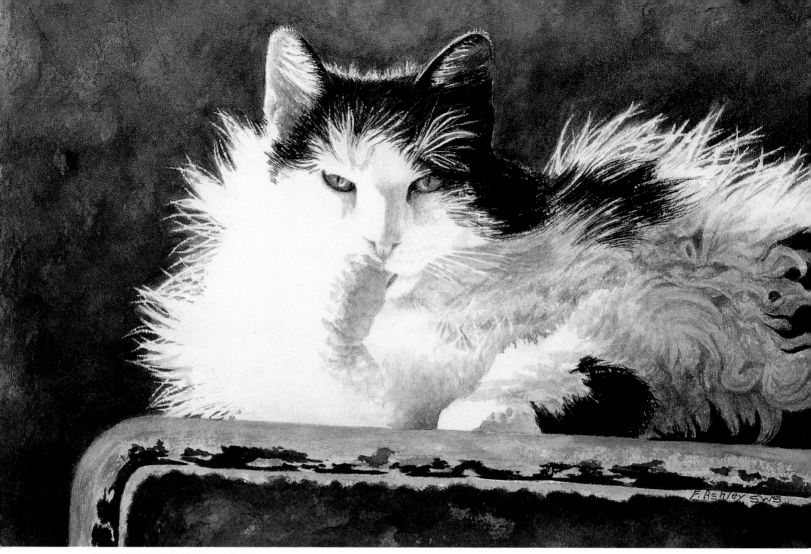

BETTY TAKES YET ANOTHER SUNBATH
Frances Ashley • Watercolor • 8 ½" x 10" (22cm x 25cm)

You don't have to listen to everybody;
take your time and do it your way.

Frances Ashley

Get in and get out! Something we watercolor painters are often told to do. Personally, I have never been able to do this. I am comfortable with my method of painting. Saturating the paper with multiple washes of color, applied one at a time with drying time in between, enables me to attain the deep, rich colors I am after. When this surface is wet and then wiped, the underpaint colors reveal themselves with a richness achieved no other way. ✳ While most of Betty's fur was the saved white of the paper, an X-Acto knife enabled me to pull tufts of her white fur over the dark background where needed.

Breakthrough painting achieves balance
between realism and loose style.

Joseph Alleman

As a student, I constantly explored. Painting tightly was an enticing challenge, a test of one's craftsmanship. Later I found the excitement of painting loose had an equally strong appeal. After graduating I searched for a balance to give my work continuity. When I finished *Morning Rehearsal*, I stepped back and said to myself, "That's it. That's how I want to paint!" It's a painting I still draw inspiration from. ✳ After painting the figure's legs, I added the foreground color using a 2-inch (51mm) flat brush in big sweeping motions. I then went back in and lifted out some of the coloring in the floor with a wet brush. I did this to redefine the legs and give the effect of light breaking through the negative spaces.

MORNING REHEARSAL
Joseph Alleman • Watercolor • 16" x 11" (41cm x 28cm)

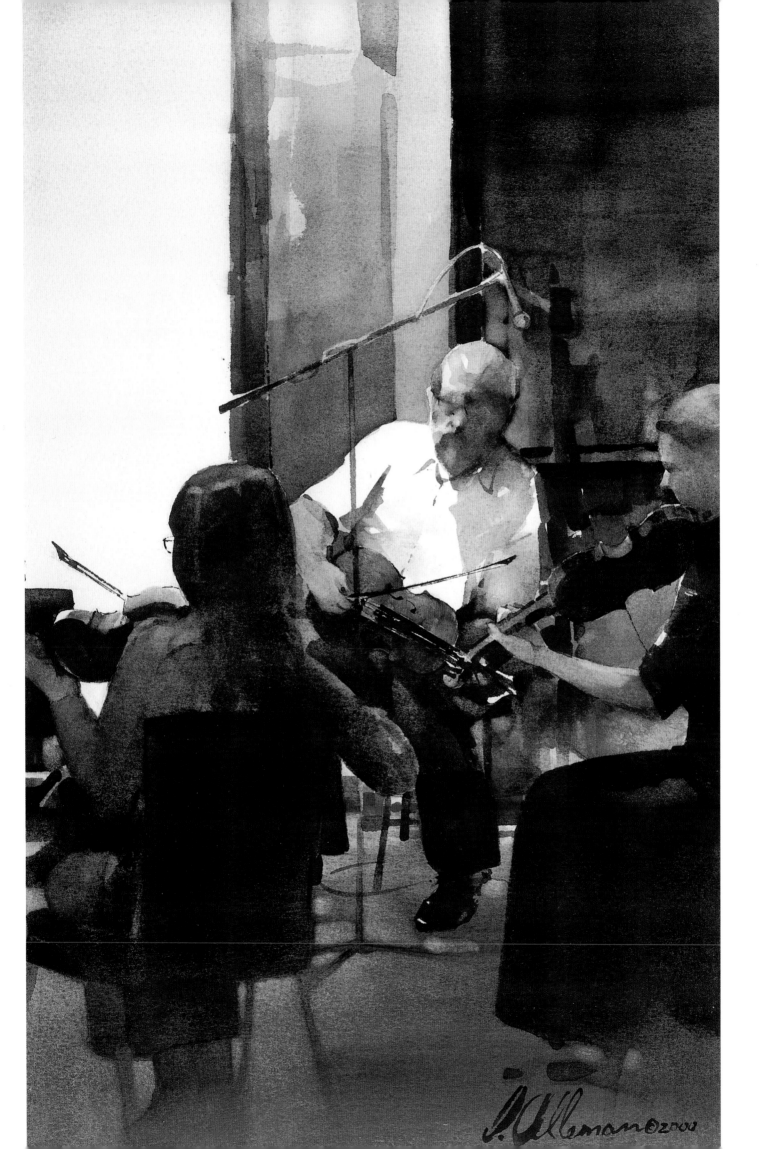

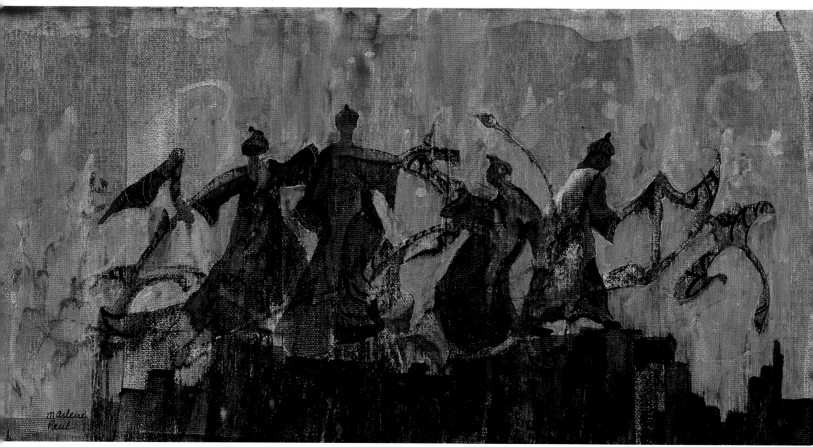

DANCING KINGS
Marlene Paul • Fluid Acrylic on Canvas • 8" x 16" (20cm x 41cm)

Transparent fluid acrylics on canvas
make an exciting combination for abstract storytelling.

Marlene Paul

In a recent workshop I was introduced to the idea of using fluid acrylics on gessoed canvas in an abstract manner and then using negative painting with opaques to bring out images. I found I preferred using the transparent fluid acrylics to paint both positively and negatively to produce the image. The canvas, I find, gives a tapestry-like texture to the painting that when matted and framed under glass, gives an interesting look to the finished work. ✳ I used a flat piece of gessoed canvas and applied two colors in a random pattern across the canvas from left to right. I then ran a bead of a third color across the top of the canvas and used a scraper to pull all the applied paint. After it dried, I let the abstract shapes suggest a story. I then applied additional layers of paint to define my figures and shapes.

Paintable transparency film
helps me to visualize a painting's potential.

Russell Jewell

Assisi represents the discovery of a personal visualizing technique. As a professional art educator, I seek techniques that give opportunities of trial and error to the student. This educational quest opened the door to what I call "Watercolor Wizardry." ✳ While painting *Assisi,* I discovered the combination of clear write-on transparency film (from a local office supply store) and watercolor crayons. During the process of painting, I place the transparency over any questionable areas. Applying the watercolor crayon directly to the film allows for exploration in color and value. This visualizing technique, Watercolor Wizardry, allows newly discovered ideas to be applied with spontaneity and confidence.

ASSISI
Russell Jewell • Watercolor • 30" x 22" (76cm x 56cm)

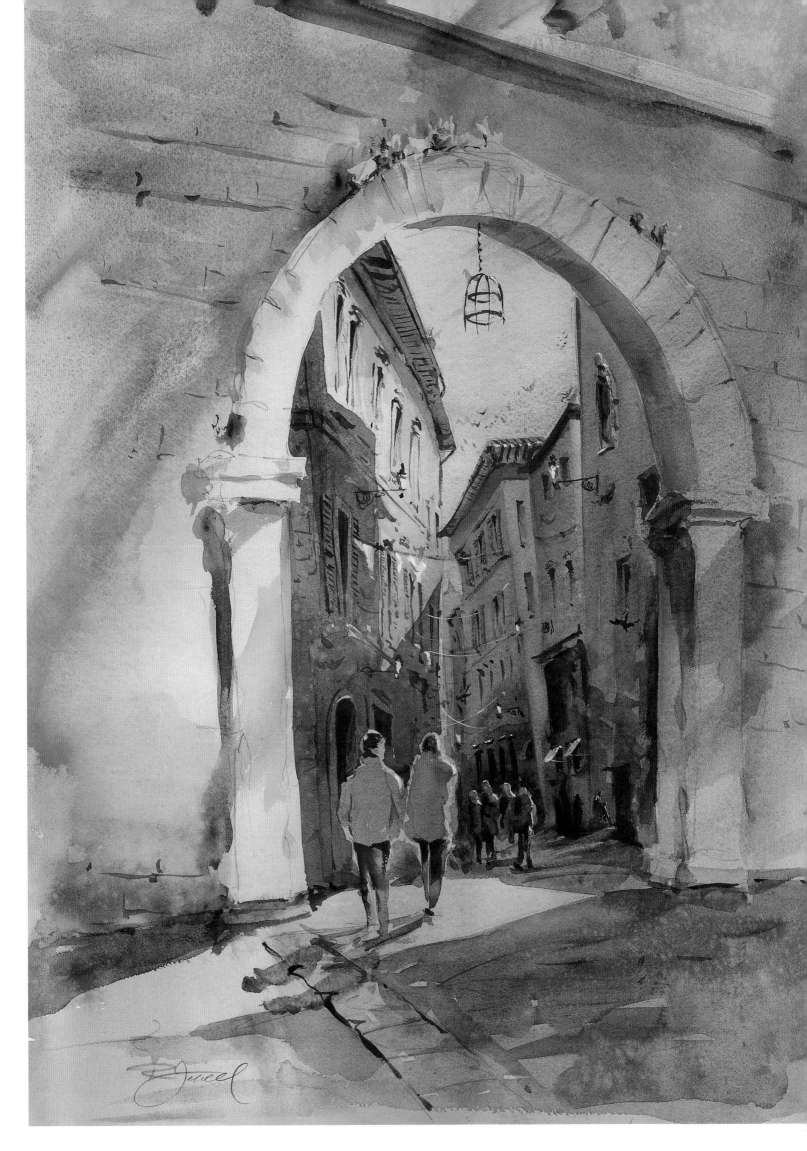

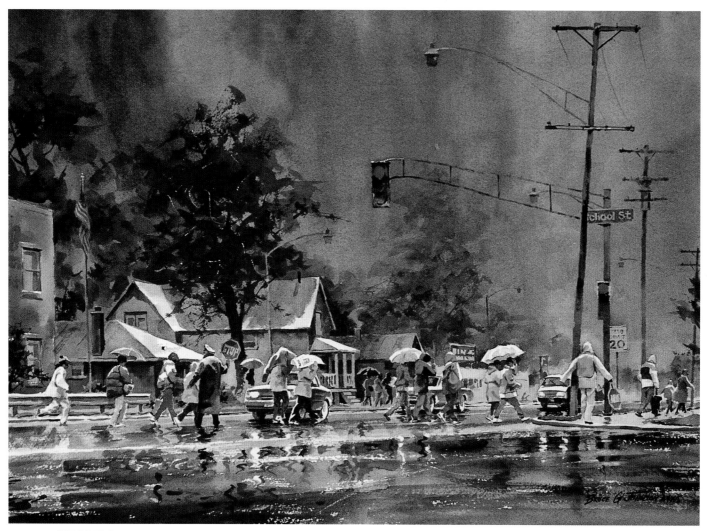

SCHOOL'S OUT

G. Bruce Johnson • Transparent Watercolor • 21" x 29" (53cm x 74cm)

Leaving white paper can work
even when it seems illogical.

G. Bruce Johnson

After finally finishing a pencil design, I envisioned an upbeat color scheme for children getting out of school: warm, dark and colorful. My big concern was that it would get too dark and defeat my purpose. I needed whites, but realistically they didn't belong here. When I finished, I was surprised and overjoyed that the whites worked. It was a big discovery for me. The reflecting tops of roofs, cars, umbrellas and people justified white. As a transparent watercolorist I had long been leaving whites, but in a representational way. Now I realized that any excuse is good enough to leave some of the beautiful white watercolor paper showing. I now almost always leave whites when painting a watercolor. ✳ My original wash was plain water from the top down to the areas I wanted to keep white. I quickly painted into it with the dark colors of this rain scene. I painted the bottom using the same colors, but worked wet-on-dry to get the dry-brushed street lines. I knew that after finishing the painting I could always add color to the white areas. My happy discovery was that I didn't have to.

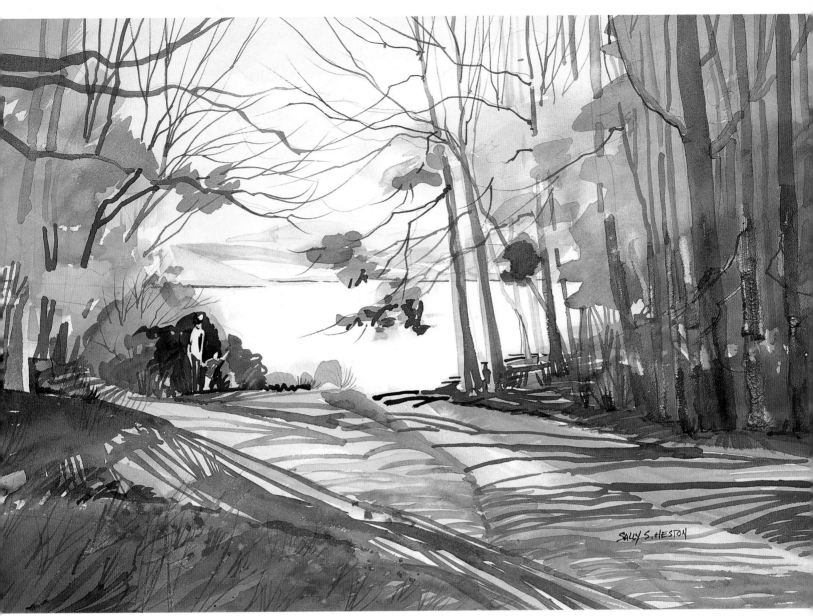

GOODBYE TO SUMMER
Sally S. Heston • Watercolor • 14" x 21" (36cm x 53cm)

Rediscovering a limited color scheme
helped me focus on the power of tonal values.

Sally S. Heston

For years I have been telling my students that a limited color scheme can help to unify a design and yield dramatic emotional results in a painting—but I have not always practiced what I preach. One day, however, I decided to paint using a black-and-white reference photograph that I had taken at a favorite location. Having no color reference, I was forced to create my own, and immediately was drawn to the warm hues that I recalled of that autumn day. I also discovered that a limited palette is easier to work with and, like a black-and-white photograph, helped to draw my attention to the range of tonal values in a composition. ✸ This painting was planned to have a warm dominance. A strong linear pattern indicating trees and shadows dominates this landscape, as it does in much of my work. The figures were included to create a focal point and to add diversion to the repetitive linear patterns throughout the design.

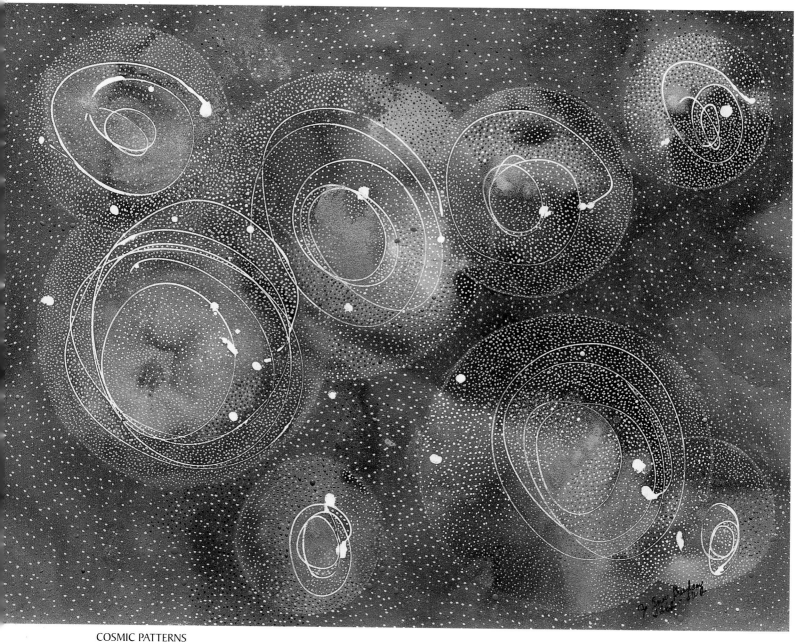

COSMIC PATTERNS

Jo Ann Durham • Inks, Metallics and Encaustic • 22" x 30" (56cm x 76cm)

A *pointillist approach with encaustic* creates dimensional qualities in watercolor.

Jo Ann Durham

The mysteries of the cosmos not only intrigue and mystify, but they ultimately provided the inspiration for this painting. These patterns of form and energy dance across the universe light years away. ✳ A gestural drawing is made with a tjanting tool filled with hot wax. Inks and metallic powders are then poured on the wet surface and more layers of inks are added. The wax is ironed off, leaving a pure white and expressive drawing. Encaustic is applied using a pointillist approach, which gives a dimensional quality to the work. Shades of blue, gold, red and lavender encaustic create swirling patterns in the galactic darkness.

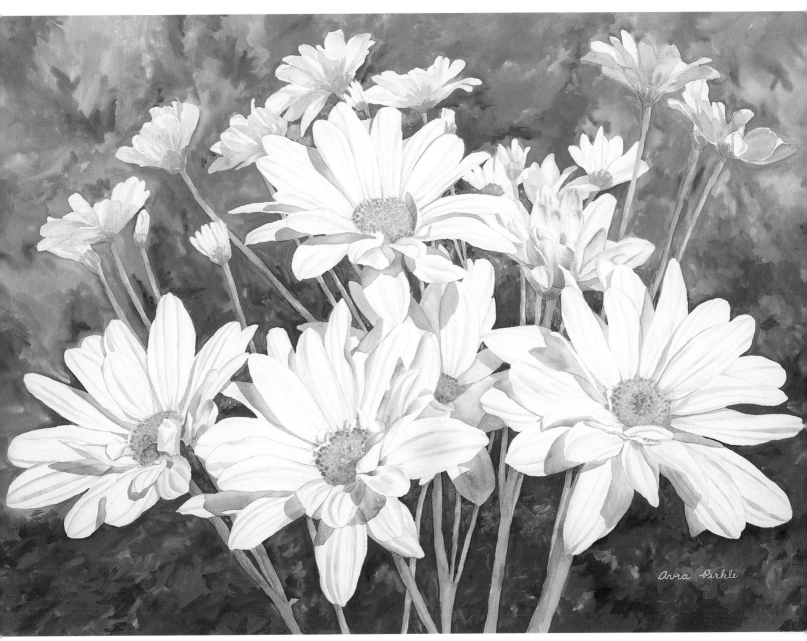

DANCING DAISIES
Avra Pirkle • Watercolor and Gouache • 29 ½" x 41" (75cm x 104cm)

Loosely applied gouache makes a varied and playful background.

Avra Pirkle

Over my years of painting florals, I have enjoyed rendering the flowers in a careful, precise manner. On the other hand, when it comes to the backgrounds, I find myself constantly trying different ideas, styles and techniques. When I experimented with gouache in a loose, playful and spontaneous way, I discovered that it beautifully complemented my main subject. To my delight, the gouache background expressed the joy and excitement that I feel when I am surrounded by the overwhelming beauty of flowers. Also, it was just plain fun to do. ✳ To paint the background, I first planned and tested my colors on a scrap piece of paper to make sure that the values were right, since gouache changes value after drying. Having prepared different puddles of all the colors I planned to use, I started at one corner and worked my way around the flowers, painting quickly, blending colors before the gouache dried. By varying the ratio of water to pigment, I achieve different effects, from flowing watercolor washes to painterly brushstrokes.

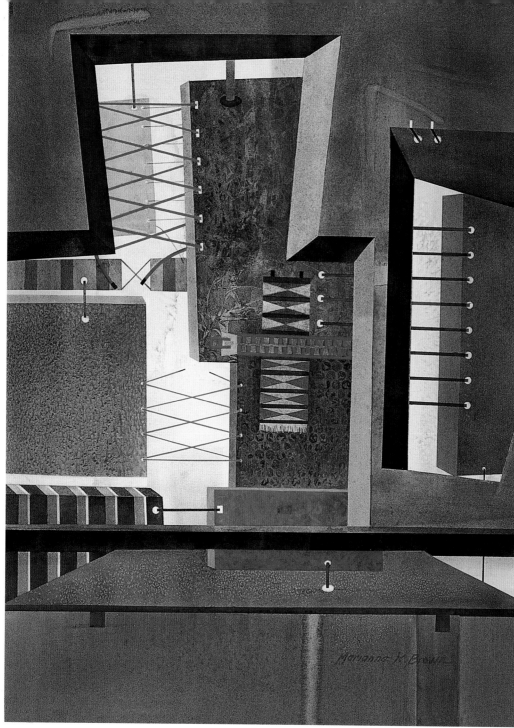

TIED UP VII

Marianne K. Brown • Watercolor • 30" x 22" (76cm x 56cm)

Go deeper with geometric shapes
in an abstract painting.

Marianne K. Brown

Tied Up VII is part of my series of paintings using floating shapes tied together by line variations. I previously depicted shallow space in these paintings by overlapping shapes. I wanted to show more implied depth in this painting, so I designed strong diagonals and contrasting values to achieve this effect. The first light-graded wash created deep space. The windows developed by the diagonals made areas in which shapes appear more distant. The unique direction of the connecting lines adds a sense of caprice to the mood of the painting. ✳ There are watercolor textures, graded washes, patterns and wet-into-wet washes within each hard-edged shape. All hard edges were taped before I applied the paint. The central zipper is an addition to my ideas of connecting shapes.

EMISSARY OF LIGHT AND FORM
Lana L. Grow • Mixed Media • 22" x 30" (56cm x 76cm)

Even abstract layered pieces can have
a consciously designed beginning.

Lana L. Grow

My abstract paintings usually evolve on the paper after I begin layering. The painting *Emissary of Light and Form*, however, began in a new and more definite way. Finding a magazine picture with high interest inspired this painting. I used a viewfinder to isolate an abstract design and made a pencil drawing of the piece. My second discovery was to use a new type of safe-release tape found in various widths. My third discovery was that if I didn't save a particular area light enough, I could paint the area with gesso and retrieve the light areas. ✳ I kept the colors to a minimum and added a punch of complementary color for excitement. The painting evolved using various texture implements, inks, crayons and liquid acrylic.

45

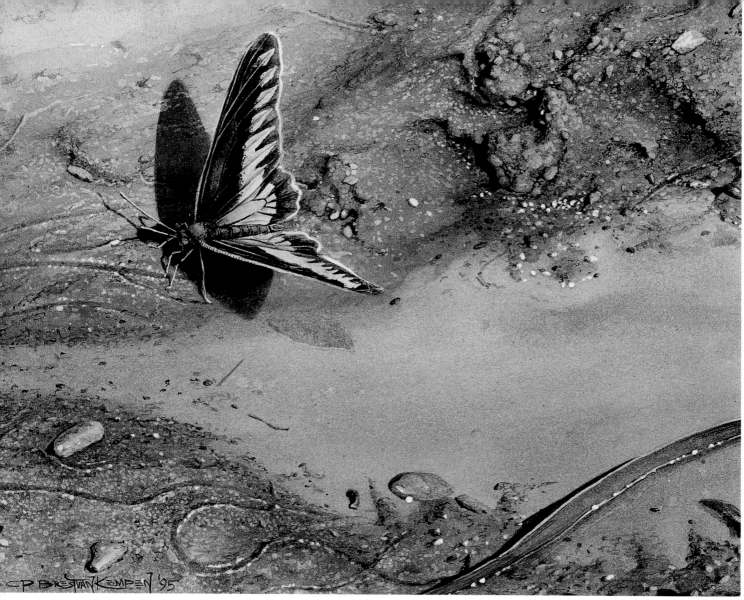

RAJAH BROOKE'S BIRDWING
Carel P. Brest van Kempen • Transparent Watercolor on Bristol Board • 7" x 9" (18cm x 23cm)

You can utilize your materials' shortcomings
to your own advantage.

Carel P. Brest van Kempen

This painting depicts two of the most characteristic elements of tropical rainforests: butterflies and mud. My biggest challenge with this piece was to vaguely suggest the bottom of a shallow mud puddle and the mud suspended in the water, along with the reflection of the sky and butterfly wings above. I keep a lot of bristol board around the studio for pencil drawings, but I have found it a very frustrating surface to work on with watercolor, as once a color is laid down it is virtually impossible to move it around. Armed with this knowledge, I intentionally selected bristol board for *Rajah Brooke's Birdwing* with the hope of using this characteristic to my advantage. Before applying any other colors, I did some light scumbling in earth tones with a rather dry brush to simulate the bottom of the puddle, assuming these textures would be rather permanent due to the paper's color retention. For this same reason, I bathed the entire area that would represent the puddle's surface with water before applying the blues, which had to be more uniform. The scumbling shows through the blue, suggesting the contours of the bottom of the puddle. ✱ After tracing my drawing onto a piece of vellum-surface bristol board, I masked off the butterfly and all of the highlights with liquid latex. The scumbling on the bottom of the puddle was done with a no. 2 dry round sable, using Sepia and Raw Umber. After painting the background, I allowed the piece to dry completely, then removed the latex very carefully (bristol board tears very easily when frisket is pulled off of it) before painting the subject itself.

46

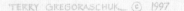

SIGNS OF SPRING
Terry Gregoraschuk • Watercolor • 14" x 19" (36cm x 48cm)

Using a large selection of subtle blues
can define different areas of snow
in a white-on-white painting.

Terry Gregoraschuk

Waking up early one spring morning, I discovered this wonderful image. I knew right away that it would make a great painting, but at the same time knew it would be very challenging. My challenge was to discover how to paint snow on top of a white tricycle seat with snow as a background, using only transparent watercolors.
✳ I mixed several different blue washes—Cobalt, Ultramarine, Cerulean—and intermixed them along with Payne's Gray, Burnt Umber or purple to create a large selection of blues. Using a different blue wash for each specific white area helped differentiate one white area from another white area. Masking fluid was applied to certain areas to retain a sharp leading edge of pure white. Any background areas that touched a masked area were darkened slightly to create greater contrast between the whites. Absolutely no opaque paint was used at any time!

47

LOOKING FORWARD
Jean Pederson • Watercolor With Gouache • 11 ¼" x 15" (29cm x 38cm)

*Incorporating opaque gouache
into a watercolor painting
led to further exploration.*

Jean Pederson

Painting should be a constant journey of exploration. I enjoy wandering to the "What If Zone." What if I were to use a transparently painted subject with a very flat opaque background? What if I use a more graphic approach to the painting? I made the decision to incorporate opaque gouache into a painting with transparent watercolor. ✳ After painting as far as I can with transparent watercolor, I bring out the gouache. In *Looking Forward*, the gouache was applied primarily to the background. The key to mixing mediums is to work with color and value relationships. If you apply a second medium to one area of a painting, you must balance it by placing some in other areas.

*Hot, dry weather
forced the exploration of dry-brush technique
with happy results.*

Jean Pederson

The summer that I painted *All in But the Boot Laces*, the temperature was unusually hot and dry. I like to work on a wet surface, but with the dry heat, both the paper and the paint dried before they touched each other. I discovered how to handle the dry-brush technique. As the temperature cooled, I was able to incorporate a few loose washes and glazes into the painting to tie the whole thing together. ✳ The denim jeans were painted entirely using dry-brush technique. I chose three transparent primary colors from my palette and began layering. To build up the darks I simply layered more dry brushstrokes. The process took time, but the results were quite unique. Everyone who has seen the painting comments on how denimlike the jeans are.

ALL IN BUT THE BOOT LACES
Jean Pederson • Watercolor • 30" x 22" (76cm x 56cm)

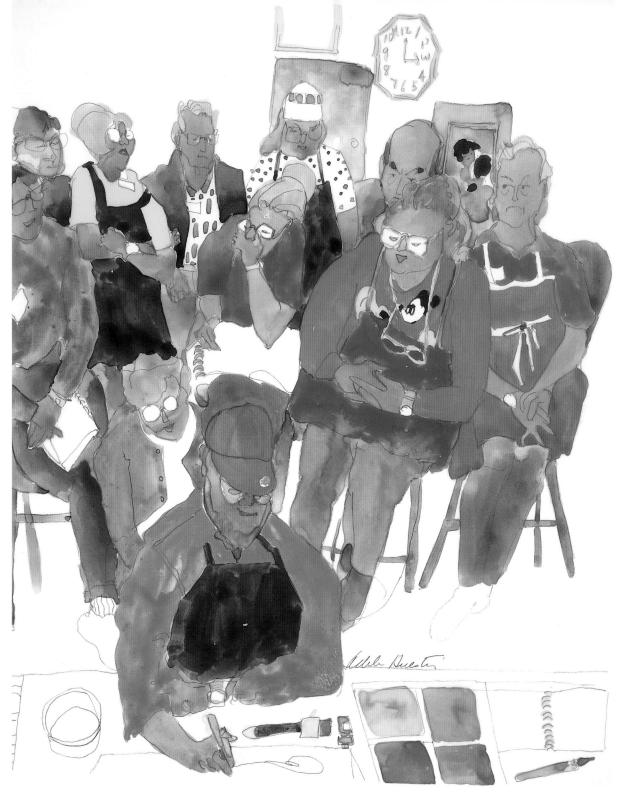

THE DEMONSTRATION
Adele Huestis • Watercolor on Vellum • 14 ½" x 12 ½" (37cm x 32cm)

Slick surfaces make a great difference
with watercolor paintings.

Adele Huestis

Since most of my ideas for paintings derive from a constant stream of sketch books, I am always looking for ways to transfer my sketch book work into a finished painting with vibrancy and a feeling of the "here and now." These artist spectators watching the demonstration were as amusing to me as the instructor. ✳ The drawing and painting were done on vellum. The colors tend to be more vibrant on this slick surface because the paint is not absorbed. I had to keep the painting flat while working on it to prevent the paint from sliding off. Other very slick surfaces I like are Yupo and three-ply bristol paper.

COLORADO MEMORY #1
Pam Stanley • Fluid Acrylic • 21" x 29" (53cm x 74cm)

Glass cleaner
and a little boldness
saved an unsuccessful painting on an experimental surface.

Pam Stanley

After attending a watercolor demonstration on Yupo plastic paper, I acquired heavy Yupo and experimented with Golden fluid acrylics. I was intrigued by the lovely color combinations and interesting shapes that seemed to float up and into one another while brushing paint on the glossy surface. Once dry, the white paper can be recovered with glass cleaner. When wet, paint is easily removed with a wet rag. ✳ Initially, I was pleased with my warm array of colors and large white shapes, and I decided to tie the entire composition together with a wash of blues. Realizing the dried surface was darker than desired, I sprayed Windex on an area. A moment later I removed the Windex with a rag, uncovering a very pleasing texture with a white vertical design later tinted blue. These recovered whites (on the right side of the painting) became an essential element.

CONSTRUCTION WORKERS
Mark Lague • Watercolor With Gouache • 15" x 22" (38cm x 56cm)

Switching to oils
leads to a completely different approach
when painting in watercolor.

Mark Lague

My watercolor discovery came about by switching to oil paint as my primary medium. I only do an occasional watercolor now, but when I do, all that I have learned from painting in oils comes to the surface. It is not just a matter of using more opaque gouache; I now take a completely different approach to painting in watercolor. My color is less interpretive, and I am far more concerned with controlling edges. It is kind of ironic that to get a breakthrough in watercolor I had to, for all intents and purposes, stop painting in the medium. ✳ In order to keep the faces of the construction workers relating to the rest of the painting, I did not use any brush smaller than a ½-inch (12mm) flat. Excessive detail in the faces would not have strengthened the painting.

Spraying an overworked image with water
brought it back to life.

Judy Perry

"Eyes so transparent the soul can be seen." These words by French writer Theophile Gautier express what I strive to accomplish in my work. As a way of pushing through and discovering my own grief, I did this painting of my Grandmother Lillian. I wanted to capture her sense of shock, deep sorrow and confusion after learning of the death of her grandson, my brother. ✳ For my first attempt I worked wet-into-wet, using Fabriano Uno 140-lb. (300gsm) hot-pressed paper, building layers of color. At one point the image seemed lifeless and overworked. I was about to abandon the effort when I decided to spray the surface with water. As I did this, the pigment began to drip and flow into the lovely creases of her face. It was coming to life again ... divine intervention?

LILLIAN
Judy Perry • Watercolor • 27 ½" x 20 ½" (70cm x 52cm)

52

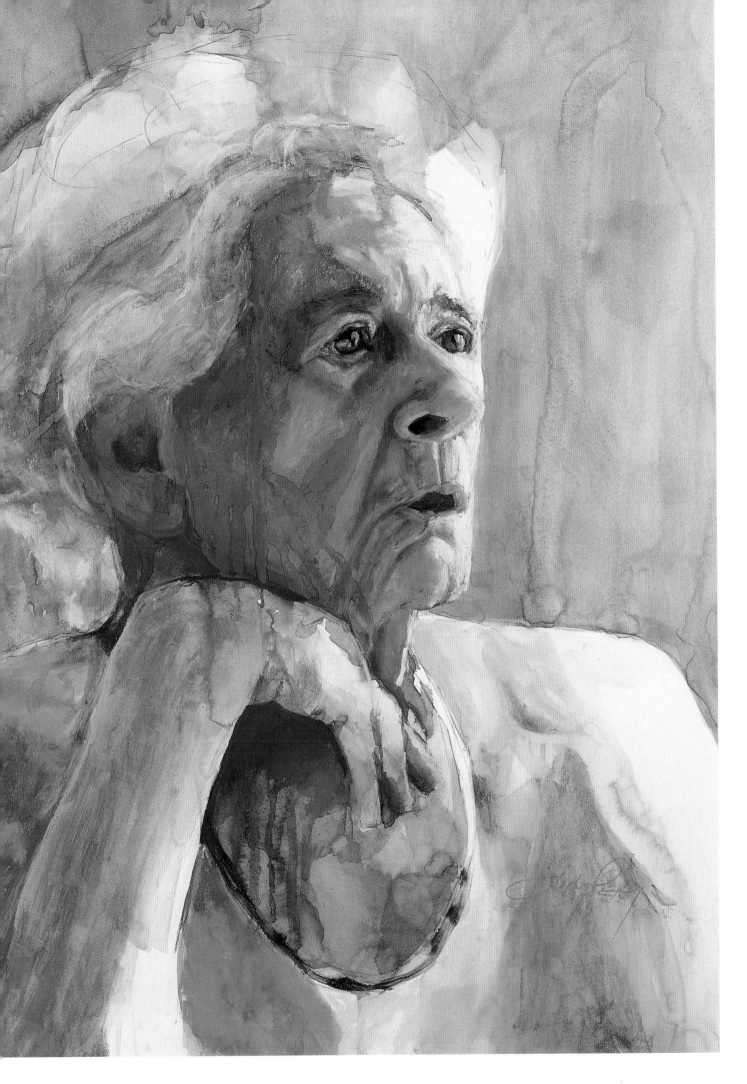

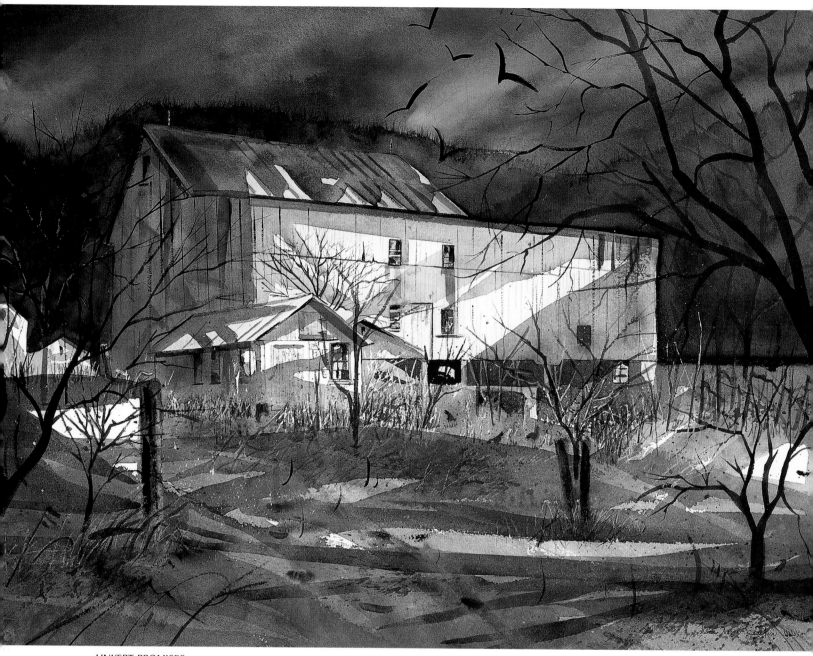

UNKEPT PROMISES
Doris Davis-Glackin • Transparent Watercolor • 21 1/2" x 29 1/2" (55cm x 75cm)

Wet and juicy painting in the field
can produce exciting breakthroughs.

Doris Davis-Glackin

I had always painted in my studio in a controlled environment using reference photos and quick sketches that had been done on location. Small brushes, quarter and half sheets of paper and occasional masking worked best for me. After taking a workshop with Dominic DiStefano and painting in the field, I had a major breakthrough. I learned to use big brushes that were wet and juicy on full sheets of paper. The blinding sun, wind, bugs, occasional raindrops and other distractions were outweighed by the excitement and visual stimulation of the moment. ✳ When I painted *Unkept Promises*, I created the drama and forsaken atmosphere by using a very limited palette of various transparent Winsor & Newton blues. Yellow Ochre and Burnt Sienna provided small jewels of color. Painting with bold brushstrokes kept colors intense, and the shortened drying time due to sun and wind kept the painting crisp and fresh. I carefully planned the placement of my whites, and simply painted around them. I used 300-lb. (640gsm) Arches cold-pressed paper.

SERENDIPITY
Sandra Hodges • Watercolor With Gouache • 22" x 29 ¹/₂" (56cm x 75cm)

An interesting napkin-layering technique
results in many discoveries.

Sandra Hodges

Using Dr. Emilio Caballero's instruction, I applied the napkin technique. If the painting turned out great, the napkin was left for texture and preserved with acrylic medium. If I wanted to unveil a great discovery, the napkin was removed, as it was in this painting. Using dots, dashes and Oriental strokes in the last layer, I further discovered a surprising stroke had created a little man fishing by the water near the center of the painting; thus my *Serendipity*! ✳ Using wet 140-lb. (300gsm) Arches cold-pressed paper, I worked in layers. For the first layer I applied single-ply paper napkins, outlined my drawing using purple and blue and painted in the basic large areas along with the silhouette of the trees. For the second layer, while the paper was still damp, I applied a single-ply napkin, wet it and used Payne's Gray, blues and browns for the haze over the hills. The painting was allowed to dry slightly and the napkins were removed. For the third layer I designed verticals (trees) and horizontals, in addition to continuous Oriental strokes, using a calligraphy brush. I continued to reiterate, repeat, mold and fashion the design. In the final layer, the foliage was highlighted with gouache.

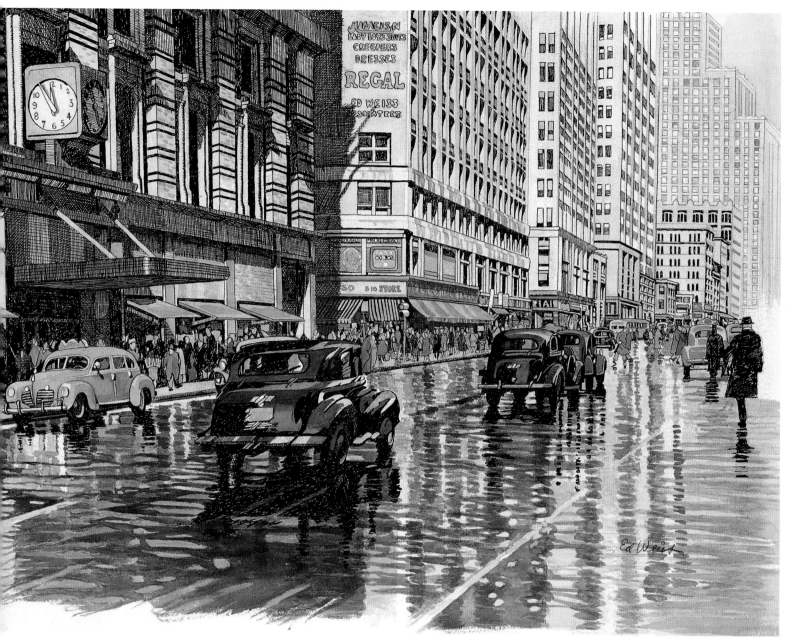

OLD NEW YORK (RAIN)
Ed Weiss • Watercolor and India Ink • 22" x 30" (56cm x 76cm)

Using India ink for drawing and darks before adding watercolor *solved the problem with dark washes.*

Ed Weiss

Several years ago my painting was suffering from a few problems with no improvement. Laying down darks resulted in unattractive puddling and irregularities, no matter what papers or variety of paints I tried. One afternoon while studying the master etchings of Luigi Kasimir, it suddenly occurred to me that watercolor and ink could be an exciting combination. Since then my work has improved dramatically for a variety of reasons: the darks are real darks and there is no further puddling, darks can be made more impressive by painting over the ink, less time is needed to complete the paintings and there is more "punch" and contrast. Also, the ink doesn't penetrate the cold-pressed paper very far and errors can be corrected with minimal scraping using a craft knife. ✳ The paper is 300-lb. (640gsm) Arches cold-pressed watercolor paper, not stretched. The subject was carefully drawn in pencil and then inked in with black waterproof Higgins India ink. Then the darks were inked in. The rest is primarily a color scheme using yellow-orange and blue-violet. The bright yellow-orange taxi on the left and the red-orange awning capture your attention first. Then I hope you go "up the street" with the reflections and the blue-green awning.

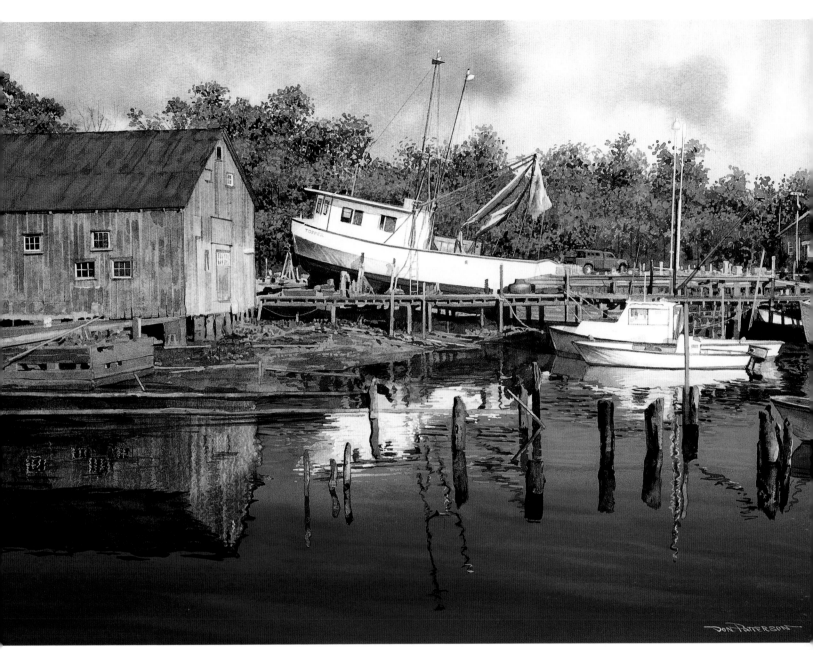

GETTING READY
Donald W. Patterson • Watercolor and Gouache • 15 ½" x 22 ½" (39cm x 57cm)

Gouache can be useful to cover problems
caused by flawed paper.

Donald W. Patterson

Over the years I have discovered that in certain instances, the use of gouache enables me to attain a high degree of finish. In *Getting Ready*, I discovered a new use for gouache. After spending many hours on this rather complex scene, I was finally ready to paint the water portion. I first protected the pilings and reflection of the building with masking fluid and then laid down glazes of transparent color. To my dismay, I discovered the paper was flawed! As the glazes dried, small dark spots about the size of fingerprints appeared. The more color I laid down, the darker the spots became. Never one to give up easily, I decided to go for broke with gouache. Using three values of color about the consistency of light cream, I painted wet-into-wet over the water area. When completely dry, the spots were still slightly visible so I repeated the process; this time the water was flawless. I now consider this to be one of my most successful marine paintings. ✳ I used M. Graham & Co.'s Zinc White, Phthalocyanine Blue, Dioxazine Purple and Payne's Gray gouache for overpainting the water area.

DISCOVER
Place
and Mood

Most of the artists in this chapter discovered special places which brought unusual inspiration. As they sought to capture the particular mood of a place, more discoveries unfolded. Depicting a distinctive mood was the goal of the other artists in this chapter, whether that mood related to a meaningful object, animal or person.

Joseph Alleman [opposite page] found himself in the right place at the right time. "I felt like I'd just walked into the middle of a painting. It was the mood created by the light, rather than the subject, that really drew me in. It seemed to be telling a story, but what? Later, on a road trip, my wife was reading out loud and a particular phrase jumped out at me: *Hope Chest*. Suddenly the mood of the painting became clear and took on a new significance."

Acts of creation are
acts of discovery.

—JOYCE K. JENSEN

HOPE CHEST
Joseph Alleman • Watercolor • 13 ½" x 9 ½" (34cm x 24cm)

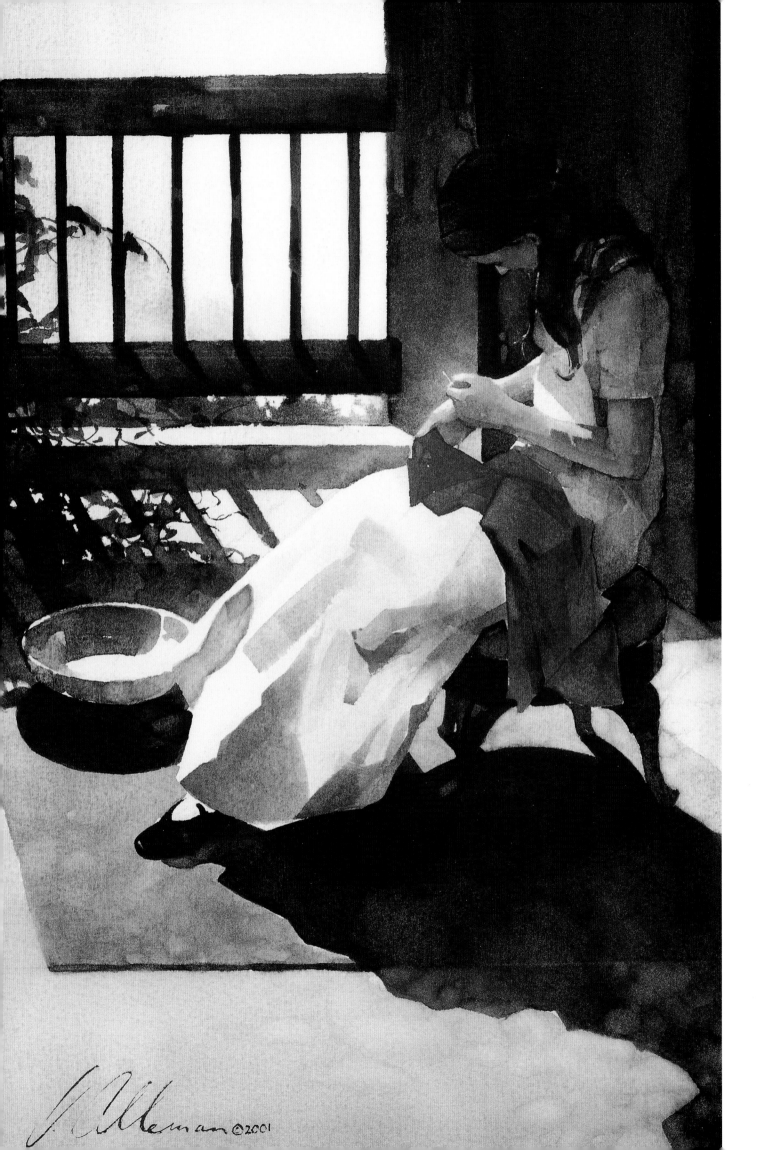

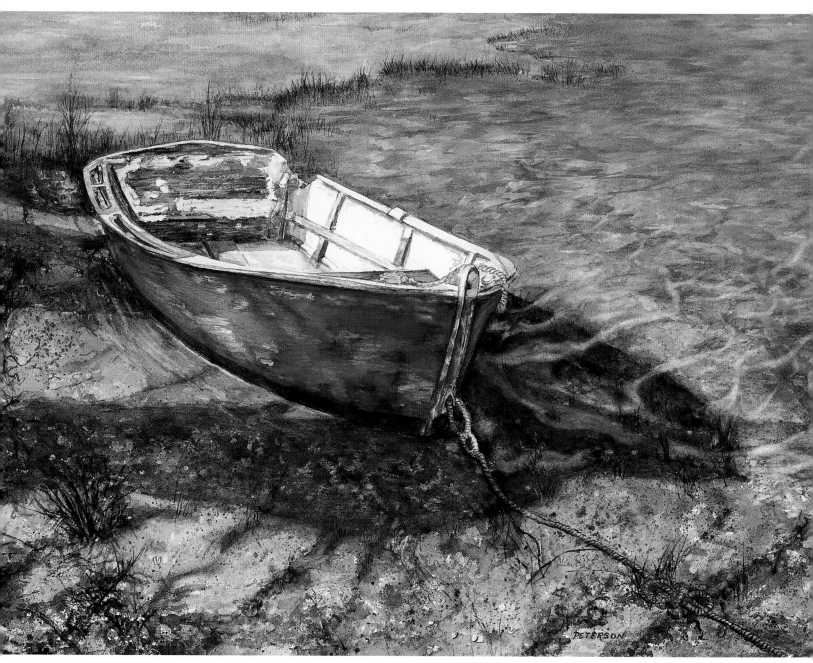

OLD FRIEND
Linda Peterson • Transparent Watercolor • 20" x 30" (51cm x 76cm)

Repeating textural techniques
over many layers of washes
created the desired mood.

Linda Peterson

I watched as shadows from the waning Cape Cod sun illuminated a treasured boat at water's edge, worn by time, evoking memories of summers past. To convey these emotions, it seemed necessary to carefully detail the weathered surface of the boat's peeling paint and decaying wood as it rested on the beach, partially obscured by transparent, shimmering water. ✳ To develop textural details, I applied dry-brush, negative painting, scumbling, scraping, blotting, sponging and stenciling. Then I ran granular washes of Raw Sienna, Cerulean Blue and Cobalt Blue. After the surface was dry, I repeated masking and all the textural techniques, this time using warmer washes. I repeated these processes on many layers until I removed the frisket layers to reveal sun-flecked, multicolored areas. My discovery of layering multiple washes and textural techniques gave *Old Friend* the mood of a valued object in an ever-changing environment.

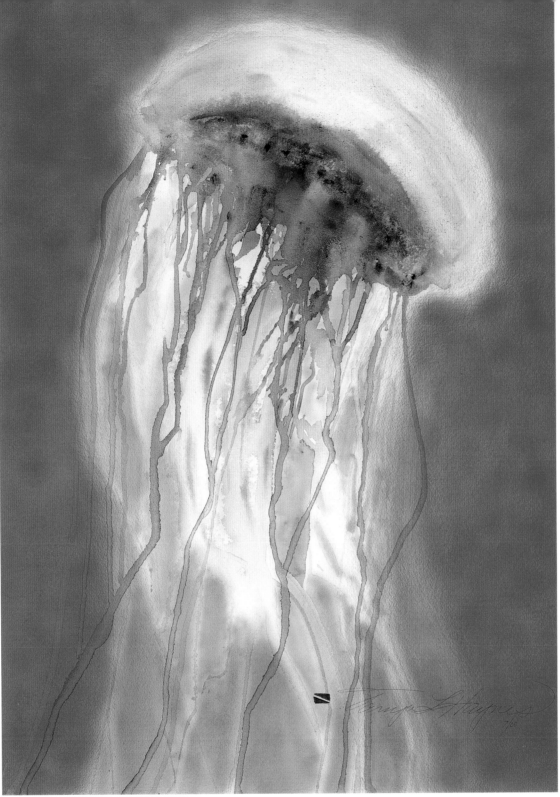

JELLYFISH SUSPENDED
Tanya L. Haynes • Watercolor • 40" x 30" (102cm x 76cm)

Endless beauty and inspiration
can be found underwater near ocean reefs.

Tanya L. Haynes

I discover the subjects for my paintings while scuba diving in the beautiful reefs of the world. I find solace
and inspiration in the depths of this vast frontier of vibrant colors, fluid motion and symbiotic relationships.
I return to the studio with hundreds of photographs from a single expedition. I strive to share the majesty of
this hidden world and to engage others in the goal of protecting the oceans I so love. ✳ I began by painting
the crescent shape of the jellyfish, wet-into-wet, with saturated washes. The fluid, transparent tentacles
were achieved by setting the paper vertically, then pouring and spraying additional colors, allowing them to run.

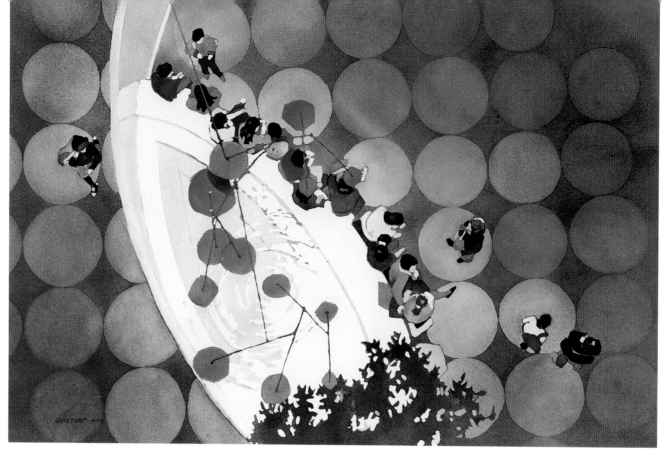

GUGGENHEIM
Jean H. Grastorf • Watercolor With Gouache • 20" x 28" (51cm x 71cm)

Exploring an elemental form (a circle)
can lead to self-discovery.

Jean H. Grastorf

While enjoying the Guggenheim Museum's art collection, I leaned over the circular ramp and was delighted by this unique perspective of the lobby below. The interior of Frank Lloyd Wright's architectural gem was an opportunity to explore the repetition of circles. Once involved in the discovery of this elemental form, I was able to move away from a literal interpretation and use more creative shapes and color. Hopefully, viewers will first be attracted to the abstract composition of *Guggenheim* and then go on to discover the Calder mobile, fountain and museum-goers. ✳ My method of pouring the three primary colors on wet paper was combined with gouache to define some details.

Underpainting can be a valuable tool
for creating a simple structure
under a complex concept.

Mark de Mos

Each painting is a learning experience dictated by the desire to create a sincere statement about the subject. This became a character study of John Baldwin, a church organist who crossed the globe repairing ancient pipe organs but who lived in a rustic cottage surrounded by the significant accumulations of a lifetime. How do you capture this complex subject? First I saw the large statue as a stand-in for John and avoided unnatural colors. Second I discovered the value of an underpainting to create a simple structure for coherent complexity. ✳ Large areas like the books and walls were painted together, working wet-into-wet with rich sedimentary colors (for example, Venetian Red and Cerulean Blue). These were further defined with darks. Textures, variations in temperature, strong diagonals and a loose, unfussy style imply the bachelor ambience and keep flat surfaces dynamic.

BALDWIN'S STUDY
Mark de Mos • Watercolor • 21" x 15" (53cm x 38cm)

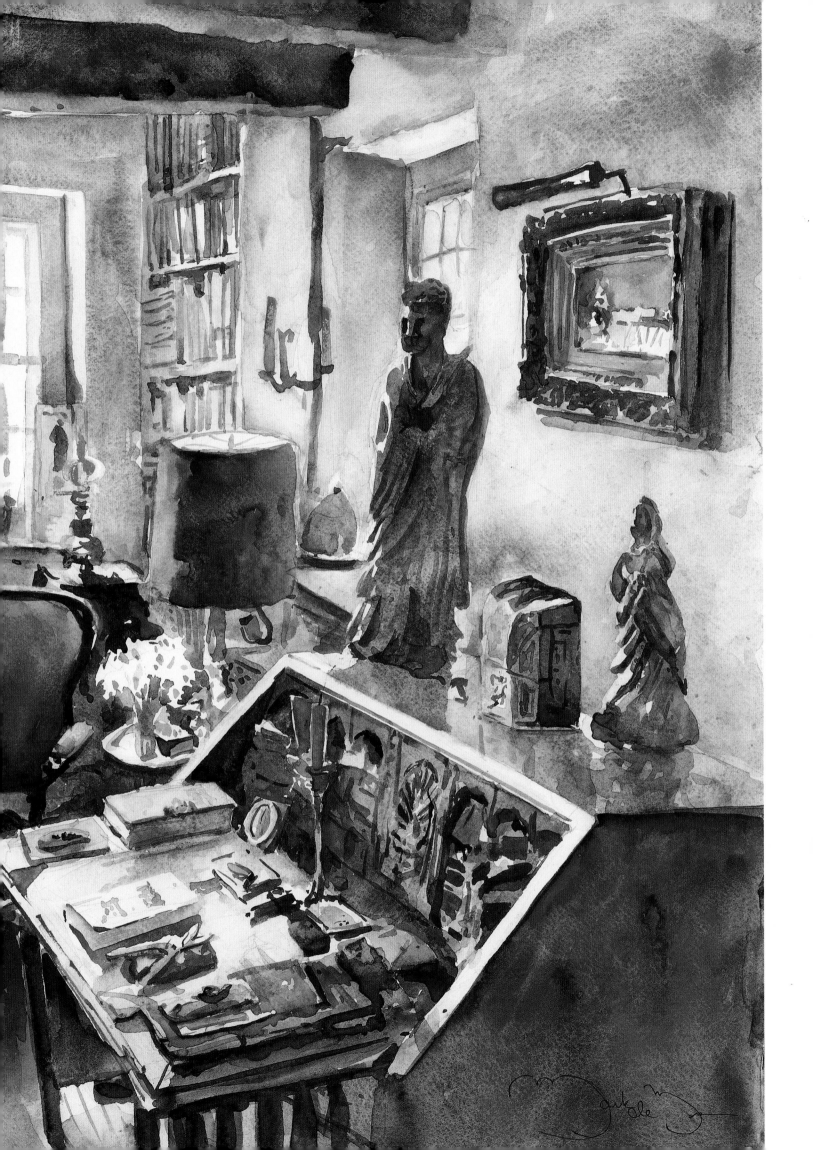

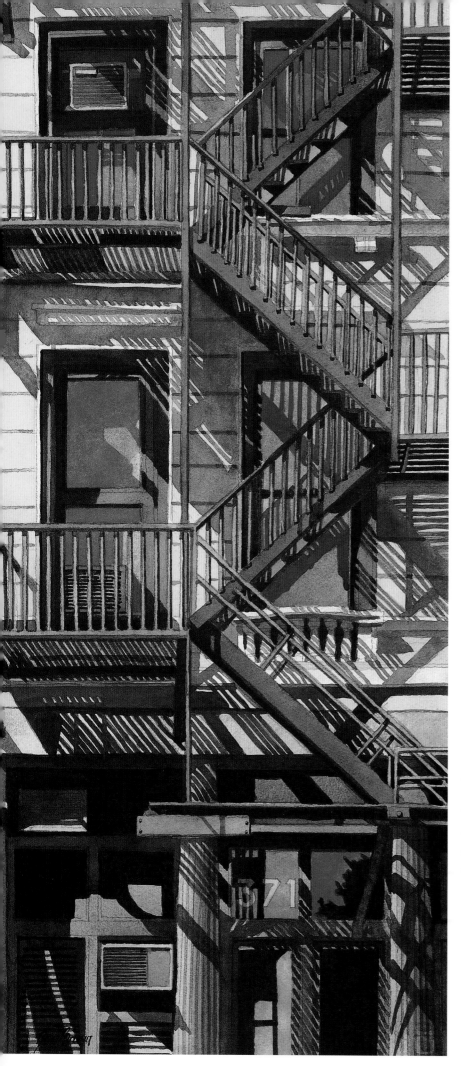

Capture a slice of the city mood ⊰
instead of painting
a complicated street scene.

Dana Brown

I am fascinated by large cities. It is stimulating to stand on a Soho street corner and smell the hot dogs, marvel at the careening cabs, and of course, watch the shadows slowly slide over the fire escape above. It can be visually overwhelming. How can I capture this excitement on a piece of watercolor paper? After many rolls of film, I came to the realization that I could get my point across by capturing a *slice* of the city. I still enjoy every minute detail, but when it is time to begin painting, I isolate one aspect and build a simpler composition. ✳ For this painting, I used a limited palette to ensure color harmony and gradually built many layers to achieve strong, saturated color. Near completion, I applied a final layer of pure Aureolin to the fire escape and sheer layers of Cerulean to the windows for punch.

THREE AIR CONDITIONERS
Dana Brown • Watercolor • 29 ½" x 12 ½" (75cm x 32cm)

The language of pure color ⊱
can express the flavor of a place.

Kathleen Cornelius

I paint watercolors that express my appreciation for the rich complexity of other cultures. *French Lemonade* is an analogy for my experience in the village of Cannes, France. The key ingredient in *French Lemonade* is the triadic color scheme. A primary palette is a challenge, but using the pure hues red, yellow and blue adds energy and accents the French flavor of the painting. ✳ Attention to the relationships of hue, value and intensity are key to the successful use of this particular combination of color. The dominant New Gamboge Yellow, repeated in the sunflowers and in the lemons, lends warmth. Brilliant colors of Winsor Red and Cobalt Blue flow over the paisley-patterned fabric in a joyful expression of life in southern France.

FRENCH LEMONADE
Kathleen Cornelius • Transparent Watercolor • 30" x 23" (76cm x 58cm)

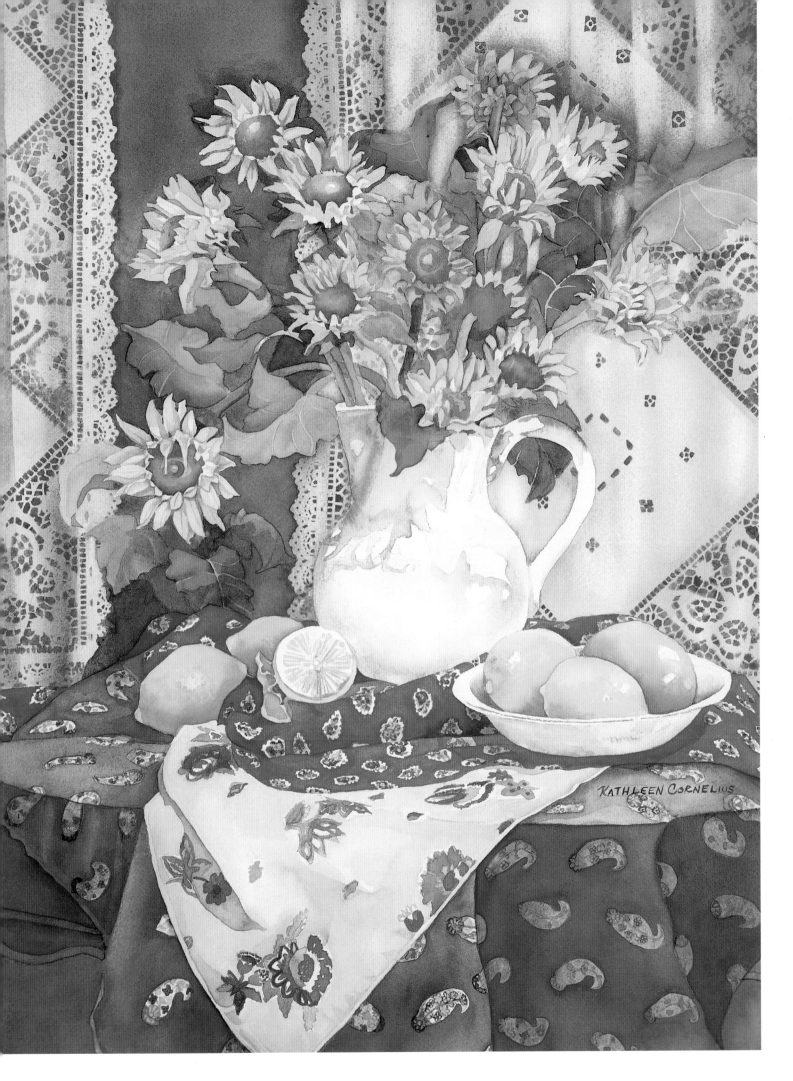

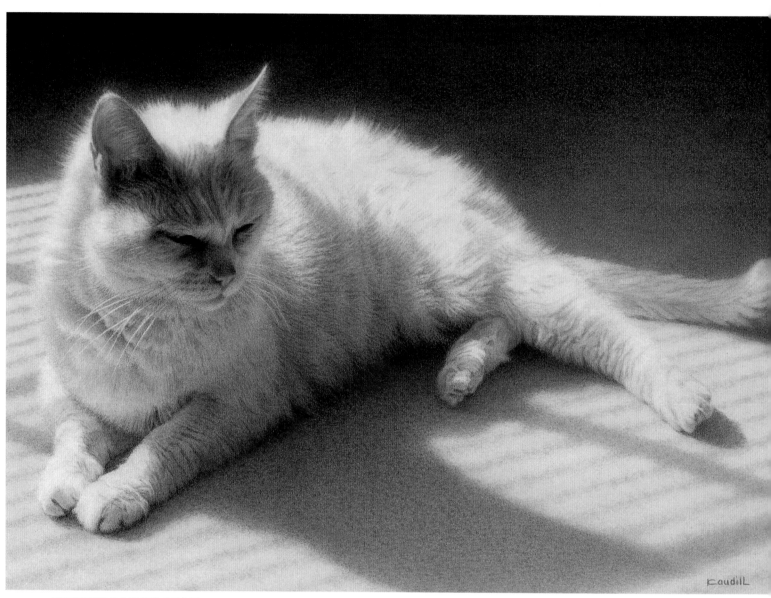

NOVEMBER SUNSHINE: MINNIE
Kathy Caudill • Transparent Watercolor • 10 ½" x 15 ¼" (27cm x 39cm)

Use a razor blade to soften your paintings
and create a gentle mood.

Kathy Caudill

Several years ago I discovered that I could enhance the soft look of my watercolor paintings by lightly scraping the dry paint with the edge of a razor blade. The razor acts as an eraser to gently lighten or remove selected areas of paint. This was the perfect technique to use to portray my old friend, Minnie, as she basked contentedly in the late November sunshine. She had been diagnosed with cancer, and I knew her days were numbered. I wanted to paint a realistic portrait of her that captured the familiar softness of her fur as well as the gentleness of her spirit, so I could remember her as she was on this day. ✳ For this painting, I used only transparent watercolor. I used the razor technique on the edges of the fur, the subtle passages within the fur and on the whiskers, which were scraped off with the tip of the blade. (Note: I prefer the thinner and more flexible double-edged blade over the single-edged blade because it does not dig too deeply into the surface of the paper.)

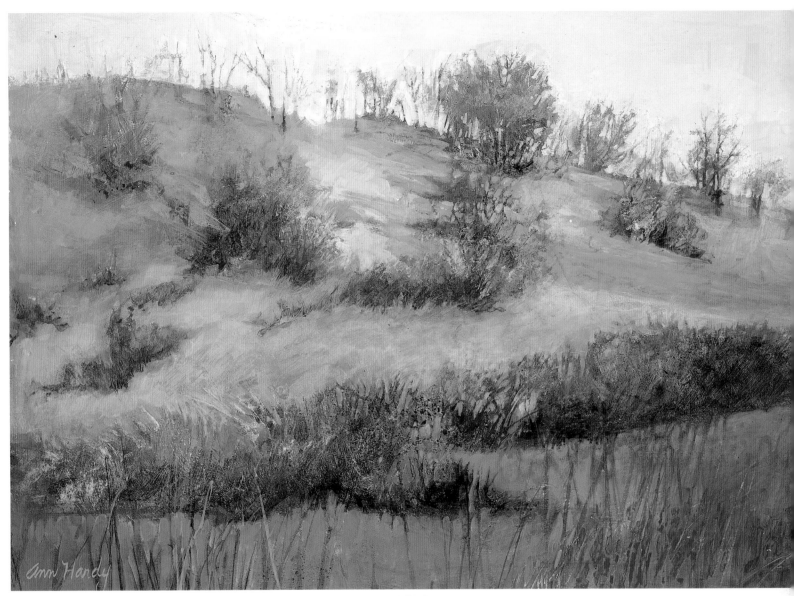

BIG BEND

Ann Hardy • Transparent and Opaque Acrylic With Watercolor Pencil • 22" x 30" (56cm x 76cm)

Represent nature through suggestion rather than dazzling with detail.

Ann Hardy

I think Robert Henri said "Painting is poetry on a flat surface," the orchestration of color, shape, texture and mood. Creating the mood of this arid area was what I was after. I have a running debate with myself on whether my paintings should evolve or whether I should have the end result in mind from the start. I'm still debating. It's more fun to evolve, but more logical to have the end result in mind. ✳ This scene was changing so fast as the sun was setting, blasting a portion of the dune with light, while the rest of dune was falling into shadow. I took a couple of photos and then quickly did a watercolor sketch, knowing how photography can misrepresent the shadows. In studio, the entire paper was painted with variations of Cadmium Orange. Then I broke the painting into the three shapes of sky, shadow and sunny areas. From that stage I did a lot of negative painting while softening and crisping some edges, then finished with some watercolor pencil accents.

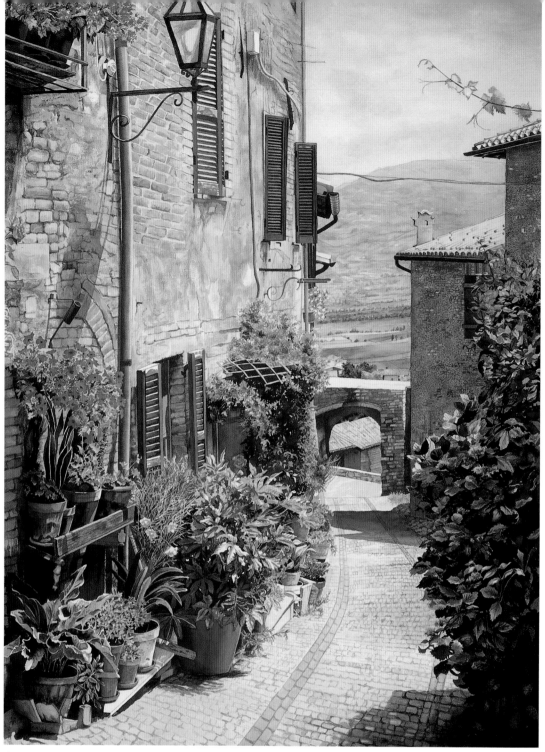

STREET IN MONTEFALCO
Estelle Lavin • Watercolor • 41 ½" x 29 ½" (105cm x 75cm)

An accidental glimpse
of a small winding road
led to a whole new view of painting.

Estelle Lavin

On the outskirts of a town in Umbria, while shooting reference pictures of the beautiful landscape for a new series of paintings, I ran out of film and went into the shadows under a bridge to change the roll. Glancing up, I was intrigued by a winding cobblestone road. Following it, I found myself amidst ancient residential buildings, wonderfully scarred with centuries of repair, blooming with potted gardens. Realizing I had found a new "take" on painting Italy, I shot many pictures of the area, culminating in this painting. From then on, I forsook landscapes for the fascinating winding back streets of small towns, alive with history, living people and potted gardens. ✳ To add variety in building surfaces, I used both drybrush (on the left) and several wet washes sprinkled with salt (on the right) for textures.

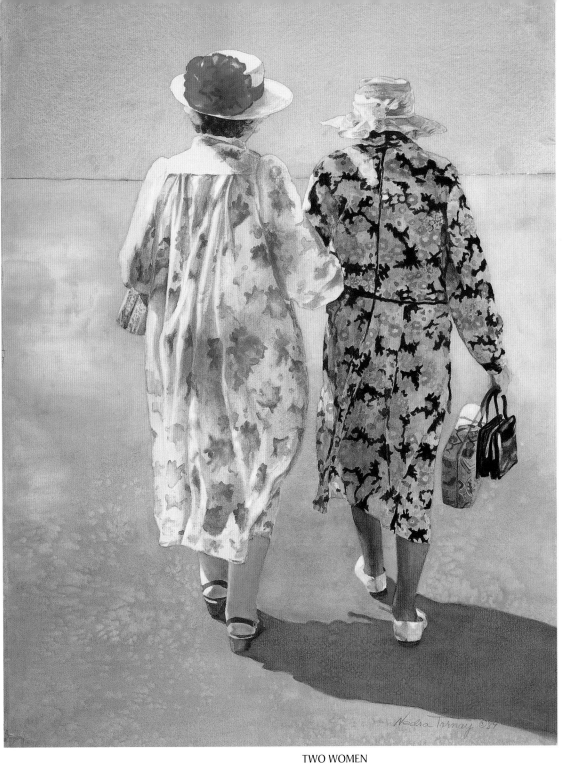

TWO WOMEN
Nedra Tornay • Transparent Watercolor • 30" x 22" (76cm x 56cm)

When content is significant, technique becomes less important.

Nedra Tornay

To me, these two women are a visual representation of love, dignity, respect and friendship. Their silhouettes convey a sense of pride and also a sense of pathos. To emphasize the emotions their images evoke, I portrayed them in an isolated setting. ✳ I began my painting with the background, using Cadmium Orange and Cobalt Violet mixed together on my palette. This particular combination of pigments is an exciting mixture to use for the ground texture. While this mixture was still wet, I sprinkled some salt on it. I rendered the women's clothing with a vivid and detailed underpainting. When the paper dried I used a wash of Ultramarine Blue to darken the areas in shadow.

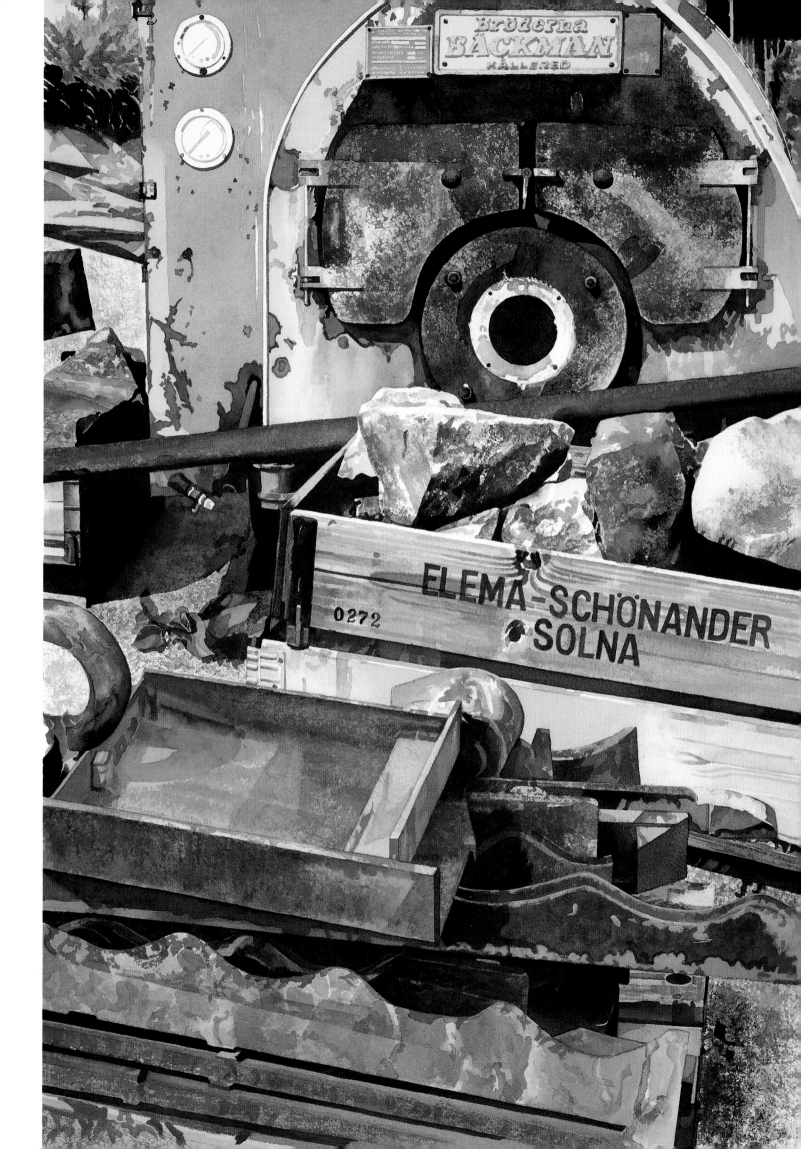

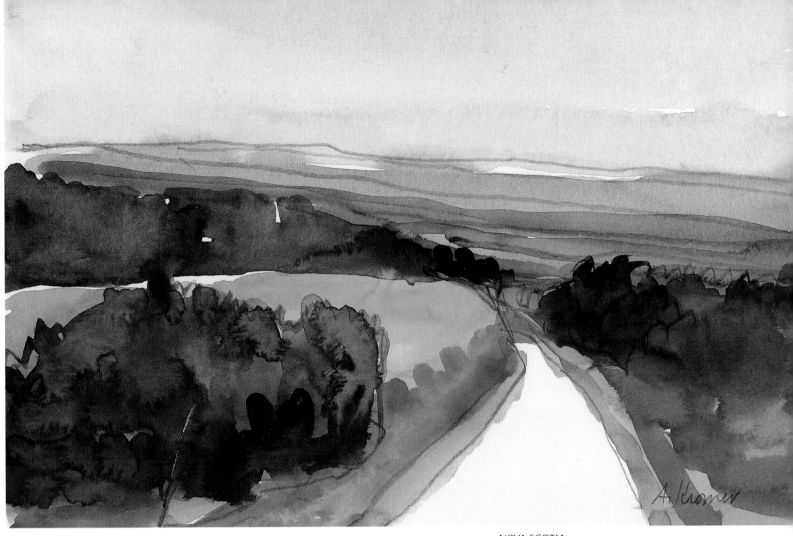

NOVA SCOTIA
Ann Kromer • Watercolor • 11" x 14" (28cm x 36cm)

You can capture the essence of a landscape through a car window.

Ann Kromer

Sitting in the passenger seat as we drove through the countryside, I realized so many wonderful scenes were flashing by. With a water bottle in the drink holder, a block of cold-pressed paper and a small watercolor box, I decided to record the scenes rushing by. Now, after many miles of travel, I have quite a travelogue of paintings that I collectively refer to as my "drive-bys." ✳ *Nova Scotia* was painted on a beautiful July day, as we emerged from a foggy morning into the sunny afternoon. The greens of the countryside were a kind of lush I had never seen before, but hopefully I captured them in the drive-by.

Texture can be created with careful color and value choices.

Linda Kooluris Dobbs

In Stockholm, one finds grandeur in glorious and elegant buildings untouched by World War II; but here, in Beckholm, one of the city's many islands, I discovered beauty in a shipping scrapyard. I was excited by all the broken and rusty bits. This painting required close analysis of value and chroma for each hue to correctly portray the textures of metal, wood and stone. Foreign words intrigue me as a graphic element. In this image, I made the lettering mostly legible, otherwise *greeking-in* (faking) the rest. ✳ One of my major goals was to create a stimulating effect with all the variations of hue, tints and shades of complementary colors: purple and yellow, blue-green and red, and blue and orange .

AQUA AND RUST
Linda Kooluris Dobbs • Watercolor • 28 ⅛" x 18 ⅝" (71cm x 47cm)

71

DISCOVER
Nature
and other special subjects

The artists in this chapter made discoveries about unusual aspects of nature or other special subjects that had a dramatic impact on their work. Some stumbled onto unexpected beautiful natural subjects; others found subjects sniffing or tugging at their legs. For one, the bathroom mirror spotlighted a familiar, but compelling subject.

Susan Hinton [opposite page] discovered that dramatic sunlight creates a variety of contrasts that produce startling visual depth. "There is nothing quite as dramatic as a sun-illuminated subject. The backlit flower and leaf forms of these zinnias at the Denver Botanical Gardens provided three types of contrast: *Color:* High-key color interplays with rich, deep translucent colors. *Edges:* Organic shapes are balanced by sharp edges. *Value:* Intense light offsets shadow patterns in the surrounding foliage. These contrasts produce a visual depth unattainable under lower light conditions."

Trying something new helps to
stretch the imagination
and adds a new perspective to the craft.

—JEANETTE ROBERTSON

ZINNIAS
Susan Hinton • Watercolor • 28 ¾" x 19" (73cm x 48cm)

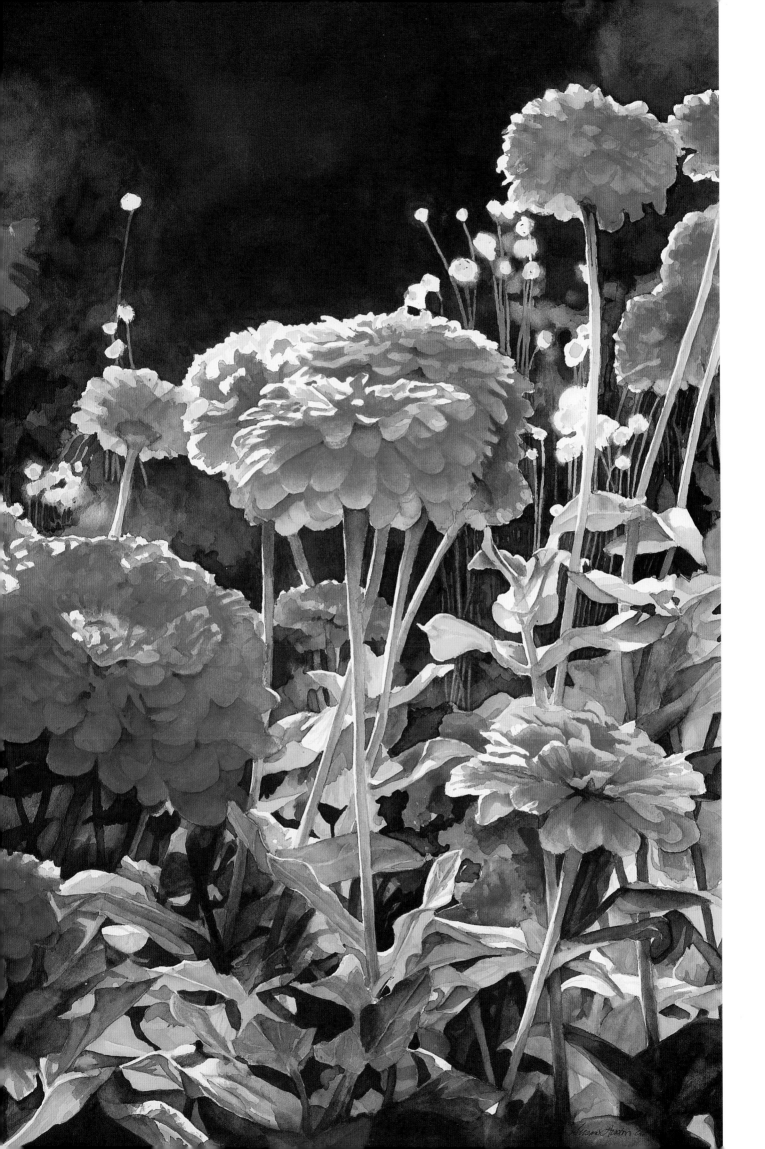

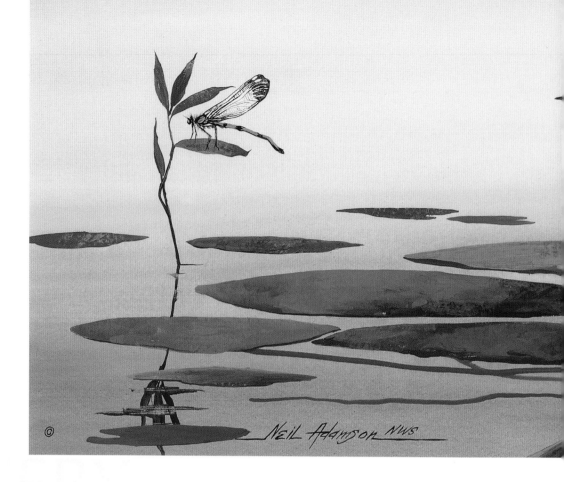

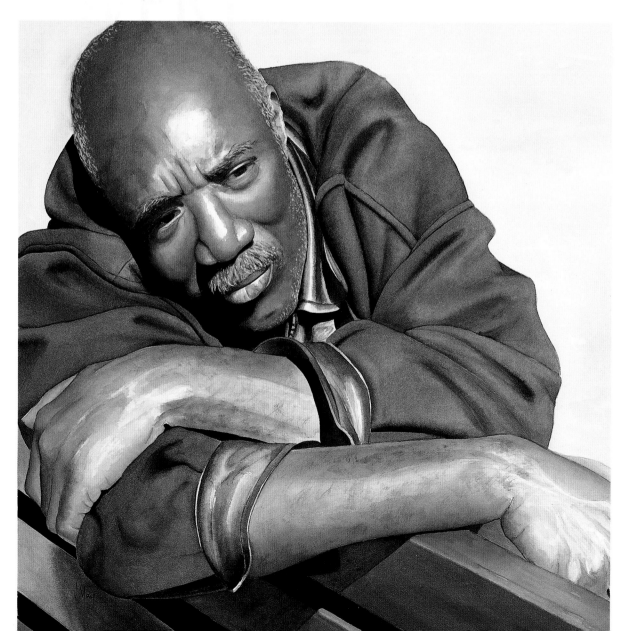

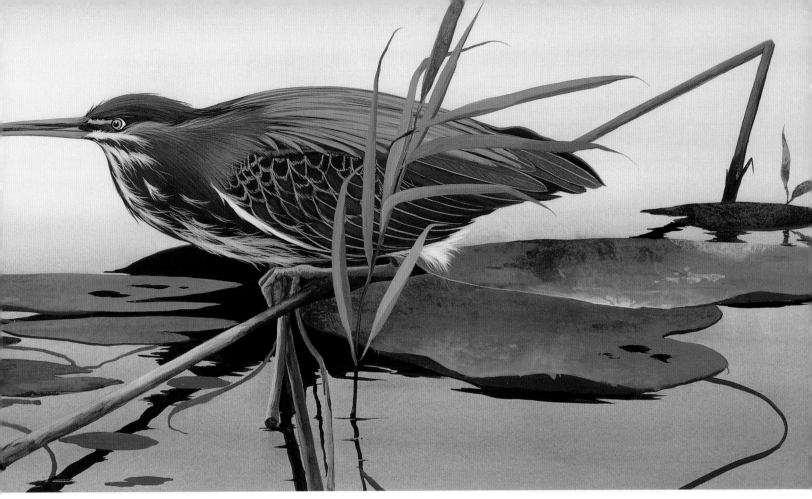

DRAGONFLY IN TROUBLE
Neil H. Adamson • Acrylic Watercolor • 17 ½" x 32" (44cm x 81cm)

Nature will reward you
if you wait.

Neil H. Adamson

I spent four days in the Florida Everglades photographing various birds and landscape areas, looking for anything that would make a good painting subject. During that time, the Green-Backed Heron took my complete attention. I was amazed at his patience; motionless for hours in various poses, keeping hidden, yet ready to capture his prey in a second. I studied him for several days, taking many photographs; one of my favorites gave me the pose for *Dragonfly in Trouble*. Although in the photograph you could not see what he was after, I added a little twig and the dragonfly to give the painting drama. ✳ My medium was acrylic watercolor on Strathmore plate surface illustration board, using the acrylic as a wash in the sky and water. I used lots of dry-brush technique to paint the bird with many different colors, and glazed in the lily pads.

Attempting a portrait for the first time
opens new avenues for expression.

Virginia May

Over the years I've painted a diversity of subjects, but never portraits. One day, instead of wandering the city streets looking for an interesting building, back alley or unique item for a still life, I went searching for a model (and the nerve to ask a complete stranger to pose for me). I was fortunate in finding Bill. Although this was to be my first portrait, I found myself approaching it in the same manner as many of my still lifes, developing a detailed, closely cropped design with strong natural light and deep shadows. I was pleasantly surprised with the discovery that I could not only portray a physical likeness, but also a depth of character. ✳ The challenge in this painting was to capture the various textures: the fabric jacket with leather trim, skin, hair and the wooden bench. I washed on many layers to achieve the depth of color and value I was after, even obliterating some detail to get the desired, cohesive result.

BILL
Virginia May • Watercolor • 21" x 21" (53cm x 53cm)

75

GERBERAS I
Joyce Roletto Faulknor • Watercolor • 20" x 24" (51cm x 61cm)

Glass *gives you the best of both worlds:* abstract shapes that add up to a realistic painting.

Joyce Roletto Faulknor

It was the glass that intrigued me. The beautiful prism effect created wonderful abstract shapes. The discovery of combining free-form abstract shapes with the end result being a realistic painting, struck me as having the best of both worlds. ✳ The abstract shapes were created by working wet-into-wet. I worked with my darkest values first. If the value is just right when wet, it is not dark enough. The paints on my palette are never completely mixed. This creates vibrant colors within the shapes, and a painting that is fresh and strong in contrast.

Glass *is an unending source* of rich and varied artistic inspiration.

Margaret Dwyer

I have come to love glass objects as an exciting source of artistic inspiration. It began when I happened upon a random collection of colorful glass pieces on my back porch. It was late in the afternoon, and the strong sunlight created reflections and long, colorful shadows. The abstract patterns were amazing! Looking more closely, I discovered a whole new world of subtleties and richness. Thus began a new path for me. I found this wavy glass vase in an antique store and was immediately drawn to it. ✳ Noticing the patterns of colors, I painted each color group separately to uncomplicate the subject (all the greens at once, then the blues and so on). I glazed with pure color to build depth, while leaving the white of the paper for added value and brilliance.

WAVY GLASS
Margaret Dwyer • Watercolor • 22" x 15" (56cm x 38cm)

AGAPANTHUS
Elizabeth Groves • Transparent Watercolor • 22" x 30" (56cm x 76cm)

Each painting is a unique discovery of the beauty of nature
that lies right before our very eyes.

Elizabeth Groves

Each of my paintings is a unique discovery. I attempt to transform the view of ordinary, everyday, natural things that most of us overlook by showing the more enchanting aspects of common subject matter through abstraction and simplification. I enjoy scouring my garden for interesting shapes, textures and colors of leaves, twigs, sepals, stamens and seeds, and arranging them into a desirable composition. I then abstract the shapes to represent the predominant characteristics of the chosen subject, seeking the essence of the organic forms in terms of lines, planes and shapes. ✳ When in bloom, the agapanthus has clusters of blue flowers on tall stems. Instead of fresh blossoms I used the dried petals in subdued shades of violet that complement the crumpled brown and yellow leaves. These two colors dominate the painting, and the shapes are simplified and stylized.

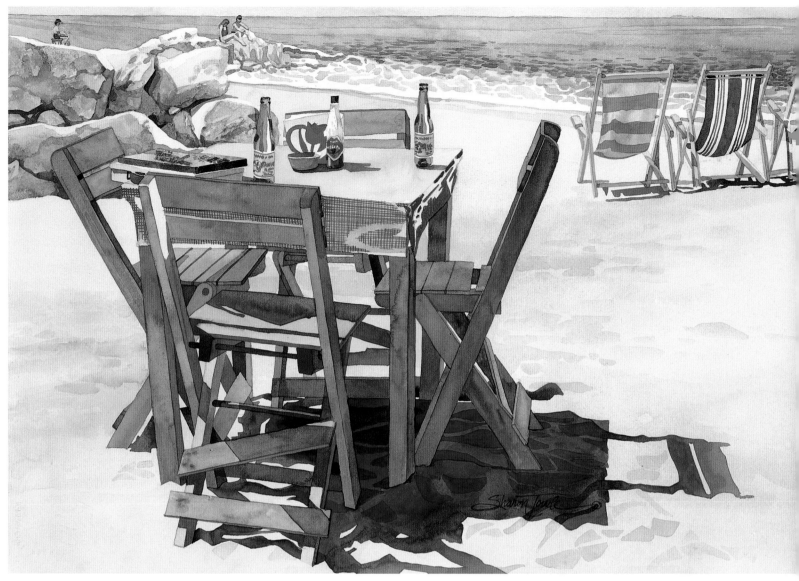

MISMALOYA EXPERIENCE
Sharon Towle • Transparent Watercolor • 15" x 22" (38cm x 56cm)

Small figures can add a story
to a lonely landscape.

Sharon Towle

Figures occasionally do belong in a landscape. Having lived my entire life in a metropolitan area, I have never wanted to clutter up my landscapes with people. Constantly being in crowds has made me appreciate uncrowded areas—if not in real life, then at least in paintings. This is my space and I want to enjoy it in solitude! But after a group painting trip to Puerto Vallarta a few years ago, I started working on this piece and had wanted to put one of my friends in the picture to give it more "painting on location" flavor. Then, of course, I couldn't just leave her all alone out on the rocks, so I included the swimmers that she was sketching. It was then I realized that this painting had become more of a story and not just a vista. Little people now occasionally pop up in my landscapes. ✳ I like "hot" shadows, especially in tropical settings. I combine blues, purples, oranges and sometimes pinks to give the feeling of hot sand.

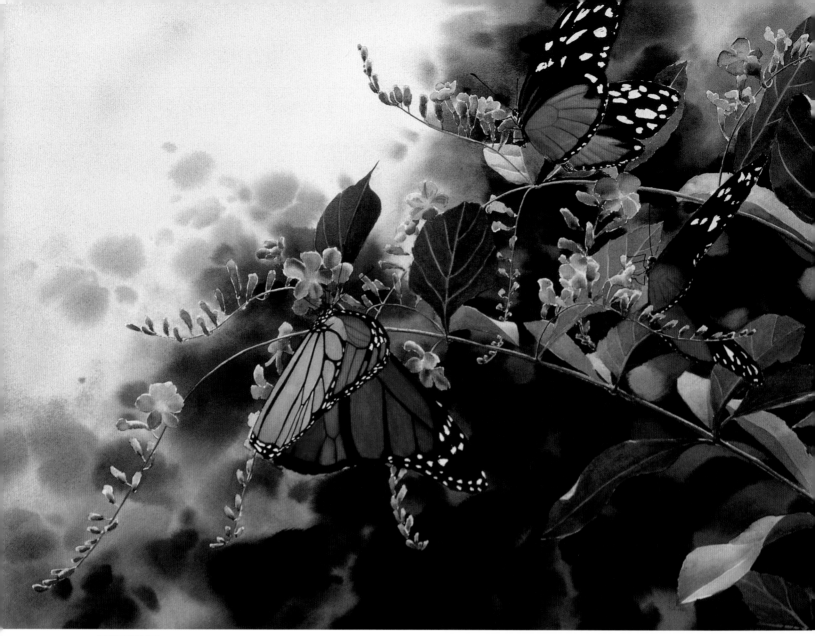

BUTTERFLIES
David Lee • Transparent Watercolor • 21" x 29" (53cm x 74cm)

The delicate beauty of butterflies
suggested the combination of abstract and realistic elements.

David Lee

A few years ago I visited a butterfly conservatory garden. The tiny creatures attracted and amazed me immediately. The color and patterns on their wings were absolutely beautiful, especially when illuminated from above and behind by natural light. The shapes of their wings were ever-changing as they moved around the flowers and leaves. I suddenly realized that all these were perfect elements for semiabstract paintings, so I took a lot of reference pictures of many different types of butterflies in various settings. Then I started painting these realistic pictures with abstract qualities, which brings a new dimension to my watercolor paintings. ✳ After a satisfactory composition was drawn on the paper, masking fluid was used to preserve the white paper for delicate flowers, small leaves and stems. The background was painted boldly and quickly with a large brush on a wet surface, almost like the Chinese "pouring ink" technique. The realistic elements were painted carefully and accurately. The challenge was to blend the realistic elements into the abstract background harmoniously. One corner of the painting was intentionally left blank to leave a resting place for viewers' eyes.

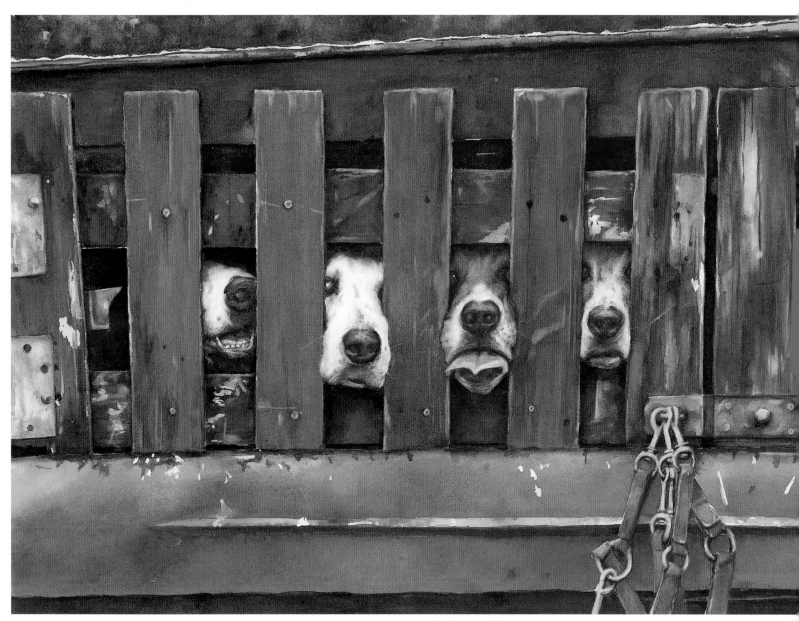

THE NOSE KNOWS
Fran Mangino • Transparent Watercolor • 15 ½" x 21 ½" (39cm x 55cm)

Combining several elements,
including a poem,
draws interest—and sales.

Fran Mangino

I quickly responded to these foxhounds and photographed them after their hunt. The title was chosen from a line in an untitled poem: "The eyes can spy, the lips lie, but the Nose Knows." The poem is always displayed next to the painting, which gets the attention of the viewers. This quick response to the subject, combined with a good title that was enhanced by displaying the source poem, encouraged viewer involvement and thus increased sales. ✳ A different technique I tried in this transparent painting was to use only four colors to complete the work. The worn wood effect was achieved by using a ¼-inch (6mm) flat fabric brush. It was thin enough to make lines and stiff enough to quickly scrub off dried paint. The frame chosen matched exactly the color and texture of the wood in the painting. Everything worked together to complete the entire look of *The Nose Knows*.

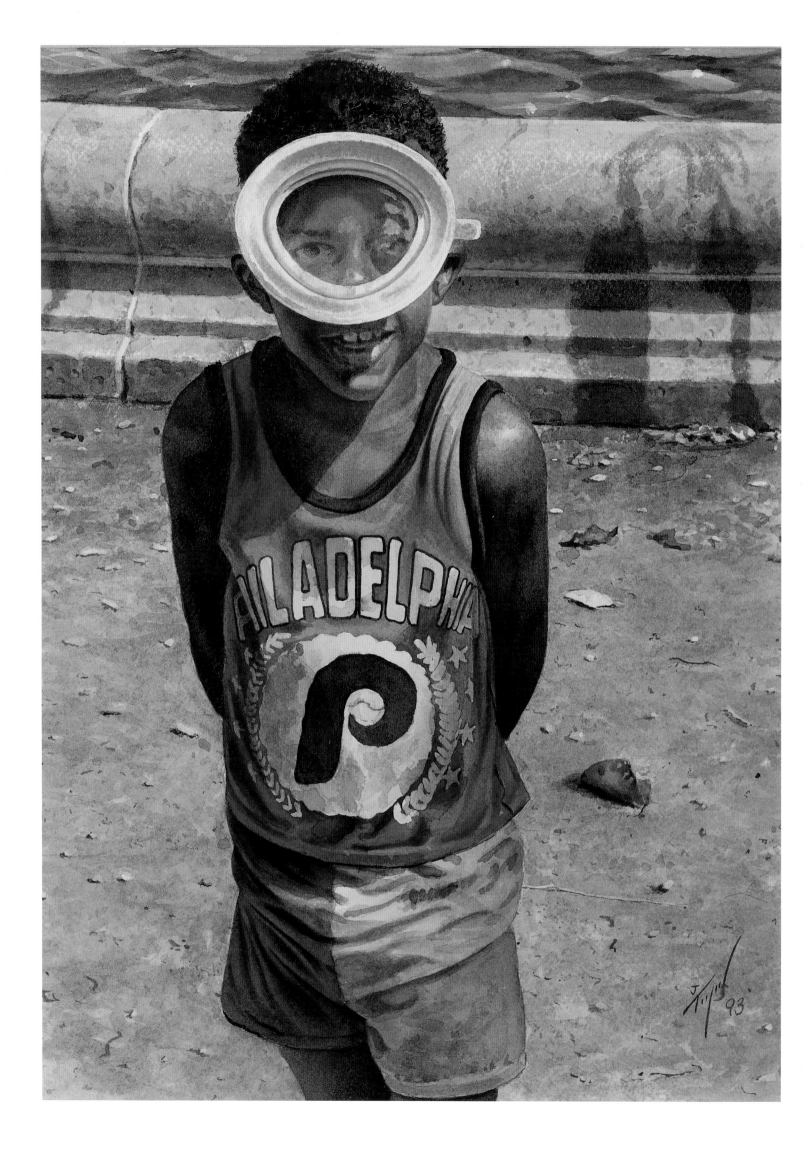

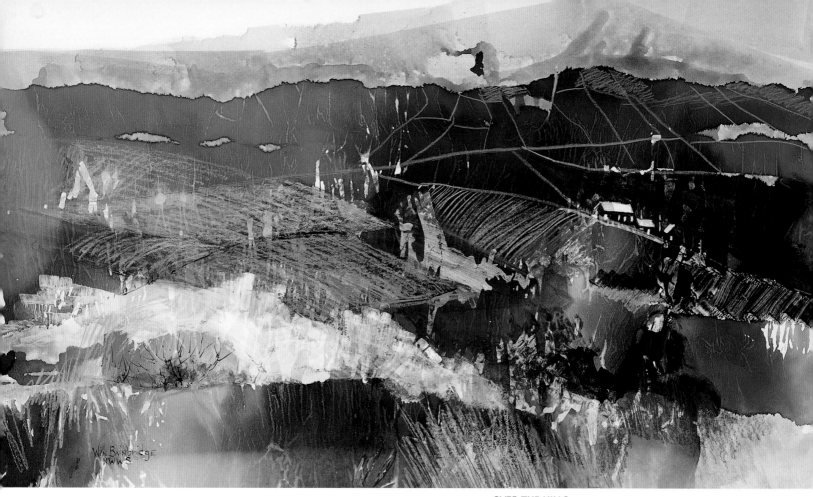

OVER THE HILLS
Win Bainbridge • Mixed Media • 28" x 38" (71cm x 97cm)

Adding other mediums to watercolor creates interesting effects.

Win Bainbridge

As I travel I am always intrigued by green landscapes—so many shades of green! While in Great Britain, I took numerous photos and have rendered them in many ways. A few years ago I started to abstract those landscapes. Then, I took a class where I learned to pour dyes through different weights of paper. I discovered how effective this is for creating various shades of green for landscapes. By simplifying, I found a new way to say an old thing. ✳ *Over the Hills* is part of a series of similar vista landscapes. I use many tools to achieve the desired result. Pouring inks and dyes through various papers is the first step. Next I use transparent watercolor, colored pencils, pastels, pens, brushes—whatever it takes to come up with what I have in mind.

Wonderful discoveries may be closer than you think— even tugging at your leg.

James Toogood

In Philadelphia on any given hot summer day you are likely to find throngs of people cooling themselves in the city's public fountains. Whole families in swimsuits with towels, beach blankets and lunches will spend the entire day. While working on a study at the famous Swan Fountain, I felt a tug at my pants. When I looked down, this is what I saw looking up at me. The little fellow had been snorkeling in the fountain! ✳ To make him stand out in the composition, besides making his mask bright I began his skin tone with a combination of Cadmium Red, Yellow Ochre and Burnt Sienna making an orange that contrasted with the predominantly Ultramarine Blue complement of his suit. The background was painted with more muted colors to make him stand out further.

AQUA MAN
James Toogood • Watercolor • 12 ¼" x 9 ¼" (31cm x 23cm)

83

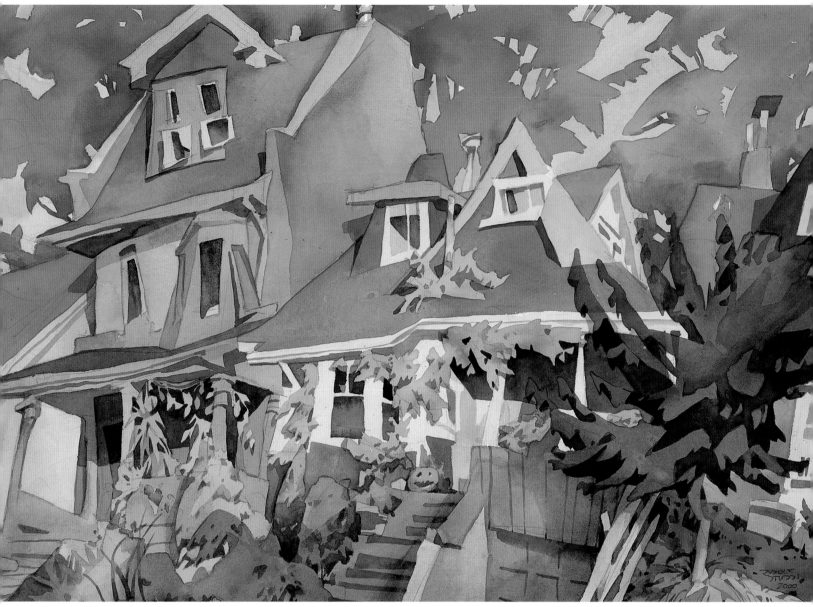

RED FALL
Rudolf Stussi • Watercolor • 20" x 26" (51cm x 66cm)

A *beautiful fall day*
inspired an opportunity to use red in abundance.

Rudolf Stussi

It was the most perfect fall day, the apogee of the Canadian colors that last only half a week. The temperature reached 20° (68° Fahrenheit), the sunlight had a yellow cast, the sky a deep autumn blue. The orange pumpkin on the stoop provided a fitting focal point for these distorted (my approach) houses in Toronto by Lake Ontario. The pleasure of painting on such a day made it a painting that just flowed from the brush. But the most exciting part for me was the rare opportunity of using the red of the foliage as a simple background foil. It is the red that gives the picture its warmth and appeal and sets it apart. ✳ One basic wash of a mixture of Cadmium and Alizarin Reds plus some Gamboges and a little Umber created the simple background of fall trees that set off the complex structures in the foreground.

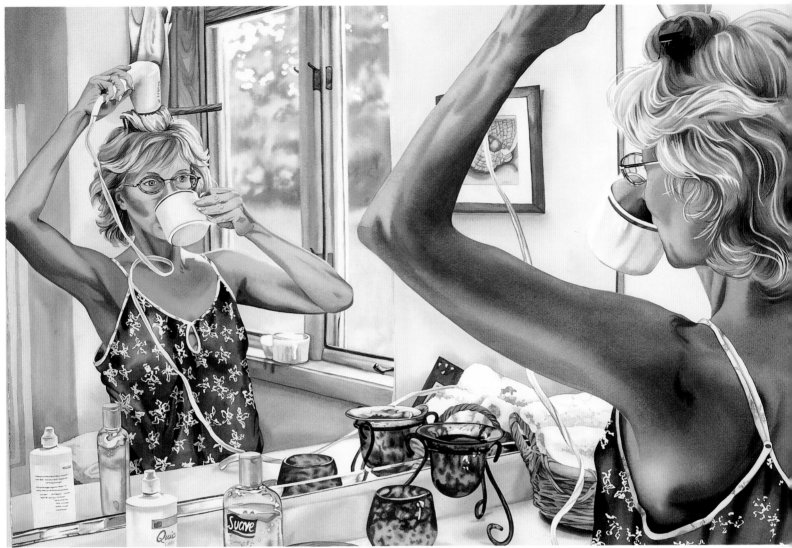

JOYE IN THE MORNING
Joye Moon • Watercolor • 20" x 30" (51cm x 76cm)

Recognizing the idea
is the greatest discovery
and the first step in creating a captivating composition.

Joye Moon

Ideas often present themselves in the most unexpected and offhand way. While drying my hair one morning, I was fascinated with the intense warm light streaming through the windows and the reflected image of a woman doing several tasks at once. As I looked at her and she at me, both of us caught in the moment, I suddenly realized that all of us are at once both self and other. My goal then became to create a work of art that expressed this idea. My task was to depict the "real me" and the "other me" in a workable composition. Recognizing the idea was the first step in discovering drama in the composition and invention in paint application. ✳ An important element of the composition was the dramatic sunlight. Since the back of the "real me" was in dark shadow, I needed a color to capture the rich, warm dark skin tone. I used Avignon Orange by Maimeri paints. Because the sunlight was extremely intense on several objects and on the "other me," I needed to soften the edges as the sun had. I painted those areas traditionally, then when the paint dried, I used a Fritch Scrubber to gently soften the edges of the windows, candle and parts of the figure. The result, I hope, was the rendition of my serendipitous idea and its inherent drama.

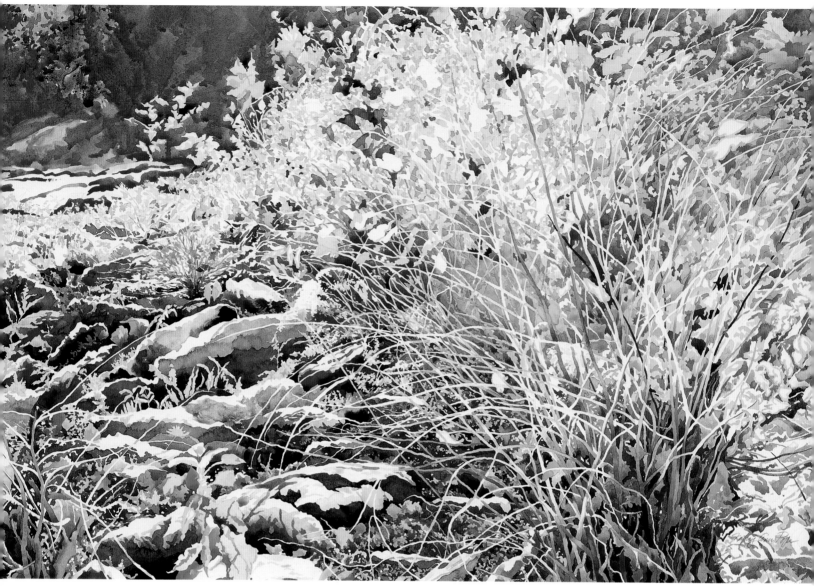

THICKET

Mary Ann Pope • Transparent Watercolor • 21" x 31" (53cm x 79cm)

The surprise discovery of a compelling subject
leads to creativity in concept and color mixing.

Mary Ann Pope

Usually I paint entire landscape vistas. But one sunny fall morning, I was walking up the edge of a river looking for a landscape subject, when I saw before me a thicket of tall weeds. A very large yellow bush, glowing in the sunlight, caught my attention. Instead of painting the river and its banks, I decided to concentrate on making a landscape of just this golden bush against the background of the river. ✴ The thicket was a golden yellow, so I pulled out all my watercolors in the yellow-to-ochre range and experimented, combining the yellows with other colors to find those just-right combinations for neutrals. With a mostly yellow painting I needed the neutrals and complements for interest and clarity. The limitations of shape and color forced me to be more creative.

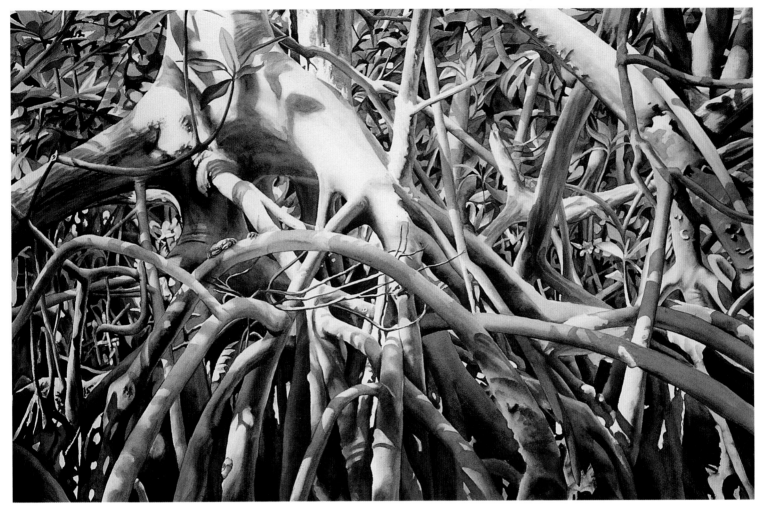

MANGROVE MYSTERIES
Leigh Murphy • Transparent Watercolor • 20" x 30" (51cm x 76cm)

A trip into nature
can lead to unexpected discoveries.

Leigh Murphy

The original intent for my expedition into the mangrove forest of the Everglades was to find some water birds to photograph for a future painting. Since the birds were scarce that day, I ended up discovering the mangroves themselves. As a child I had paddled through these wild and eerie waterways, but this was the first time I observed them with the trained eye of an artist. I marveled over the complexity of life amid these looping and twisting roots. ✳ I found ways of dealing with my dislike of the use of green. Using Cobalt Turquoise, Burnt Sienna and Cadmium Orange in the foliage areas made them much more lively. The gradual change from cooler to warmer colors helps draw the viewer's eye toward the tiny tree crabs sheltering on the trunk of the mangrove.

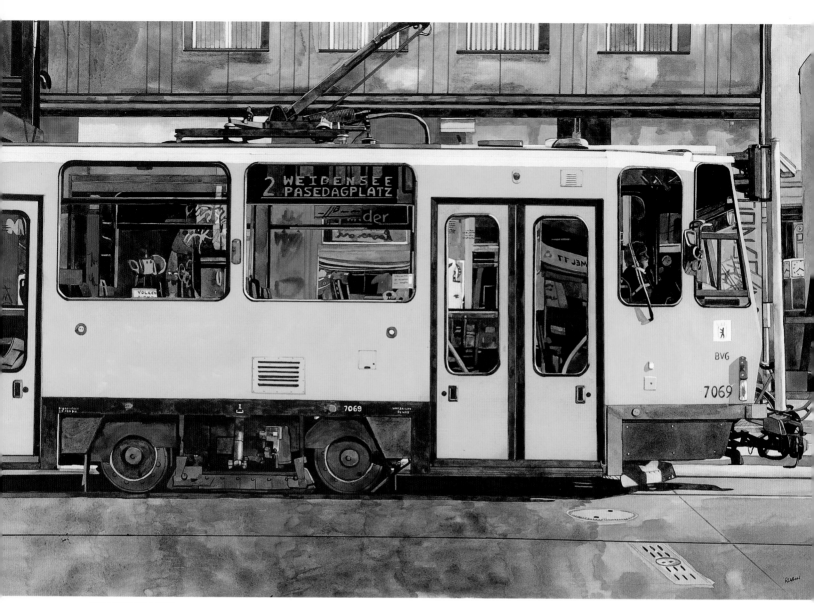

YELLOW TROLLEY
Deborah Rubin • Watercolor With Gouache • 18" x 26" (46cm x 66cm)

An *exhibition of train paintings* opens a "bright" new world.

Deborah Rubin

I had been a flower painter for over twenty years when I was asked to participate in a gallery exhibition of train paintings—a challenge for sure. I had recently returned from Germany where the trains and trolleys were all bright colors—yellows, greens, oranges—so I decided to paint the *Yellow Trolley*. The color yellow became my transition between the flowers and the trains, giving me the boldness to jump into a subject matter I never would have pursued otherwise. The mechanical workings of the trolley became a new meadow to explore, comparable in beauty and form to the flowers I had been painting. ✳ Yellow is an elusive watercolor. It can look brilliant when applied but pale when dry. Thus, the yellows I used were much darker than the finished color. I needed to mix several together in order to get this strong yellow, as the rest of the painting consisted of gray and brown tones. I needed the contrast to create the boldness of the painting.

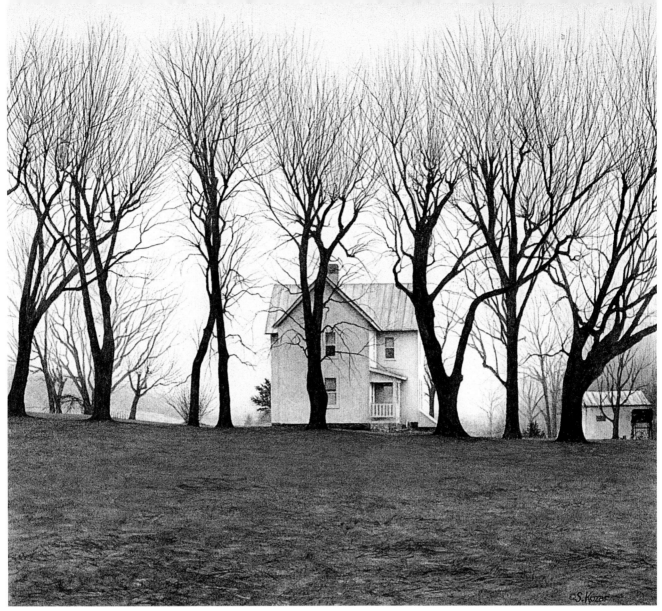

MISTY MORNING: SPRING TREES
Steven R. Kozar • Watercolor • 8" x 8" (20cm x 20cm)

A *photo reference of unusual visual quality*
 can take you "out of the box."

Steven R. Kozar

This painting was a bit of a surprise for me. My work has been largely about intense color and light, strong contrast and broad vistas. I had photographed a panoramic farm scene and this painting was to be a segment of the whole composition. But I was taken by the unusual visual quality. I enjoyed portraying the saturated, yet soft effect of light present in this scene. And those trees! They had a beautiful but somewhat haunting quality that I'd never painted before. This painting took me "out of the box," though it is a square. ✳ After completing a detailed pencil drawing, I then painted the very simple sky. The difficult part is knowing when the value of the sky is correct when the rest of the composition is still unpainted. To correctly convey the specific lighting conditions, the "white" house needed to be painted darker than one might think, and the edges of the shadows had to be soft. I didn't use any masking fluid or tape. I've grown tired of that process, so as often as possible, I try to risk it by painting quickly with as big a brush as I can (usually a Kolinsky sable).

DISCOVER *Light*

The artists' discoveries in this chapter are all about light. There is nothing more captivating nor more elusive to an artist than light. Charlene Brussat [opposite page] expresses the feeling of many artists: "When the light is perfect, capture the moment as quickly as you can."

Brussat says, "Lately, my grandchildren are becoming a great focus for my paintings. For this painting the light was perfect, as was the anticipation of Daddy coming home. I really liked the subdued rich color against the crisp beauty of the white paper. Since my 'white paper discovery' (see page 130), I search each piece to find where I can leave that wonderful space untouched."

Intense value and color contrasts
provide entertainment.

—DAN BURT

WAITING FOR DADDY
Charlene Brussat • Watercolor • 24" x 18" (61cm x 46cm)

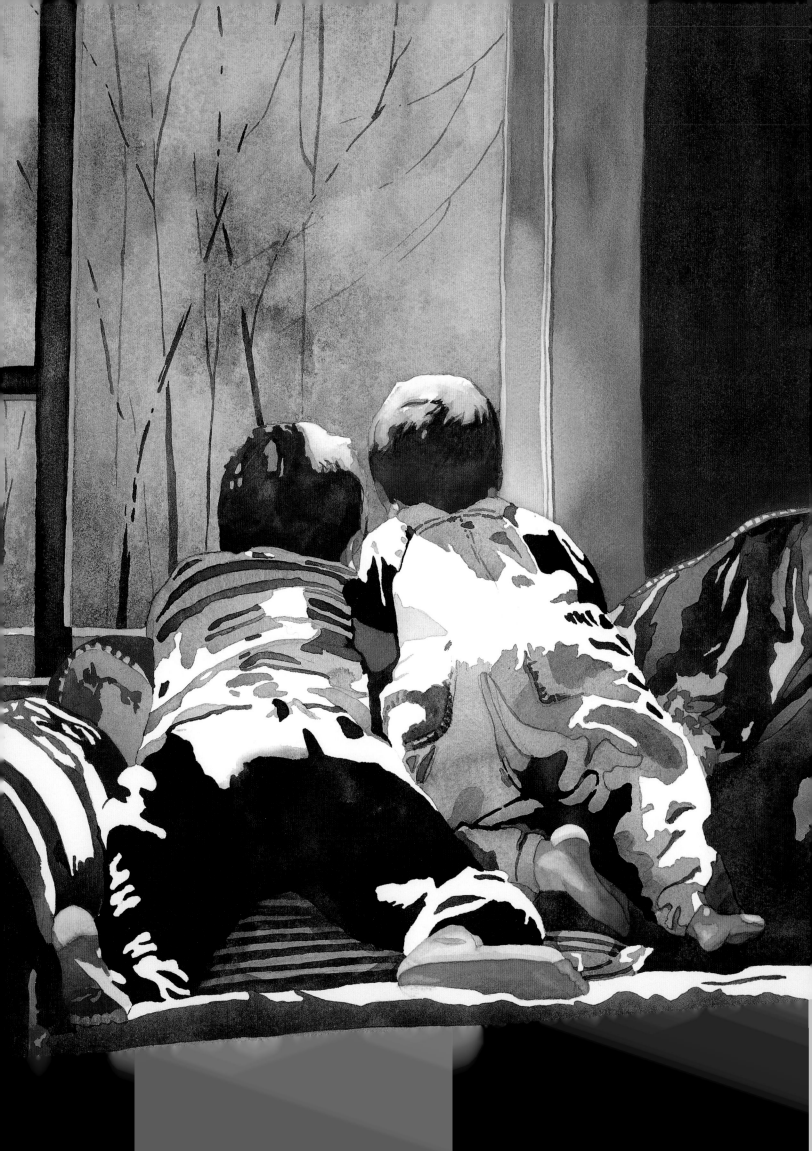

ONIONS
Susan Hinton • Watercolor • 21 ½" x 28 ½" (55cm x 72cm)

Sunlight often creates extraordinary moments
that must be captured in that instant.

Susan Hinton

One morning the sun was streaming through the east kitchen window onto the counter. The illumination and reflected light transformed these onions into glowing orbs of translucent color and texture that were further dramatized by the contrasting rich, dark shadows. The ordinary was transformed into the extraordinary in an instant. ✳ After drawing the onions I masked them completely, along with the lighted areas of the counter. I established the background and shadows first with several washes of color, tipping the paper and letting the colors flow and mix, then dropping in additional areas of more intense color for variety. I painted the onions last with a variety of colors, layering and building the intensity and values slowly.

*Selecting a wonderful place
and perfect time of day
can put magic
into your subject.*

Susan Harrison-Tustain

The diffused sun hung low in the sky as I took my little friend to a field full of golden daffodils. To my joy, Sarah's cream gown literally glowed as she danced and twirled amongst the blooms. I wanted the viewers of my painting to feel the warmth of the sun on their faces and hear Sarah's little giggle as she picks daffodils for her mother. ✳ This glow was created with transparent color. Fine wash upon wash creates jewellike colors. I always begin with a wash of Indian Yellow. My second wash is Translucent Orange. I then deepen some areas using Alizarin Crimson. Notice how the colors sing by simply juxtaposing purple—a mix of Alizarin Crimson and Phthalo Blue—next to the previous washes. Despite the richness of color, the gown still reads cream. This method is also wonderful when painting backlit flowers. Try it!

JONQUILLES POUR MA MÈRE
Susan Harrison-Tustain • Watercolor • 14 ¼" x 7 ¾" (36cm x 20cm)

BUDDING ARTIST
Dani Tupper • Transparent Watercolor • 14" x 21" (36cm x 53cm)

Transparent glazes
give real luminosity to sunny paintings.

Dani Tupper

This little girl came prepared to "paint" with the artists at a plein air session sponsored by the Southern Colorado Watercolor Society. While other artists started to paint the stone mansion and rose gardens, I sketched and photographed Victoria. My discovery in recent years has been letting one hue glow through another in subsequent glazes. This produces a real luminosity. Alternately, I allow two or more colors to merge together while the paper is still wet. These two ways of applying paint give me a variety of color combinations and textures that cannot be accomplished by mixing the paints on the palette. ✳ After sketching the figure, I glazed the lightest shades of the flesh, hair and background. Subsequent glazes and mingling of hues developed the values and textures. I laid in all the shadows and folds of the white dress before adding the red figures and trim to complete the painting.

IT'S A WRAP
Kay Carnie • Transparent Watercolor • 20" x 29" (51cm x 74cm)

Paint shadows separately
to keep control over color and value.

Kay Carnie

This painting was the result of a collaborative project with three other artists. The task was for each of us to paint a still life of the same four objects. The biggest challenge for me was to create a composition that would relate the objects to one another. I decided to use packing paper as a vehicle to tie the objects together. The complex folds of the paper created a sort of puzzle in the play of light, shadow and reflected light. ✳ I learned to see shadows with a new insight that allowed me to depict them more realistically in regard to warm and cool colors, reflected light and soft edges. I mix at least two colors, a warm and a cool, and paint the shadow separately from the area in light. The shadow needs to appear transparent. By applying the shadow area separately, I have greater control over the value and especially the freshness of the colors.

BAD BOY
Ruth Cocklin • Transparent Watercolor • 29" x 38" (74cm x 97cm)

Contrasting edges
create a dance of light.

Ruth Cocklin

When I saw the bright lights of the convention hall dancing and reflecting off the hard chrome and warm leather of the Harley-Davidson motorcycles, I knew that transparent watercolor was the only medium that could capture such a scene. Hard edges against soft passages create the shapes and elements of the motorcycle, and define the luminous reflective surfaces. ✳ All of the whites and light areas were carefully planned and defined, and no masking fluid or white gouache was used. The design elements of the motorcycle create the movement of the painting, with the curves of the handlebars and lights guiding your eye through the painting to enjoy the dancing light.

Metal objects create dramatic reflections,
combining bright, clear colors with strong darks.

Esther Melton

I discovered the importance of careful planning to ensure a sense of movement throughout the composition. The strong shadows helped achieve this goal. ✳ Masking fluid saved the whites and some light areas of the painting. To paint the colorful reflections in the metal jacks, I glazed over the surface of the jacks with the bright colors which were reflections from the marbles and the crayons, and then applied masking fluid over all areas that were light in value. At this point, I was free to paint the darkest colors and allow them to mix on the paper.

MARBLES AND JACKS
Esther Melton • Transparent Watercolor • 30" x 20" (76cm x 51cm)

PEARS I
Esther Melton • Transparent Watercolor • 19" x 28 ½" (48cm x 72cm)

*Increasing the value range
 by strengthening darks
 increases visual excitement.*

Esther Melton

I was fascinated with the textures in this quilt and enjoyed choosing the warm and cool color combination for the squares. At the time I was working on this painting, an instructor encouraged me to increase my value range by strengthening the dark values. By heeding this advice and exploring the possibilities, I feel I increased the drama and excitement in my work. ✳ The textures of the pears and the quilt were built up using many glazes of color. Once the main areas of the painting were completed, Winsor Green and Winsor Red were glazed in several areas on the pears and the quilt to strengthen the intensity of the warm and cool contrasts.

TOOTLE'S SUNBEAM
Tommie Hollingsworth-Williams • Transparent Watercolor • 23" x 23" (58cm x 58cm)

Through certain colors,
a painting can reveal the warmth of a sunbeam.

Tommie Hollingsworth-Williams

For several years I have painted cat portraits, including some of our old cat, Tootle, but this time I wanted to paint something more than just another cat picture. Often I observed her sitting or sleeping in a sunbeam, especially as she grew older. One day I saw Tootle dramatically backlit and felt compelled to capture the feeling of warmth and happiness she so obviously enjoyed. I knew I had succeeded when a guest at the 2001 Grand National Exhibition commented, "Oh, that makes me feel warm all over." ✳ To show the warmth of a sunbeam, I used a limited palette of Burnt Sienna, New Gamboge, Permanent Magenta and French Ultramarine Blue. By using magenta in the folds of the curtain and shadow, I enhanced the golden yellows of Tootle. I carefully painted around the backlit hair, then went over some areas with a yellow wash to soften the edges.

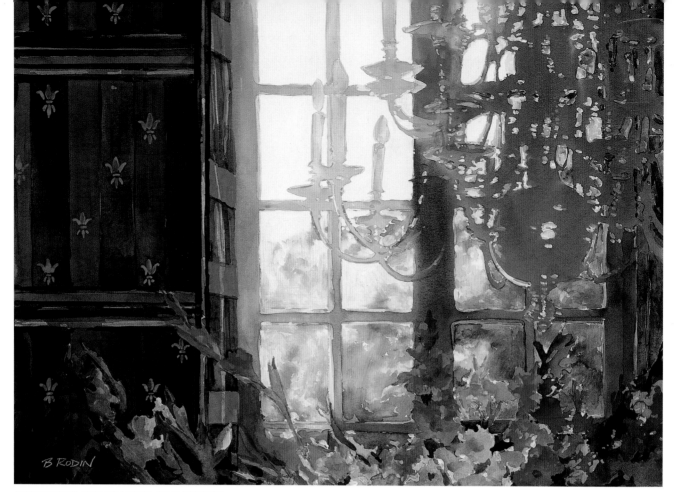

CHANDELIER AND GLADIOLI AT CHEVERNY
Bev Rodin • Watercolor • 22" x 30" (56cm x 76cm)

Using pure colors for light "halos"
gives the glowing effect of backlighting.

Bev Rodin

I have always been interested in backlighting. While on a trip to France, at Cheverny, I noticed a large, opulent vase of gladioli on a table below a chandelier, and light from a window was creating a beautiful effect of transparency and halos. I was able to take only a poor-quality photo as there were a lot of tourists. In my studio I experimented with this subject. I made the chandelier quite large, while keeping the wall and flowers subordinate elements. ✳ I experimented with the colors on the chandelier and discovered that yellows and mauves, along with a soft Cerulean Blue gave a glowing effect. This combination sparkles more than just using gold. In order to make the chandelier the focal point I kept the flowers more subdued, including only a few sparks of brighter color. Using pure colors as halos to show backlighting is now a method I use in painting many other subjects, making my struggles with this painting well worth the effort.

Utilizing outdoor painting techniques to portray interior scenes
led to discovering "inside out" design.

Judi Betts

Until recently, my paintings had been primarily exterior views. Then, I was asked to instruct some interior design students in watercolor technique as it pertained to furniture. This challenge led to my discovery of new ways to utilize design configurations, not only using interlocking and overlapping shapes, but also by tying objects, such as furnishings, together with light patterns. This, in turn, allowed me to expand my concept of invented "magical shapes" (playful bits of light) since I could use them both inside and out. In *Café au Lait,* these shapes can be seen as exterior foliage and also as openings in interior pieces.

CAFÉ AU LAIT
Judi Betts • Transparent Watercolor • 30" x 22" (76cm x 56cm)

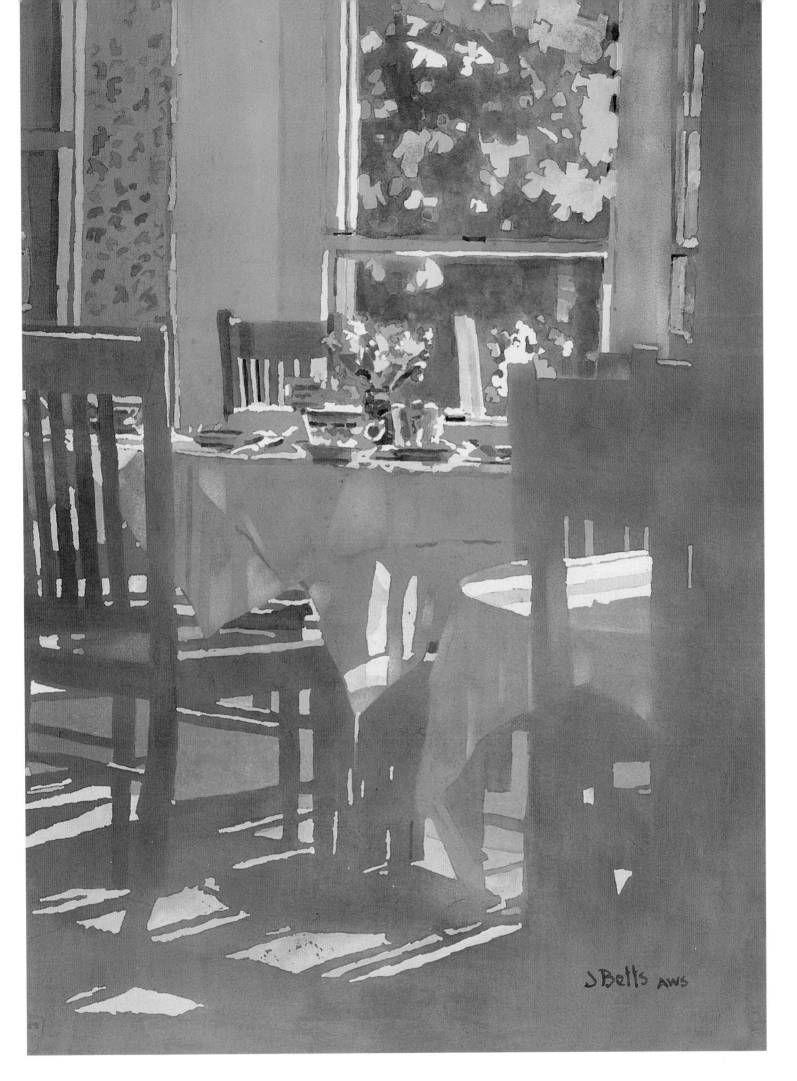

J.Betts AWS

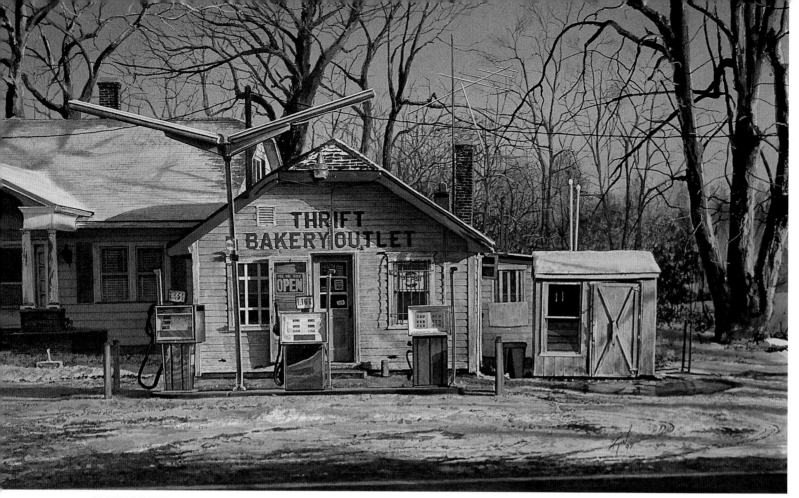

THRIFT BAKERY
James Toogood • Watercolor • 13 ½" x 20 ½" (34cm x 52cm)

Proper technique does not necessarily assure a successful watercolor. ⋏
Timing is everything.

James Toogood

At the Thrift Bakery and Filling Station you can buy donuts and get gas. I discovered this little place not too far from my home, but each time I went there to do a study, something seemed wrong. Perhaps the sun was in the wrong position or the leaves on the trees partially blocked my view. Finally, I took the time to determine what I thought would be the optimum lighting conditions and decided that it would be a sunny winter morning. The sun would be low in the sky and long, interesting shadows would fall across the scene. ✳ To optimize the feeling of light in this painting, I underpainted the "white" areas of the store, house and snow. I used Cadmium Yellow on the store, Cerulean Blue on the house, and a little of both with a touch of Dioxazine Violet on the snow in the foreground. The warm yellow comes forward and prioritizes the painting's center of interest— the store—and reinforces the warm feeling of light on a cold winter morning.

A bright light source ➤
simultaneously emphasizes and hides detail.

Susan Hinton

I was experimenting one night with a bright light source. My son was in front of the light when he turned to me. I was immediately struck by the light's effect of simultaneously emphasizing and hiding detail, which transformed his face into such strong areas of light, shadow, color and reflection that the result was almost ethereal. ✳ Each area was painted wet-into-wet, the shadowed areas of the face first. Most of the illuminated side was left unpainted to emphasize the strength and effect of the light and to provide a greater contrast with the shadowed and darker-value areas of the hair and background.

MATT
Susan Hinton • Watercolor • 28 ½" x 21" (72cm x 53cm)

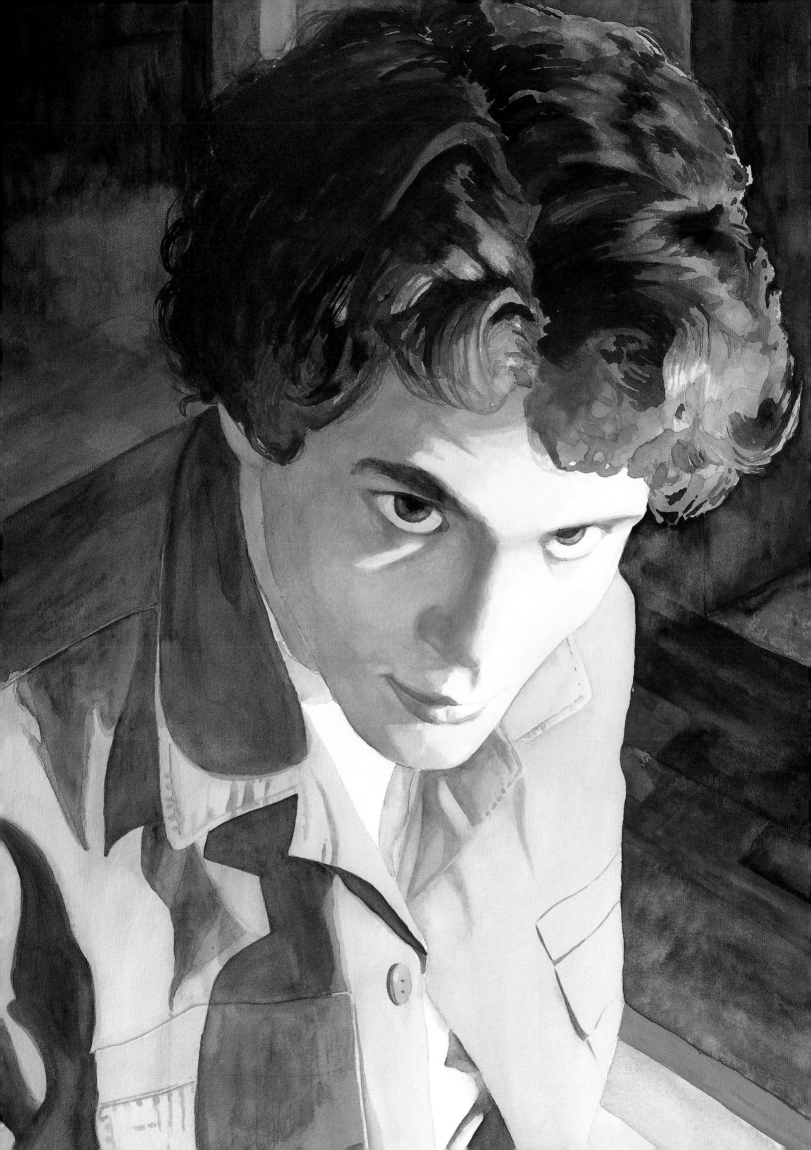

DISCOVER
Personal Expression

Artists in this chapter made personal discoveries; each is unique. Some have to do with symbolic content, others with approach and self-expression. Other discoveries are about refreshing imagination or reawakening old memories. Still other discoveries were made when artists were forced to respond to accidents or chance events. Most would agree that it is good to listen to your instincts.

Ann Gaechter [opposite page] discovered that she could dramatize simple subject matter through symbolism. "*The Survivor* represents loss and the legacy of hope. Slashing diagonally across the paper, the empty tomato stem adds tension to the painting, as well as symbolizing the pain of loss. The radiant red of the surviving tomato depicts the vibrancy of life, while hope is suggested in the subtle reflected light and bright white highlights. The rich dark-green background complements the subject."

I respond intuitively to what is happening on the paper, creating a dialogue between my internal artist and my materials.

—KATHLEEN BRENNAN

THE SURVIVOR
Ann Gaechter • Transparent Watercolor • 12" x 9" (30cm x 23cm)

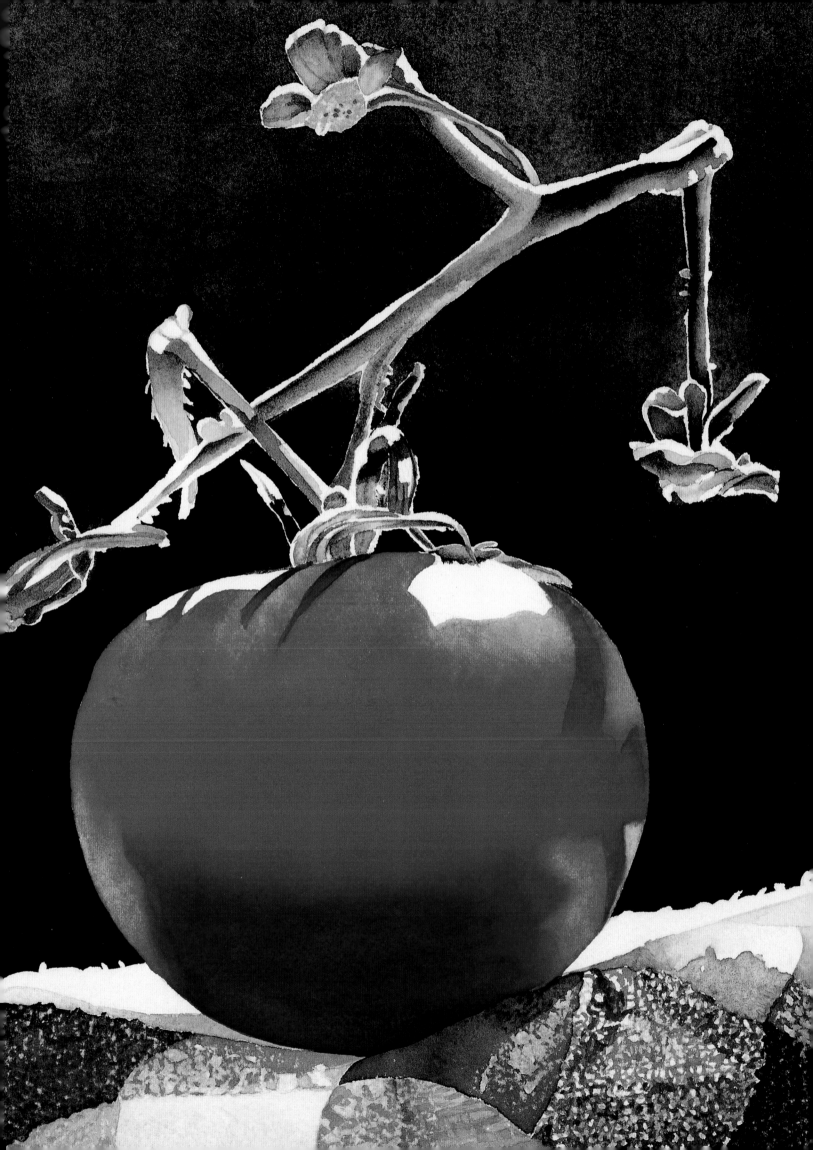

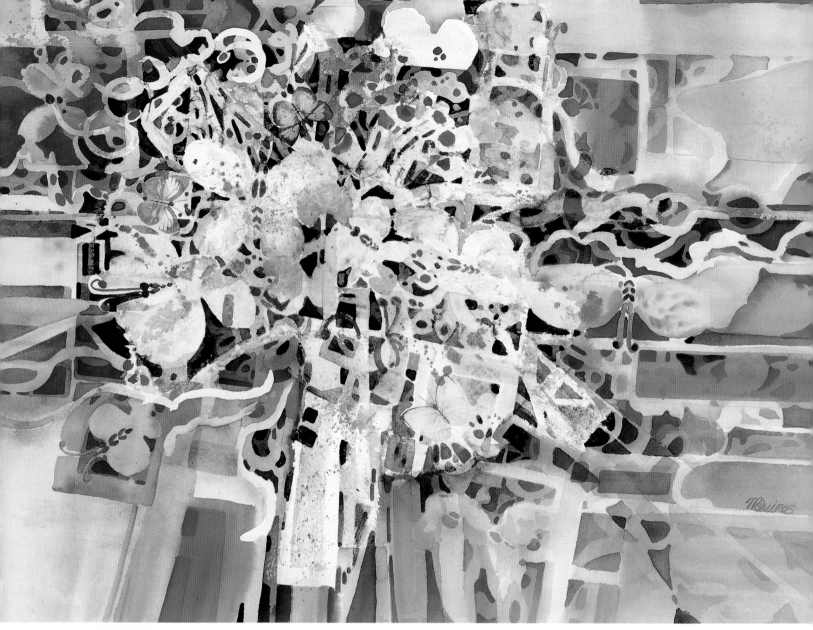

MARIPOSAS
Mary L. Quiros • Watercolor and Collage • 22" x 30" (56cm x 76cm)

The warm, exciting atmosphere of a class demonstration
brings inspiration.

Mary L. Quiros

Mariposas (butterflies) evolved from a quick lesson on the fundamentals of collage. As teachers, we can demonstrate technique, encourage confidence and awaken the student's discovery, but it is exciting when the teacher experiences a similar awakening. Not only were creative juices flowing, but the surrounding environment and student interaction in class also impacted the painting. Here on the border with Mexico, the climate is markedly hot, especially on this particular day. The class was in high spirits and enjoying the discovery of this new type of expression. In a word, we were all having *fun*. Later, when reflecting on the painting, I experienced the "ah-ha" moment of seeing the external influences in my work. The colors reflected the warmth of the day, and the spirit of the students found its expression in the joyful bursting of life. I am touched by my own discovery of often unnoticed sources of inspiration. ✳ The materials are watercolor and Chinese rice paper with real butterflies on 300-lb. (640gsm) paper.

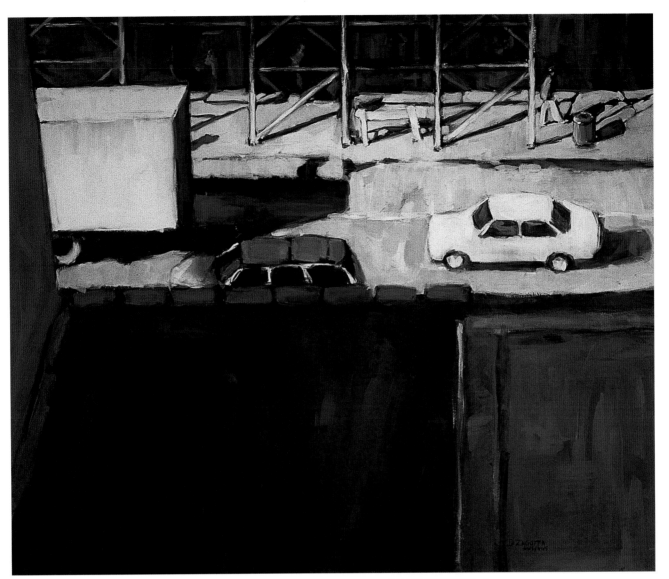

CANAL STREET NO. 2
Donna Zagotta • Watercolor and Gouache • 28" x 33" (71cm x 84cm)

Adding white gouache
* allowed for more self-expression*
* in an improvisational approach.*

Donna Zagotta

As a musician, I've always loved the idea of improvisation. You simply begin and allow one thing to lead to another, responding to each moment as you express yourself, heart and soul. Feeling the need for a change in my painting, I began searching for a more improvisational approach. Because I wanted to keep the water-solubility factor, I decided to add white gouache to my transparent watercolors rather than move to acrylics or oils. The simple addition of a tube of white paint allows me to paint in the improvisational manner I was after and to get in touch with my creativity. I express myself joyfully because I'm no longer feeling stifled by all of the rules, regulations and myths surrounding transparent watercolor. ✳ I put colors down intuitively and spontaneously. If I like what's there, I build on it. If I don't like it, I can change it, lighten it, darken it, brighten it, dull it, paint over it, paint it out, or wipe it off and begin again. Now that's freedom!

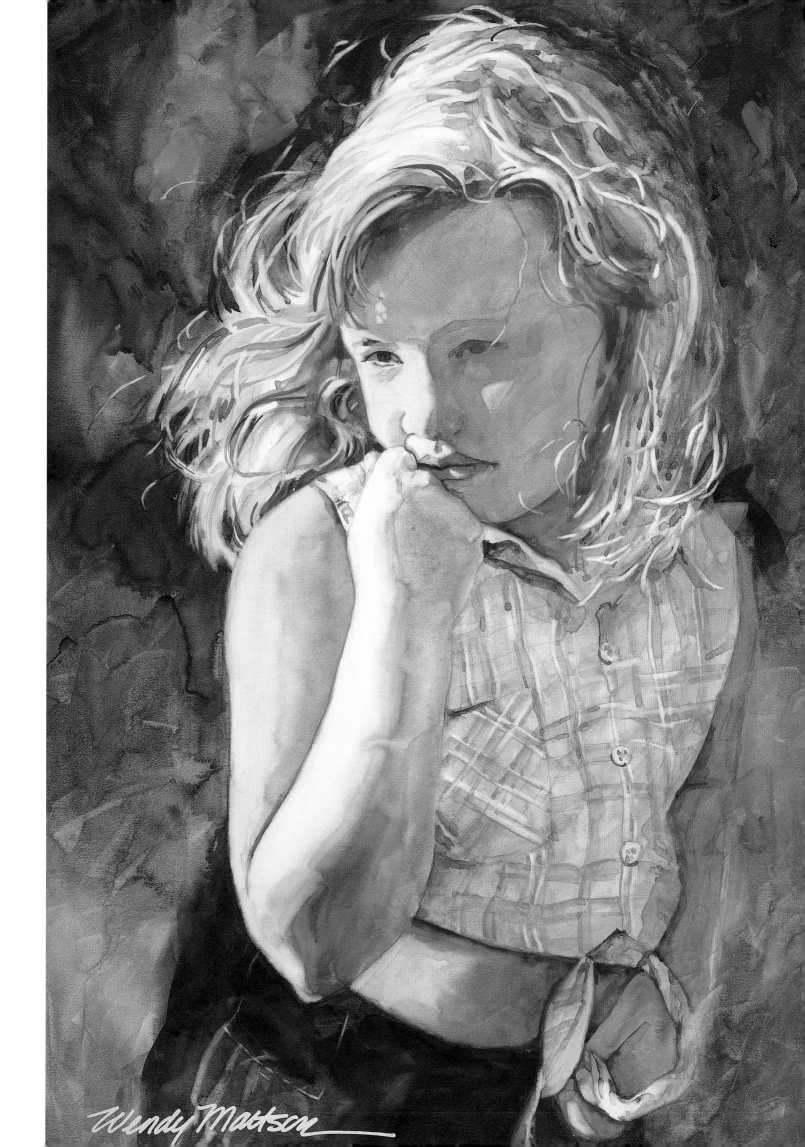

Wendy Mattson

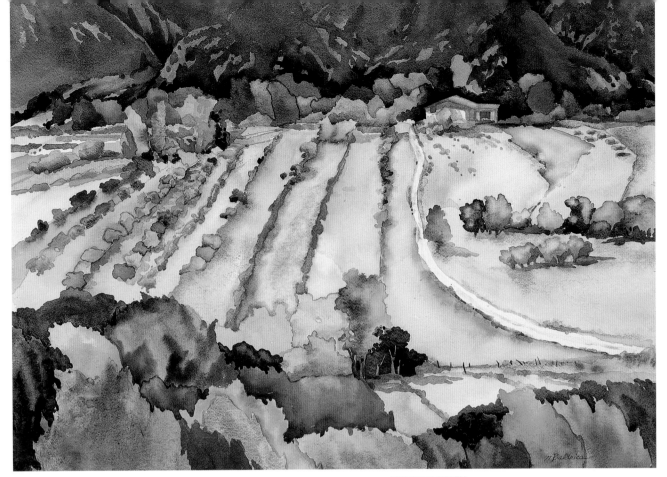

VALDEZ VALLEY
Nancy Baldrica • Transparent Watercolor • 22" x 30" (56cm x 76cm)

Changing the season in a landscape can improve the color scheme.

Nancy Baldrica

When I visited Valdez, New Mexico, in June, I was immediately attracted to the sensual nature of the wild landscape and how beautifully it contrasted with the orderly geometric textures of the partitioned fields. By changing the season in my painting I escaped what might have been an essentially monochromatic composition, since in June everything was green. By moving the clock forward four months, I was able to make use of the warmer hues in my palette, thereby complementing the cooler, verdant shades. ✳ I approached the work as a patchwork of miniature wet-into-wet vignettes. I enjoyed underscoring the granulating characteristics of certain pigments by setting them against the more pristine, transparent hues whose texture is far more refined.

Painting with emotion-charged abandon can produce surprising results.

Wendy Mattson

I was emotional as I entered my studio one night and sought to immerse myself in the painting process. For once I didn't care what the result was, I just wanted to paint! Music blared as I approached my paper with wild abandon. After a few hours, my inner turmoil stilled and I stood back to discover a painting more expressive than anything I had ever painted. I realized my approach had been different from the outset. My goal had been to *express something inside me* rather than paint a successful, attractive composition. The result was not merely a likeness of my daughter but an expression of her tender heart and complex, soulful nature—much like her mother's.

TENDERHEART
Wendy Mattson • Watercolor • 30" x 20" (76cm x 51cm)

Willimon, SWS,WTW,SWA

FRUIT FOR LUXOR
Edward L. Willimon • Transparent Watercolor • 22" x 30" (56cm x 76cm)

Looking through old photos
awakens the memory and the imagination.

Edward L. Willimon

While sorting through color slides taken in 1944, I discovered several taken in Luxor, Egypt, which awakened memories and the possibility of combining several photos into an interesting composition. After slight modification, the painting emerged as *Fruit for Luxor*. ☀ Sunlight and strong shadows with focal areas of rich colors were used to create a busy and abrupt watercolor painting. Dark shadows emphasized the hot sunlight and tied various shapes into one composition.

Setting aside reference photos of the sky
allows the mind's eye to paint spontaneously.

Jeff Nichols

A passion for creating the illusion of bright light in watercolor has prompted me to paint numerous skyscapes with rays of warm sunlight beaming from around the clouds. However, my work seemed to have a stiff appearance and didn't flow or have the "painterly" look I wanted. I attributed this to focusing on my reference photographs too closely. Therefore, as I began to paint *Steadfast*, I set all my reference photos aside except for the windmill. I discovered that painting from my mind's eye forced me to become more spontaneous with my painting. ☀ Using masking fluid to outline the sunlit edges of clouds is a neat and easy way of creating a backlit effect. This step must be taken early in the painting process, prior to building up your layers of color.

STEADFAST
Jeff Nichols • Watercolor • 14" x 20" (36cm x 51cm)

111

SAMADHI SERIES: FEBRUARY
Kristine Fretheim • Transparent Watercolor • 14" x 20" (36cm x 51cm)

Spring can be found
even in the dead of winter.

Kristine Fretheim

Eihei Dogen, a thirteenth-century Zen master, said: "Spring is in the plum branch covered with snow." Our house was buried in snow, streets and walkways a maze of ravines carved into a sparkling, white world. There on the kitchen counter, I discovered spring. The light and shadows surrounding the teacup and bottles held that same sparkling quality as the winter outside, yet I saw buds and blossoms unfolding there. ✳ I created texture in the shadows by sprinkling salt into wet, cool blues on top of a dry underpainting of lighter, warm blues. The contrast of warm and cool mirrors the warmth and cold of spring and winter. Watery blooms suggested foliage. I lifted leaf and butterfly shapes with stencils and a damp sponge, creating soft images that hint of spring stirring deep in winter.

A serious illness
prompted the discovery of watercolor painting
and a new inner strength.

Gene Rizzo

My "discovery" was a new aspect of myself. I never touched an artist's brush prior to February 1996. After serious but successful cancer surgery in mid-1995, I needed to find a new mental focus that would allow me to become passionately consumed and forget my health concerns. It was my love for watercolor art that became this new focus and helped to ease my mind. After many months of learning, I began to create meaningful images of my past life growing up along the Louisiana Gulf Coast. This passion has resulted in many artistic discoveries, not the least of which is my watercolor avocation that has given new meaning to life. ✳ My palette for *Misty* evokes the brightness of Florida seascapes while capturing the daily windswept showers from the sea.

MISTY
Gene Rizzo • Transparent Watercolor • 22" x 15" (56cm x 38cm)

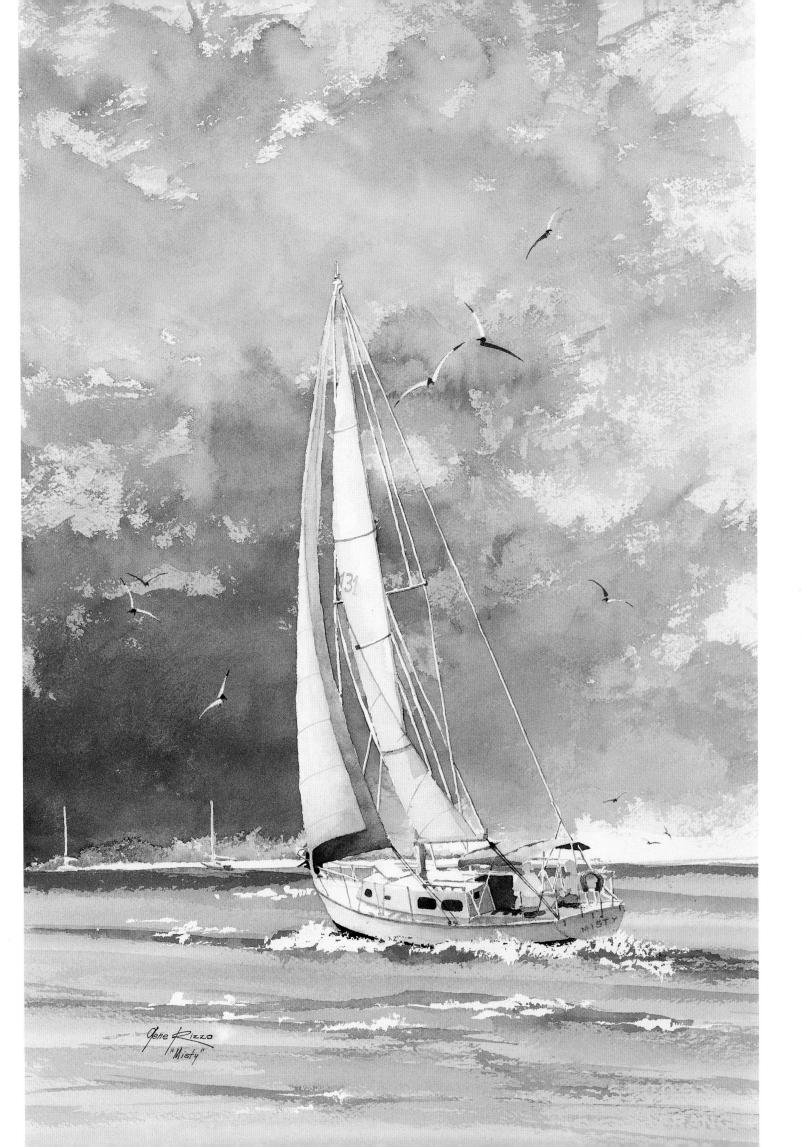

Gene Rizzo
"Misty"

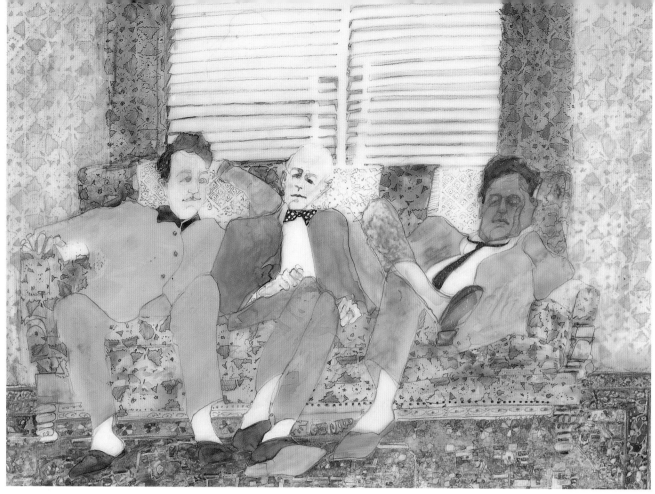

BUDS
Elisa Khachian • Watercolor on Vellum • 16 ½" x 21" (42cm x 53cm)

The desire to tell the family story
brought invention and creativity.

Elisa Khachian

As I matured, my work became more personal in its content and storytelling. An old photo tempted me to try a painting on a new surface I had been working with. My desire to tell the personal story of our family was stronger than the fact that I normally painted from life. Challenged and excited, I developed the work into a huge volume of pictures and stories. ✳ *Buds* is a page from this volume. Drawing on multimedia vellum is wonderful, but for watercolor it is a difficult surface. Images were done on both sides of the semitransparent paper. Pages were interwoven, resulting in monoprinting, collaging and multi-imaging. The translucent quality of the paper allowed for more inventive drapes, as well as a more inventive couch and rug. The face was painted on watercolor paper, transferred to acetate and placed under the top layer. All editing was done to tell the best story, and give the feeling of nostalgia and history.

Spilled paint becomes the catalyst
for a creative breakout.

Linda Loeschen

There was my beautifully stretched Arches cold-pressed sheet, dry, flat and ready to go. Then I happened to jostle the board and my creamy Indian Red spread all over that lovely white paper! I was beside myself. To stop the flow, I grabbed the closest thing at hand—a plastic bag—and ran out of the studio practically in tears to tell my husband my sad tale. I dragged him back to show him the horrible sight. I lifted the plastic. Wow! How interesting! What texture! And so it started. Pouring, spraying, dragging, using a brush, not using a brush, on and on. *I broke rules.* I tried black! "What if?" is now my mantra.

ON THE ROCKS
Linda Loeschen • Watercolor • 40" x 32" (102cm x 81cm)

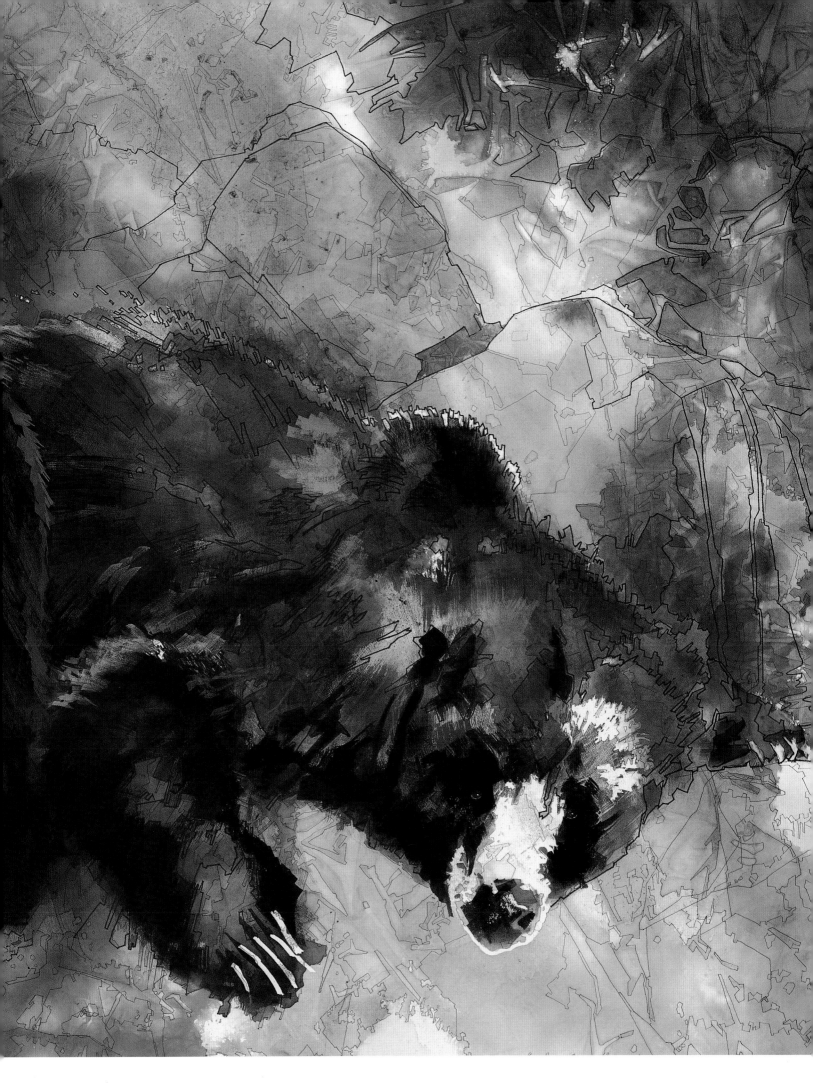

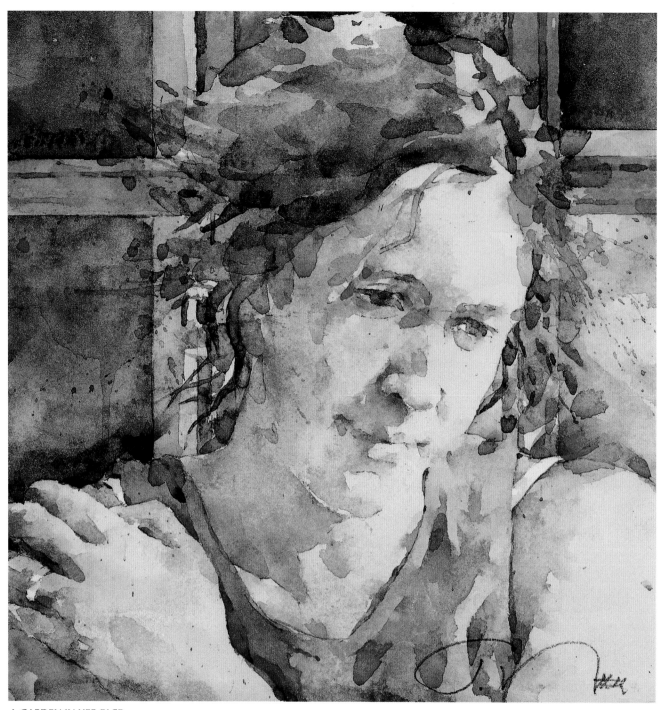

A GARDEN IN HER FACE
Ted Nuttall • Transparent Watercolor • 8 ¹/₂" x 8 ¹/₄" (22cm x 21cm)

A chance remark by a viewer
highlights a unique feature of the artist's painting style.

Ted Nuttall

During a recent show of my work an enthusiastic viewer wrote in the guest book, "I like your paintings except for the sloppy dots." It was with this observation that I realized I had begun to develop a unique painting style and that, in some respects, these intuitively placed accents were what made the paintings mine. I began to fondly refer to them as my "sloppy dots," focusing on how I might use them more effectively and make them a more integral part of my paintings. In *A Garden In Her Face* I felt, for the first time, that I had achieved a cohesiveness throughout the painting with the use of this visual theme. ✳ The entire composition was completed with a no.16 round Kolinsky sable brush. It is, essentially, the natural shape of the brush's profile gently pressed to the painting surface that creates these strategically placed dots. The technique lends spontaneity and texture to my characteristically high-key paintings.

GOIN' FISHING
Kathleen Brennan • Watercolor • 15" x 15" (38cm x 38cm)

You can discover your painting as you paint.

Kathleen Brennan

I paint experimentally, without a definite plan, so most of my paintings are a process of sequential discoveries as I intuitively try out different colors and textures, creating a dialogue between my internal artist and my materials. Here, I was experimenting with a symmetrical design in a square format. I included marks and shapes that were off balance to add interest, like the floating square in the upper left. My favorite discovery occurred when I had finished and it looked like a fishing lure was dangling into the center blue shape—hence the title. This painting always makes me smile. ✳ Several layers of watercolor paint on Waterford 200-lb. (425gsm) paper were used to develop texture. I painted fairly fast and wet, so most of the edges are soft. I usually work in a limited palette. For this painting, I used Titanium Buff, Quinacridone Gold, Payne's Gray and Cobalt Teal, with a little bit of Scarlet Lake for accents.

THREE APPLES, BOWL FROM CRETE
Joyce K. Jensen • Watercolor With Gouache • 16 ½" x 20 ¼" (42cm x 51cm)

Listening to your instincts
can uncover new creativity and freedom.

Joyce K. Jensen

Sometimes ideas seem to come from outside one's self, but really they come from deep within. When I saw the apples in the supermarket, they seemed to be preening and posing to get my attention. Like Pirandello's *Six Characters in Search of an Author*, they were apples in search of a painter! How could I resist? I planned the painting carefully but also with a sense of whimsy. Instinct had chosen the apples. Now, letting instinct take over, I went beyond my preplanned palette and reached for any color that worked. The apples emerged with a special liveliness.

You can overcome boundaries
and use "whatever works."

Edith Hill Smith

Last spring, one brave little yellow iris sprang up in my garden amidst a sea of purple ones. My title is based on this curious phenomenon. I discovered a freer way to paint after attending a workshop given by Edwin H. Wordell. He enthusiastically used any and everything when he created a painting, including scraps of his wife's watercolor paintings! His work knew no boundaries, yet his finished pieces had all the elements of a good painting: texture, form, color, shape, lines, movement, size and pattern. Since that time, I have overcome my own boundaries—and I have never looked back! ✳ Layers of transparent acrylics thinned to a watercolor consistency were applied to Crescent watercolor board. Texture was created with a variety of materials and papers. Watercolor pencils and crayons were used to enhance the images and overall texture.

THE CURIOUS IRIS
Edith Hill Smith • Mixed Media on Crescent Watercolor Board • 20" x 15" (51cm x 38cm)

118

EDITH HILL·SMITH

DISCOVER New Perspectives

There are two types of discoveries in this chapter. The first is seeing the world from a different physical or mental perspective. The second type of discovery for these artists, related to the first, has to do with renewing worn-out subjects by viewing them from a fresh perspective.

David L. Stickel [opposite page] discovered that making the viewer "look up" was a challenge calling for unusual perspective and lighting. "An example of linear perspective, this piece was done with the intention of 'pulling' the viewer's eye upward—just as the original architecture was designed to draw the worshipper's gaze heavenward. This painting of St. Peter's Basilica in Rome shows various shapes, planes and volumes in space. It combines massive support columns, decorative arches and a picturesque dome with illuminating highlights. I especially like the challenge of using only watercolor to depict the brilliant gold leaf."

Find a new way
to say an old thing.

—WIN BAINBRIDGE

GILDED GRANDEUR
David L. Stickel • Watercolor • 30" x 22" (76cm x 56cm)

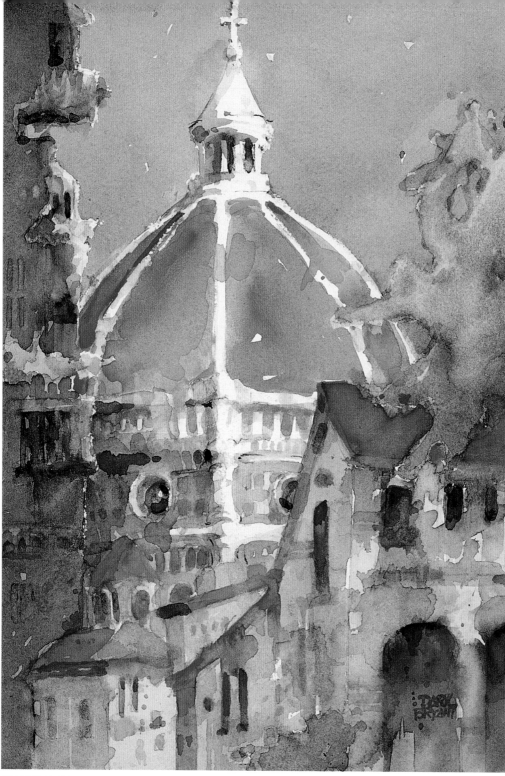

DUOMO DI FIRENZE
Daryl Bryant • Transparent Watercolor • 18" x 14" (46cm x 36cm)

Complementary colors
revive an old subject.

Daryl Bryant

After living in Florence, Italy for several years, the sight of the main church became a favorite of mine. Upon returning many years later, I wanted to paint it. However, a subject such as this is painted so often that it can become trite. With this in mind, I tried to approach the scene with a fresh eye. Combining photos and on-the-spot drawings allowed me to capture a new angle as well as to include a bit of the surrounding area.

✳ Drawing upon local color to express the flavor of Italy, I chose complementary colors: orange and blue as well as yellow and purple. I allowed them to mix directly on the paper in order to obtain maximum vibrancy and brilliance.

HOLSTEINS
Elizabeth M. Hamlin • Transparent Watercolor • 22" x 27" (56cm x 69cm)

Old "color patch" technique is revived,
expressing things from a "new perspective."

Elizabeth M. Hamlin

My limited skill as a beginner resulted in the style I now call "color patch." Years ago I rendered an image of boats in storage, with outboard motors attached, in traditional watercolor style. The motors looked like they were made of fluffy cotton. Influenced by hard-edge painting, which was in vogue at the time, I decided to use a separate hard-edged shape each time that the color or value changed. It worked; the motors now looked hard and metallic. Over the following years, I used this "color patch" technique only occasionally, until I started my aerial series. As I contemplated the shapes on the ground below me, I imagined the fields and pastures, trees and barns and lights and shadows painted in hard-edged shapes, and a new series was born.

123

ON THE GRAND TOUR, VENICE
Anthony J. Batten • Transparent Watercolor • 29" x 39" (74cm x 99cm)

It is possible to find a new view
of an over-painted location.

Anthony J. Batten

One of the great difficulties facing modern artists is that of coming up with a contemporary statement.
Virtually everything we would choose to depict has been tackled previously and, most discouragingly, very
often by an acknowledged master. However, if one looks at these earlier images, it becomes apparent that
they were simply capturing the details of contemporary daily life. Today's Venice is basically a great tourist
hub. One of the most painted spots on earth, the area around the Piazza San Marco, became the subject of
my painting *On the Grand Tour, Venice*. I searched for and found a view that I had never seen depicted before.
The discovery of this view of the arcade of the Doge's Palace from across an adjoining canal excited me.
Combining this new view with today's people—the casually sprawled tourists, backpackers and school
groups—brought this corner of the famed city to life in a thoroughly contemporary way. ✳ This work was
the final step in a process that included an on-site watercolor sketch of structures and pencil sketches of
tourists with color notes, among other things. Several optional lighting schemes were developed before I
settled on this one.

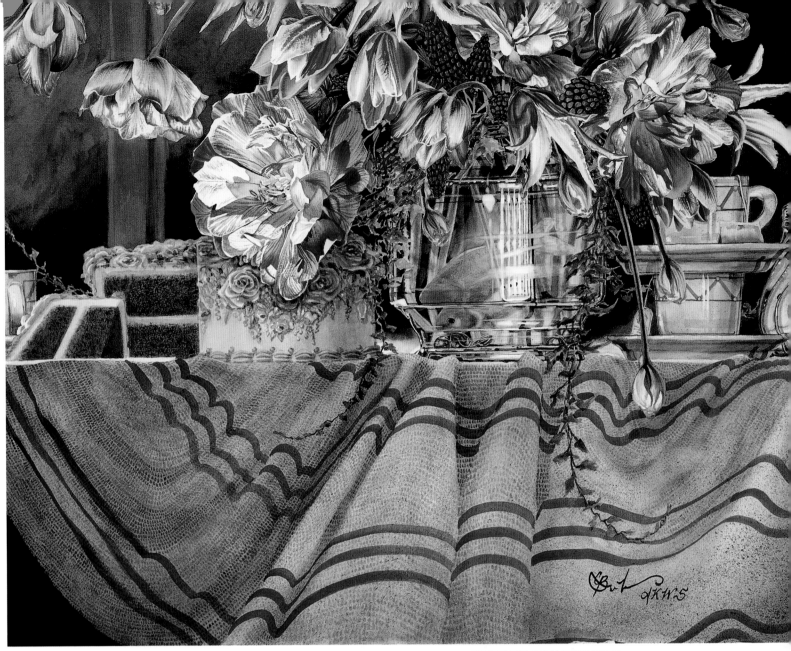

SPRING TEA WITH GOLD DUST
Cindy Brabec-King • Watercolor • 22" x 30" (56cm x 76cm)

Taking time to let your unconscious work on a problem
can turn a "not-working" piece into a favorite.

Cindy Brabec-King

Spring Tea With Gold Dust was a six-month-old piece, put away because something didn't click. The tulips worked, the goldfish in the jar worked, the cake worked, but the tablecloth didn't. I had tried to incorporate the five senses in many pieces; in this one there was a hint of smell, taste, touch and sight. Then one night I awoke with the realization that creating rolling stripes in the failed fabric, similar to sheet music, would give the painting the one thing it needed: sound. ✳ Straight, intense Alizarin Crimson was applied with a ¹/₂-inch (12mm) flat brush in exaggerated strokes. It worked! A little time and renewed thought turned an unsatisfying piece into a favorite.

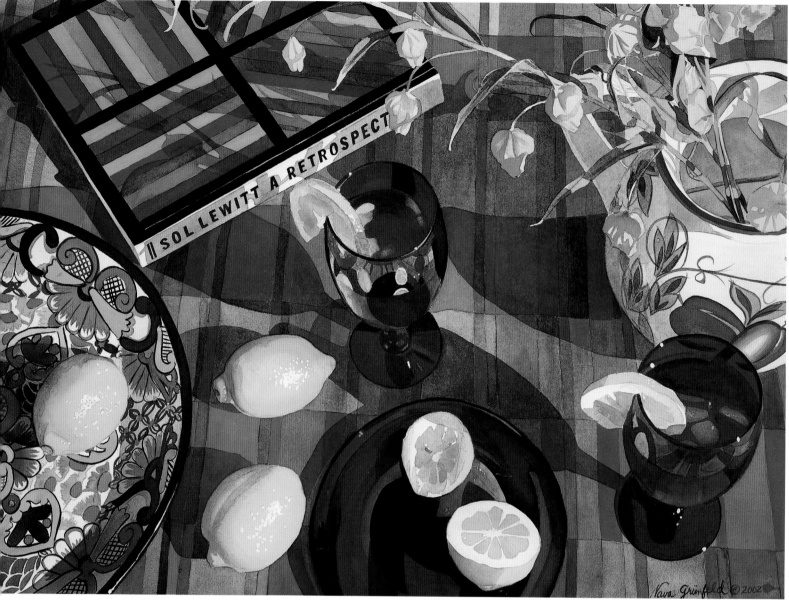

AFTERNOON WITH SOL

Nava Grunfeld • Watercolor • 29" x 41" (74cm x 104cm)

*Putting still-life setups on the floor
opened up a whole world of design possibilities.*

Nava Grunfeld

Ten years ago when I first started using watercolors I had a discovery. After painting traditional views of my still-life objects, I put the setup on the floor and knew immediately that that was how I wanted to paint it. The sunlight was streaming through, creating interesting shadows and light patterns that weaved their way between the objects. It reminded me of my previous career as a graphic designer, and I was able to use my design skills to compose a painting with pattern, colors and shapes.

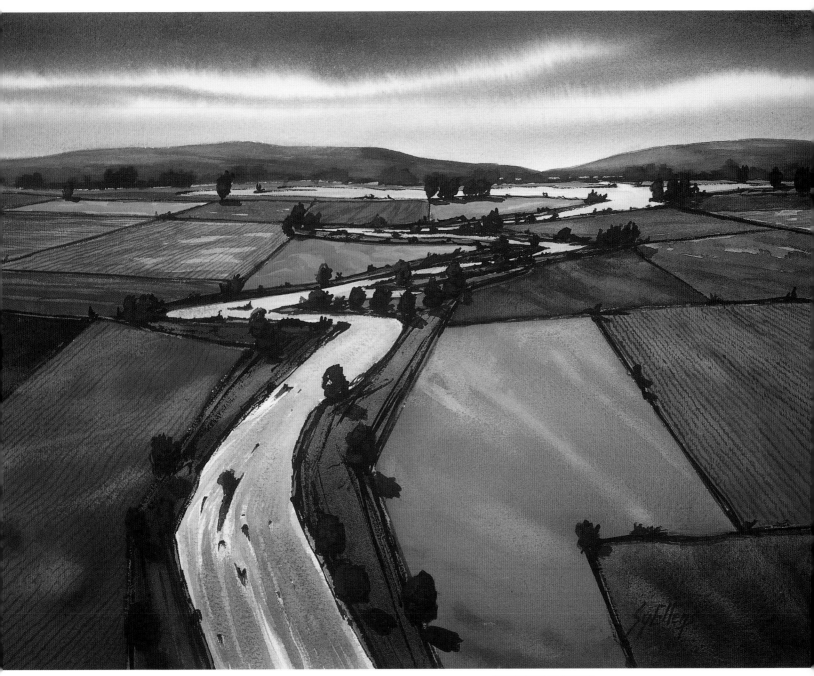

ENCHANTING COLOR
Sy Ellens • Watercolor • 20" x 28" (51cm x 71cm)

I've looked at scenes from both sides now:
viewing landscape from an aerial perspective.

Sy Ellens

When I am in an airplane I like to be seated next to a window so I can look down and see all the patterns, shapes and colors unfolding below. The view always seems so calm and peaceful. During one particular flight, I suddenly got the idea to do paintings of some of those patterns that I was collecting mentally. After doing some acrylics, I began using aerial views as a watercolor subject. ✳ I also discovered that by using the wet-into-wet method and saturating each space or "field" with color that I could achieve vivid colors. Some spaces had to be glazed over to get the effect that I wanted. Rather than be limited by the use of photographs, I enjoy the freedom of creating my own color combinations.

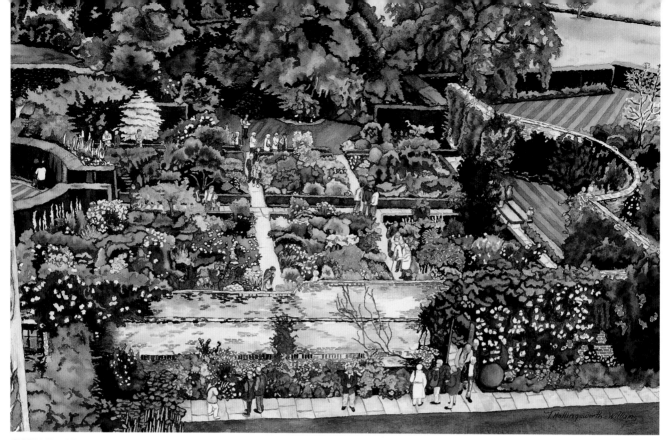

SISSINGHURST SUNDAY
Tommie Hollingsworth-Williams • Transparent Watercolor • 15" x 22 ½" (38cm x 57cm)

The view from a tower
suggests a storybook picture.

Tommie Hollingsworth-Williams

As soon as I saw the beautiful Sissinghurst Castle gardens from the tower, I knew I had to paint that view. Using the interesting grid of walls, clipped hedges and sidewalks in the rose garden as the focal point, I began to draw. But when I started painting, the people soon became the center of interest. This was a storybook glimpse into the lives of people visiting the gardens on a sunny Sunday afternoon. With the tower on the left and the sidewalk at the bottom forming the open book covers, the stories come to life: gardeners, photographers, an elderly tour group, sibling rivalries between two children trying to hold dad's hand, the embrace of newlyweds studying the map, and one old fellow just waiting patiently for everyone else. ✳ Amidst the many greens, the viewer is led through the garden by following the red (the complement of green) and white coats.

Painting a familiar subject,
but changing costume or setting,
creates a world of new possibilities.

Bill James

What fascinated me about this subject was the uniforms the three boys were wearing. I observed them at a Civil War reenactment while traveling in Virginia. Although they were representing the South, their uniforms were all different in appearance. I realized a story could be told in a painting. Apparently, years ago the soldiers prayed before each battle. As these three did so, the boy on the right looked up. Perfect. I got what I wanted. ✳ This watercolor was one of the first in which I decided to paint a subject in some kind of uniform. Since then, I've painted many more. This one got me started in a whole new direction. I realized that there were new possibilities in painting a familiar subject with a different setting.

CONFEDERATE BOYS PRAYING
Bill James • Transparent Gouache • 24" x 16" (61cm x 41cm)

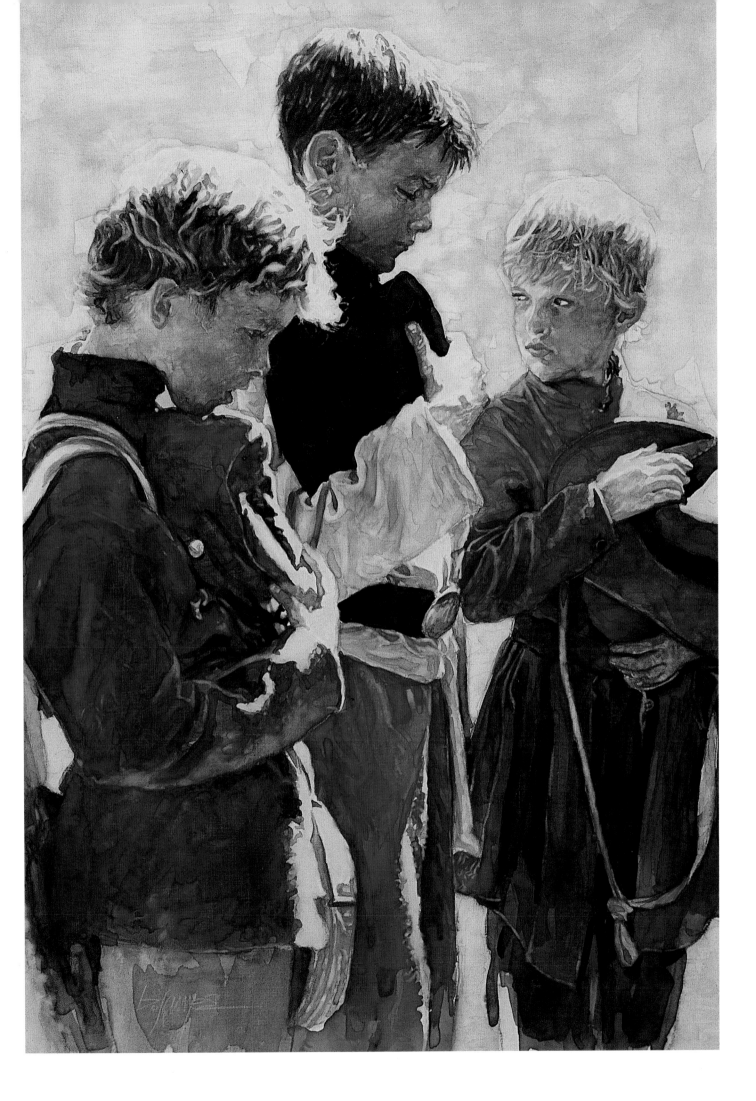

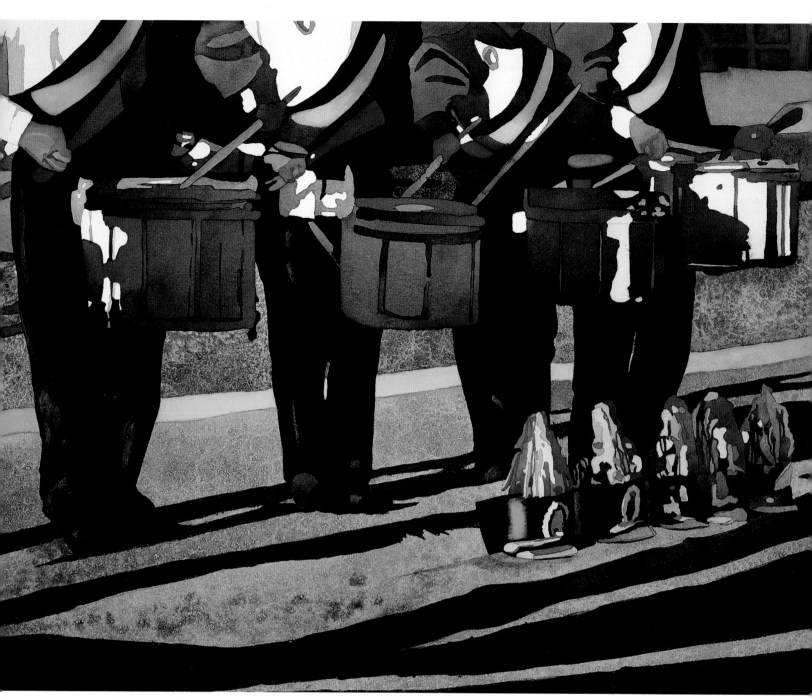

HATS OFF TO YOU
Charlene Brussat • Watercolor • 18" x 24" (46cm x 61cm)

BREAKTHROUGH DISCOVERY

Rediscovering the value of white paper
leads to a breakthrough and change.

Charlene Brussat

In some of my most recent paintings I have made an amazing discovery: Leaving areas of the white paper untouched creates fantastic contrast. During the twelve years that I had painted in watercolor, I just had to cover up all that white paper with paint. Then I would end up scrubbing back whenever I had gone too dark. In this painting of my granddaughters' drum and bugle corps, however, I was determined to leave the white shirts alone, and it worked. I got the fabulous contrast I love and learned the value of white paper. ✳ I used transparent watercolor with no masking, and I painted on dry Arches 300-lb. (640gsm) paper. I layered rich, brilliant color until I got the intensity I was after.

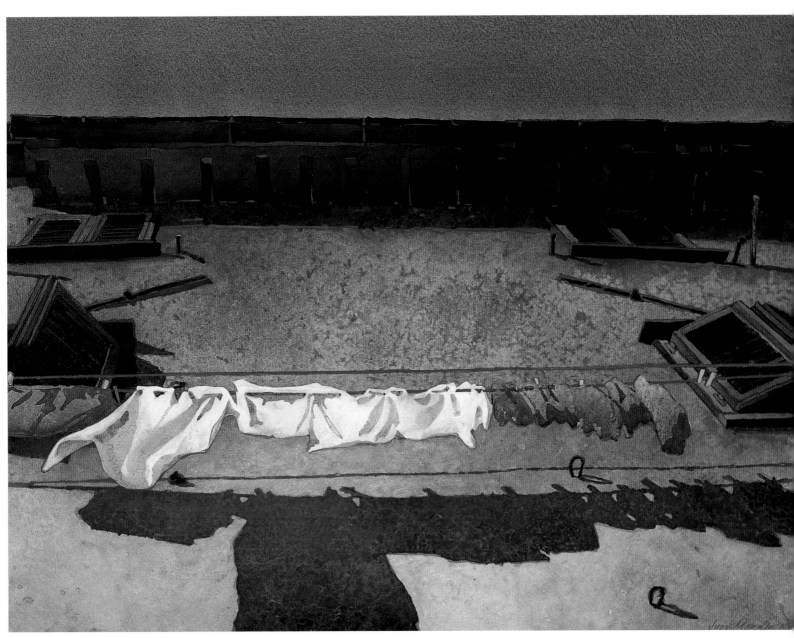

HANG UPS ON LINE
Judy Morris • Watercolor and Latex Paint • 20" x 29" (51cm x 74cm)

Applying latex paint
can help reclaim whites.

Judy Morris

I had visited Italy many times and painted my share of laundry before I found the inspiration for *Hang Ups on Line*. On one of the narrow streets of Volterra I looked up. The sky was breathtakingly blue, the laundry was crisp and white, and the buildings reflected layers of texture that only time can create. I knew instantly it would be a painting! And I knew from that moment on I would look at ordinary subjects with a creative eye, always trying to find the unusual view. ✳ The painting was progressing nicely until I painted the laundry. It was a disaster! Not wanting to start over, I sponged off as much of the "bad laundry" as possible but, in the process, found the paper was no longer white. My search to recover the white of the paper led me to the hardware store, where I had a quart of flat, latex wall paint mixed to the exact color of my 300-lb. (640gsm) Arches watercolor paper. I applied that wall paint to the shape of the laundry and let it dry completely. I discovered that applying flat, latex wall paint is a useful method for recovering whites.

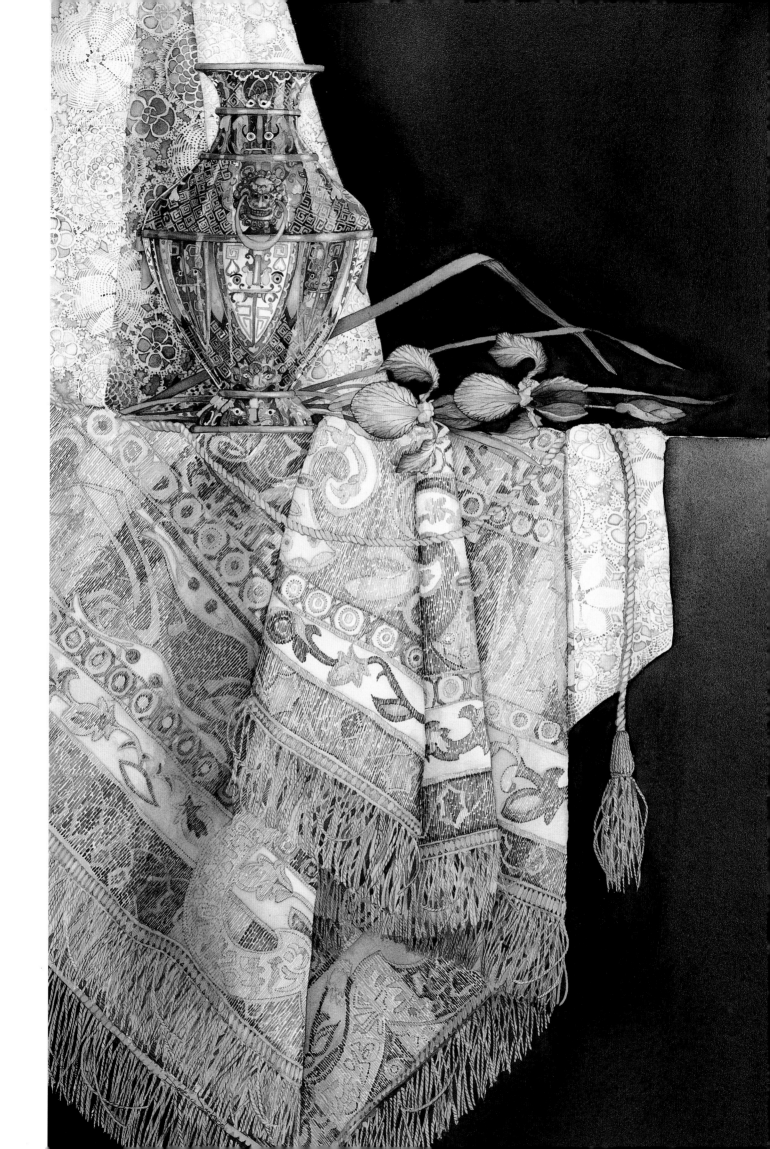

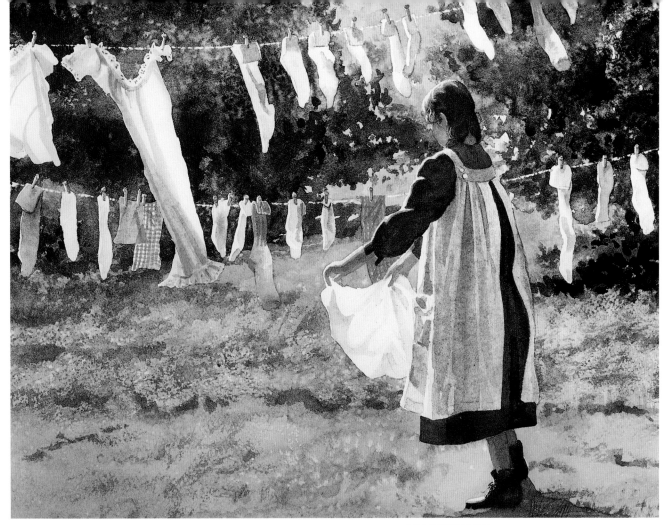

MONDAY'S CHILD
Dona Abbott • Watercolor • 12" x 16" (30cm x 41cm)

A *historic resource* *can inspire a new approach.*

Dona Abbott

Eager for a gorgeous day in the Rockies, I headed to the historic Walker Ranch, where volunteers dressed in period clothing were demonstrating the skills of the Colorado frontier. My paintings have always been inspired by things I have seen and experienced. Here was a chance to filter my experience through the charming atmosphere of times past and step into another era. Certainly, I could identify with the pleasures of hanging fresh laundry, but using a historic reenactment as a resource was a new approach for me. ✳ After masking the lighter elements, I splashed pigment on the background, using a spray bottle to create texture, and reserving a pathway for the light to play through the foliage.

Intentionally creating new challenges *in each painting* *leads to discoveries and artistic growth.*

Diane Jackson

Painting an intricate, creatively arranged still life has remained a beckoning passion for me. Each one represents further pursuit of the illusive mastery of the watercolor medium. My personal discipline has been to make each new painting challenge me with a greater degree of difficulty than the previous one. Facing new challenges, in turn, leads to new discoveries. *Rhapsody* was born out of that discipline. The challenge of working with the complex multiple patterns and fine fringe of the colorful cloth quickly stood out as an area for artistic growth. ✳ For *Rhapsody*, I looked beyond the surface of the cloth—the focus of my painting—to find grids of basic colors beneath the delicate woven pattern.

RHAPSODY
Diane Jackson • Transparent Watercolor • 28 ½" x 18 ½" (72cm x 47cm)

PEACHSCAPE
Elizabeth Kincaid • Watercolor • 13 ½" x 21" (34cm x 53cm)

A *tight closeup of a flower*
　　can become a whole landscape.

Elizabeth Kincaid

The breakthrough in *Peachscape* resulted from a new idea: move so close to a flower that it becomes a whole landscape! *Peachscape* is one rose; it is also a mountain range with distant peaks and deep valleys. Imagine being able to move through its deep spaces. Flowers as landscape is an idea that has intrigued me for a long time, but *Peachscape* was where I first discovered an image that could work in this way. My challenge was to bring out the hidden landscape, and I accomplished this in the way I cropped the flower. ✳ I masked small light areas and painted details before glazing large washes of Indian Yellow, Permanent Rose and Winsor Violet. Glazing over the veins softens them, so they meld with their surroundings.

LIFE CIRCLES
Dona Abbott • Transparent Watercolor • 21" x 28" (53cm x 71cm)

The computer can be a valuable tool
for tackling complex subject matter.

Dona Abbott

I have carried the image of my grandmother's quilting circle in my mind since childhood, when I played beneath the quilt frame. I wanted to paint it from above to reveal the intersecting circles of the Double Wedding Ring pattern, as well as to reveal the interplay of patterns, textures and personalities. The ways the women worked creatively with color and pattern as they dealt with life's vicissitudes was a huge influence in my life. Passing artistic and life skills from one generation to another is just one of the circles in life that this painting captures. Discovering Adobe Photoshop enabled me to visualize this unique and complex point of view. It opened a door, taking my work to another level. ✳ By scanning my original sketches of each figure onto separate layers of Photoshop, I was able to experiment with and literally see a myriad of combinations in far less time than it would have taken me to resketch each option manually.

SUNSET OVER FIRENZE
Steve Stento • Watercolor • 15" x 30" (38cm x 76cm)

By attempting new things in your work
and challenging yourself,

you grow as an artist,
and you just might be surprised by the results.

—STEVE STENTO

You can improve your work
by breaking out of your comfort zone.

Steve Stento

The idea for *Sunset Over Firenze* had floated around my head for a long time before I actually worked up enough nerve to attempt it. Not only was the epic scale daunting, but the palette and the mood of a Tuscan sunset were completely different from my normal midday scenes. Without having done anything like this before, I had to think my way through the whole piece, instead of using tried-and-true techniques and color combinations. Along the way, I discovered that by attempting new things in your work and challenging yourself, you grow as an artist, and you just might be surprised by the results. ✳ On 300-lb. (640gsm) cold-pressed paper, I applied washes of Yellow Ochre with touches of Cadmium Yellow and Burnt Sienna over the entire painting to establish the warm glow of sunset. To achieve depth, I simplified the shapes and values and relied on temperature changes for the background, slowly adding more detail and darker darks as I reached the bottom of the painting. The balcony was something I added to the scene to improve the composition and make the view more dramatic.

CONTRIBUTORS

Dona Abbott
2855 Iliff Street • Boulder, CO 80305
(303) 494-7752 • dabbott303@aol.com
p. 133 *Monday's Child*
p. 135 *Life Circles*

Neil H. Adamson
7089 South Shore Drive • South Pasadena,
FL 33707 • (727) 347-3555
p. 74 *Dragonfly in Trouble*

Joseph Alleman
893 W. 500 Street • Orem, UT 84058
(801) 400-1378
josephalleman@hotmail.com
p. 37 *Morning Rehearsal*
p. 59 *Hope Chest*

James Asher
P.O. Box 8022 • Santa Fe, NM 87504
(505) 982-8044
asherarnett@earthlink.net
p. 12 *Hotel Villa Venezia, Venice*

Frances Ashley
4806 Roundup Trail • Austin, TX 78745
(512) 444-4527
francesashley@hotmail.com
p. 36 *Betty Takes Yet Another Sunbath*

Win Bainbridge
628 Bell Street • Edmonds, WA 98020
(425) 776-0067 • winbobbain@aol.com
p. 83 *Over the Hills*

Nancy Baldrica
3305 Brenner Place • Colorado Springs, CO
80917 • (719) 380-1537
nbaldrica@aol.com
p. 109 *Valdez Valley*

Anthony J. Batten
565 Avenue Road, Penthouse #1 • Toronto,
ON M4V 2J9 • Canada • (416) 922-5222
p. 124 *On the Grand Tour, Venice*

Judi Betts
P.O. Box 3676 • Baton Rouge, LA 70821 •
(225) 926-4220
p. 101 *Café au Lait*

Cindy Brabec-King
712 Ivanhoe Way • Grand Junction, CO
81506 • (970) 242-9504
mcbking@alaska.net
p. 13 *By a Harbor Named Pearl*
p. 125 *Spring Tea With Gold Dust*

Kathleen Brennan
12 Spring Road • Orinda, CA 94563
(925) 253-8747 • katart@earthlink.net
p. 117 *Goin' Fishing*

Carel P. Brest van Kempen
P.O. Box 17647 • Holladay, UT 84117
(801) 474-2505 • cpbvk@juno.com
p. 46 *Rajah Brooke's Birdwing*

Dana Brown
1423 Pratt Avenue • Huntsville, AL 35801
(256) 880-4008 • artbydana@aol.com
p. 64 *Three Air Conditioners*

Marianne K. Brown
245 Rheem Boulevard • Moraga, CA 94556
(925) 376-0658
mkbrownart@earthlink.net
p. 44 *Tied Up VII*

Charlene Brussat
13951 Upper Applegate Road • Jacksonville,
OR 97530 • (541) 899-7953
p. 91 *Waiting For Daddy*
p. 130 *Hats Off to You*

Daryl Bryant
1136 Fremont Avenue #101 • South
Pasadena, CA 91020 • (626) 799-0921
p. 6 *Strada a Monteporzio*
p. 122 *Duomo di Firenze*

Dan Burt
2110-B West Lane • Kerrville, TX 78028
(830) 895-3683
p. 18 *Guanajuato*

Kay Carnie
10439 Heney Creek Place • Cupertino, CA
95014 • (650) 962-0218
kccarnie@aol.com
p. 95 *It's a Wrap*

Kathy Caudill
1658 Brandyhill Drive • Rock Hill, SC 29732
(803) 981-5273 • kcaudill@cetlink.net
p. 66 *November Sunshine: Minnie*

Ruth Cocklin
5923 S. Willow Way • Greenwood Village,
CO 80111 • (303) 741-0291
rellen10@juno.com
p. 96 *Bad Boy*

Kathleen Cornelius
7012 Hunt Club Drive • Zionsville, IN 46077
(317) 873-6303
Shamrock_Hill_Studio@email.msn.com
p. 65 *French Lemonade*

Lawrence Danecke
1950 S.W. 23 Court • Ft. Lauderdale, FL
33315 • (954) 764-2328
watercman@aol.com
p. 19 *School's Out*

Doris Davis-Glackin
407 Cann Road • West Chester, PA 19382
(610) 696-1017
WinghavenH@aol.com
p. 54 *Unkept Promises*

Mark de Mos
7 Richlyn Court • Morristown, NJ 07960
(973) 267-4363 • demosart@juno.com
p. 63 *Baldwin's Study*

Saundra Devick
3839 N.W. Ninetieth Place • Polk City, IA
50226 • (515) 964-8089
sdevick1@earthlink.net
p. 16 *All in a Row*

Linda Kooluris Dobbs
484 Avenue Road, Suite 609
Toronto, ON M4V 2J4 • Canada
(416) 960-8984
p. 70 *Aqua and Rust*

Jo Ann Durham
4300 Plantation Drive • Fort Worth, TX
76116 • (817) 244-3807
p. 42 *Cosmic Patterns*

Margaret Dwyer
P.O. Box 519 • New London, NH 03257
(603) 526-4988 • danacdavis@yahoo.com
p. 76 *Wavy Glass*

Sy Ellens
326 W. Kalamazoo Avenue, Suite 321
Kalamazoo, MI 49007 • (269) 342-6326
art@syellens.com • www.syellens.com
p. 127 *Enchanting Color*

Joyce Roletto Faulknor
6 Estrada Place • Redwood City, CA 94062
(650) 364-8862 • mfaulknor@aol.com
www.h2o-color.com
p. 77 *Gerberas I*

Kristine Fretheim
8677 N. Zinnia Way • Maple Grove, MN
55369 • (763) 494-4564
kfretheim@attbi.com
p. 112 *Samadhi Series: February*

Ann Gaechter
Roaring Fork Studio • P.O. Box 285
Woody Creek, CO 81656
agpaints@hotmail.com
p. 105 *The Survivor*

Jean H. Grastorf
6049 Fourth Avenue N. • St. Petersburg, FL
33710 • (727) 381-8816 • cwgfl@aol.com
p. 62 *Guggenheim*

Terry Gregoraschuk
5020 Fifteenth Street S.W. • Calgary, AB
T2T 4B6 • Canada • (403) 243-7786
primer@telusplanet.net
p. 47 *Signs of Spring*

Elizabeth Groves
2430 Alamo Glen Drive • Alamo, CA 94507
(925) 837-4968 • tgr6146000@aol.com
p. 78 *Agapanthus*

Lana Grow
1745 Chatham Avenue • Arden Hills, MN
55112 • (651) 633-5085
lgrow@msn.com
p. 45 *Emissary of Light and Form*

Nava Grunfeld
116 Pleasant Street, Suite #21
Easthampton, MA 01027 • (413) 527-9677
art@navagrunfeld.com
www.navagrunfeld.com
p. 10 *Red Vase*
p. 126 *Afternoon with Sol*

Elizabeth M. Hamlin
1073 N. Arrowhead Road • Camano Island,
WA 98282 • (360) 387-7128
crhamlin@dogday.net
p. 123 *Holsteins*

Ann Hardy
7100 Waldon Court • Colleyville, TX 76034
(817) 481-4007 • AHardyART@aol.com
p. 67 *Big Bend*

Susan Harrison-Tustain
85 Castles Road RD3 • Tauranga, New
Zealand 2031 • (64) 7 543 3933
susan@susanart.com • www.susanart.com
p. 93 *Jonquilles pour Ma Mère*

Laurel J. Hart
2533 Lambourne Avenue • Salt Lake City,
UT 84109 • (801) 467-6316
laureljhart@attbi.com
p. 21 *Heading Home*

Tanya L. Haynes
11408 E. Baltic Place • Aurora, CO 80014
(303) 671-0306 • tanya@h2oscapes.com
p. 61 *Jellyfish Suspended*

Sally S. Heston
2008 McClaren Lane • Broadview Heights,
OH 44147 • (440) 746-9921
sally@sgi.net
p. 41 *Goodbye to Summer*

Susan Hinton
1729 N. Cascade Avenue • Colorado
Springs, CO 80907 • (719) 471-8907
skhint@msn.com
p. 73 *Zinnias*
p. 92 *Onions*
p. 103 *Matt*

Sandra Hodges
2007 Ward Street • Midland, TX 79705
(432) 683-9217 • pa2bucky@aol.com
p. 55 *Serendipity*

Tommie Hollingsworth-Williams
3014 Magnolia Place • Hattiesburg, MS
39402 • (601) 268-3784
hollingsworthwms@earthlink.net
p. 99 *Tootle's Sunbeam*
p. 128 *Sissinghurst Sunday*

Adele Huestis
1250 Northcliff Trace • Roswell, GA 30076
(770) 640-9265
p. 50 *The Demonstration*

Lance Hunter
617 W. Downing Street • Tahlequah, OK
74464 • (918) 458-0421
lance@lancehunter.com
p. 2 *Small Wonders*

PIER TALK
G. Bruce Johnson • Transparent Watercolor • 20 ½" x 27 ½" (52cm x 70cm)

Estelle Lavin
11 Riverside Drive • New York, NY 10023
(212) 873-6905 • estellelavin@aol.com
p. 68 *Street in Montefalco*

David Lee
186 Hickory Street • Washington Township,
NJ 07676 • (201) 664-8720
tzeh_hsian@hotmail.com
p. 80 *Butterflies*

Linda Loeschen
P.O. Box 583 • Basalt, CO 81621
(970) 927-3243
p. 115 *On the Rocks*

Fran Mangino
1180 Smoke Burr Drive • Westerville, OH
43081 • (614) 891-6558
midlifemama@hotmail.com
p. 81 *The Nose Knows*

Wendy Mattson
P.O. Box 5664 • El Dorado Hills, CA 95762
(530) 676-0669 • cmattson@webtv.net
p. 108 *Tenderheart*

Virginia May
16417 Albion Trail, R.R. 4 • Tottenham, ON
L0G 1W0 • Canada • (905) 880-9686
vmayfineart@hotmail.com
p. 74 *Bill*

Paul W. McCormack
P.O. Box 537 • Glenham, NY 12527
(845) 831-3368 • pwmccormack@aol.com
p. 26 *Humility*

Alex McKibbin
Casa Pamajera • Caleta Yalku, Lote 103
P.O. Box 31 • Akumal, Q. Roo Mexico 77760
011 52 984 875-9215
ptcmex@netscape.net
p. 15 *Environs of Pamajera #230*

Eleanor Tyndall Meier
P.O. Box 2134 • Setauket, NY 11733
(631) 941-4319
el.meier@worldnet.att.net
p. 25 *Echoes and Resonance*

Esther Melton
201 Oakmist Way • Blythewood, SC 29016
(803) 714-0246
esthermelton@yahoo.com
p. 17 *Pears and Silver Gravy Boat*
p. 97 *Marbles and Jacks*
p. 98 *Pears I*

Joye Moon
4974 Lansing High Point • Oshkosh, WI
54904 • (920) 235-4429
joye@joyemoon.com
www.joyemoon.com
p. 85 *Joye in the Morning*

Judy Morris
2404 E. Main Street • Medford, OR 97504
(541) 779-5306
judy@judymorris-art.com
p. 131 *Hang Ups on Line*

Leigh Murphy
1536 Ingleside Avenue • Jacksonville, FL
32205 • (904) 387-0619
leighmurphyart@yahoo.com
p. 87 *Mangrove Mysteries*

Woon Lam Ng
BLK 824 Jurong West Street-81 • #08-450
Singapore 640824 • 065-6790-8760
ngwoonlam@yahoo.com
p. 30 *Trafalgar Square I*

Jeff Nichols
5561 E. Sing Drive • Columbia, MO 65202
jnartist@aol.com
www.jeffnicholsart.com
p. 110 *Steadfast*

Ted Nuttall
4225 N. Thirty-Sixth Street, #34 • Phoenix,
AZ 85018 • (602) 253-1605
nuttall@azlink.com
p. 116 *A Garden in Her Face*

Heidi Lang Parrinello
25 Madison Street • Glen Ridge, NJ 07028
(973) 743-8005 • heidialang@aol.com
p. 31 *Strength*

Donald W. Patterson
441 Cardinal Court N. • New Hope, PA
18938 • (215) 598-8991
p. 57 *Getting Ready*

Marlene Paul
32 Sweet Brier Drive • Ballston Lake, NY
12019 • (518) 877-7957
fpaul2@nycap.rr.com
p. 38 *Dancing Kings*

Jean Pederson
4039 Comanche Road N.W. • Calgary, AB
T2L 0N9 • Canada • (403) 289-6106
artform@telus.net
p. 48 *Looking Forward*
p. 49 *All in But the Boot Laces*

Judy Perry
2 Salt Meadow Lane • Old Saybrook, CT
06475 • (860) 395-1695
judy@judyperryportraits.com
p. 53 *Lillian*

Linda Peterson
77 Siders Pond Road • Falmouth, MA 02540
(508) 548-5971 • lindak25@msn.com
p. 60 *Old Friend*

Avra Pirkle
2588 Gary Drive • Soquel, CA 95073
(831) 479-8051 • avrapirkle@yahoo.com
p. 43 *Dancing Daisies*

Mary Ann Pope
1705 Greenwyche Road S.E. • Huntsville,
AL 35801 • (256) 536-9416
mapope@mindspring.com
p. 86 *Thicket*

Mary L. Quiros
2105 Galveston Road • Laredo, TX 78043
(956) 723-8910 • equiros@swbell.net
p. 106 *Mariposas*

Gene Rizzo
390A Pinellas Bayway • Tierra Verde, FL
33715 • (727) 864-3100
rizzoart@tampabay.rr.com
p. 113 *Misty*

Jeanette Robertson
P.O. Box 425 • Cazenovia, NY 13035
(315) 655-9484 • capecaz@aol.com
p. 14 *Bovine Rhythm*

Bev Rodin
10 Woodthrush Court • Willowdale, ON
M2K 2B1 • Canada • (416) 884-6955
p. 100 *Chandelier and Gladioli at Cheverny*

Deborah Rubin
143 Flat Hills Road • Amherst, MA 01002
(413) 253-7922 • drubin@rcn.com
p. 88 *Yellow Trolley*

Jean Sadler
P.O. Box 4623 • Valley Village, CA 91617
(818) 980-6418
sadlerjeansadler@aol.com
p. 35 *Daisies*

Edith Hill Smith
6940 Polo Fields Parkway • Cumming, GA
30040 • (770) 781-9768
wintonsmith@juno.com
p. 119 *The Curious Iris*

Pam Stanley
215 Aberdeen Street • Corpus Christi, TX
78411 • (361) 854-3695
rapstanley@msn.com
p. 51 *Colorado Memory #1*

Steve Stento
6221 E. Roland Street • Mesa, AZ 85215
(480) 654-0771
stento1@mindspring.com
p. 136 *Sunset Over Firenze*

David L. Stickel
1201 Hatch Road • Chapel Hill, NC 27516
(919) 942-3900 • dlstickel@juno.com
www.davidstickel.com
p. 22 *Treasures of the Heart*
p. 23 *Branching Out*
p. 121 *Gilded Grandeur*

Kathy Miller Stone
5125 Greenside Lane • Baton Rouge, LA
70806-7139 • (225) 343-7511
cypress-studio@juno.com
www.kathystone.net
p. 5 *Patterns*

Rudolf Stussi
111 Malvern Avenue • Toronto, ON M4E 3E6
Canada • (416) 694-8118
rudolfstussi@hotmail.com
p. 84 *Red Fall*

James Toogood
920 Park Drive • Cherry Hill, NJ 08002
(856) 429-5461 • jtoogood@snip.net
p. 33 *Cavello Bay*
p. 82 *Aqua Man*
p. 102 *Thrift Bakery*

Nedra Tornay
2131 Salt Air Drive • Santa Ana, CA 92705
(714) 544-3924
p. 69 *Two Women*

Sharon Towle
2417 John Street • Manhattan Beach, CA
90266 • (310) 546-1864
sharontowle@ix.netcom.com
p. 79 *Mismaloya Experience*

Dani Tupper
942 Twenty-Ninth Lane • Pueblo, CO 81006
(719) 948-3970 • kdtup@msn.com
p. 94 *Budding Artist*

Jan Fabian Wallake
13833 Ozark Avenue N. Ct. • Stillwater, MN
55082 • (651) 351-1301
j.wallake@worldnet.all.net
p. 11 *Sun Runners*

Soon Y. Warren
4062 Hildring Drive W. • Fort Worth, TX
76109 • (817) 926-0327
soon-warren@charter.net
www.soonwarren.com
p. 9 *Peony With Glass*
p. 24 *Green Vase*

Ed Weiss
16100 Woodvale Road • Encino, CA 91436
(818) 905-6864
p. 56 *Old New York (Rain)*

Edward L. Willimon
111 S. Royal Oak Drive • Duncanville, TX
75116 • (972) 296-2260
edwardwillimon@aol.com
p. 111 *Fruit for Luxor*

Rhoda Yanow
12 Korwell Circle • West Orange, NJ 07052
(973) 736-3343
p. 27 *Conversation*

Donna Zagotta
7147 Winding Trail • Brighton, MI 48116
(810) 231-9059
donnazagotta@chartermi.net
p. 107 *Canal Street No. 2*

INDEX

The BEST *in watercolor instruction and inspiration* is from NORTH LIGHT BOOKS!

watercolor
painting outside the lines
a positive approach to negative painting
Linda Kemp

Create alluring works of art through negative painting—working with the areas around the focal point of the composition. Through easy to follow step-by-step techniques, exercises and projects, you'll learn to harness the power of negative space. Linda Kemp's straightforward diagrams for color and design, as well numerous troubleshooting suggestions and secrets, will make your next watercolor your most striking work yet!

ISBN 1-58180-376-1, *hardcover*, 128 *pages*, #32390-K

PAINTING
Glowing Colors
IN WATERCOLOR
Penny Soto

Penny Soto shows you how to add emotion, drama and excitement to your work with color. By following her simple step-by-step instructions, you'll learn how to combine and juxtapose hues to create vibrant paintings. You'll also discover the many personalities of color and techniques for capturing light, shadow and reflections in water.

ISBN 1-58180-215-3, *hardcover*, 144 *pages*, #31993-K

watercolor
pour it on!
Let your creativity flow using dramatic color glazing techniques
jan fabian wallake

Create startling works of art that glow with color and luminosity! Jan Fabian Wallake shows you how to master special pouring techniques that allow pigments to run free across the paper. There's no need to worry about losing control or making mistakes. Wallake empowers you to trust your instincts and create rich and vibrant glazes.

ISBN 1-58180-487-3, *paperback*, 128 *pages*, #32825-K